H O R S E

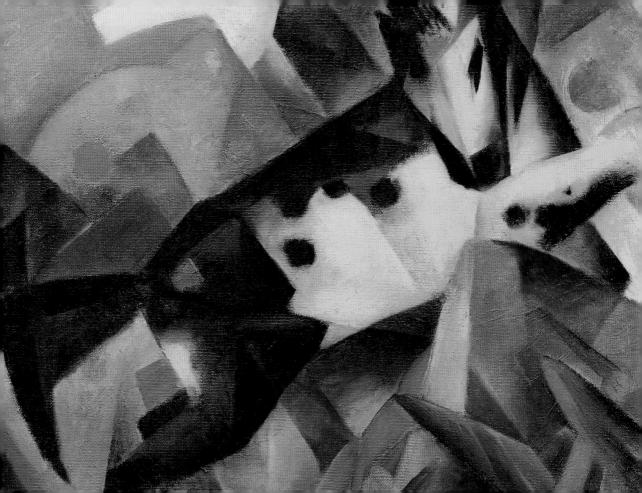

LORRAINE HARRISON

HORSE

FROM NOBLE STEEDS TO BEASTS OF BURDEN

WATSON-GUPTILL
PUBLICATIONS
New York

Copyright © The Ivy Press Limited 2000

First published in the United States in 2000
by Watson-Guptill Publications
a division of BPI Communications, Inc.
770 Broadway, New York, NY 10003

This book was conceived, designed, and produced by

THE IVY PRESS LIMITED

The Old Candlemakers, West Street
Lewes, East Sussex, BN7 2NZ

Art Director: Peter Bridgewater
Editorial Director: Sophie Collins
Designer: Angela Neal
Senior Project Editor: Rowan Davies
Editor: Mandy Greenfield
Picture research: Vanessa Fletcher

Library of Congress Catalog Card Number: 00-104342

ISBN 0-8230-2334-6

Printed in Singapore by Star Standard Industries (PTE) Ltd.

First printing, 2000

1 2 3 4 5 6 7 8 9/07 06 05 04 03 02 01 00

Page 2 illustration: Franz Marc, *Jumping Horse* (1912)
Pages 4–5 illustration: Honoré Daumier,
A Man on a White Horse (c. 1855)
Page 5 illustration: Chinese,
Fleeing Horse (2nd Century B.C.)

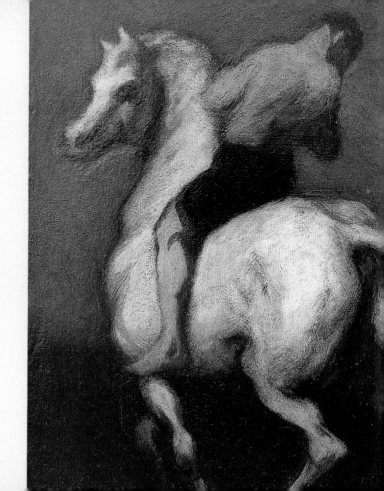

CONTENTS

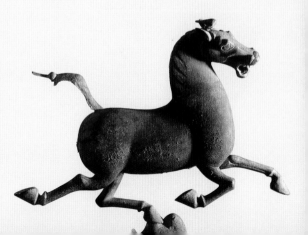

INTRODUCTION

THE HORSE HAS BEEN IN TURN REVERED, EXPLOITED, AND LOVED BY MEN AND WOMEN THROUGHOUT HISTORY.

It has accompanied humans at times of war, hunting, working, and playing. Horses have appeared in myths from around the world as mystic representations of beauty, fear, and triumph; they have been symbols of wild, untamed nature, avenging chargers, highbred performers and trusted companions.

In the history of art, the horse has been a constant subject, explored and presented with endless variation and invention. From the earliest evidence of primitive art on the cave walls at Lascaux in France (c. 15,000 B.C.), to the sophistication of the Renaissance drawings of Leonardo da Vinci (1452–1519) and the abstracted forms

JOHN EMMS
*The Dapple Grey
and Stable Lad*
1897

VARI
Small Horse
1983

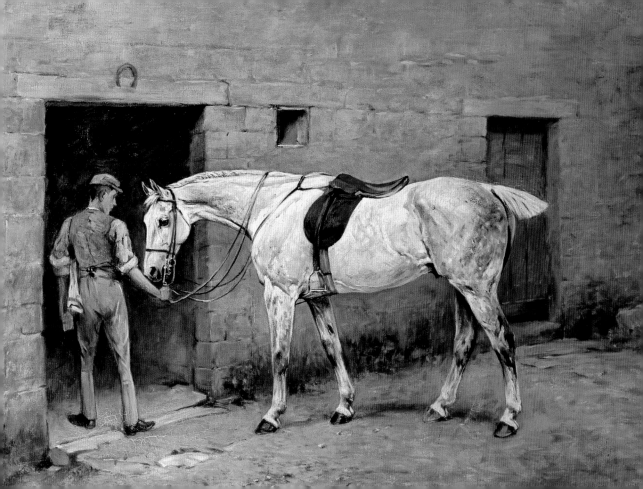

TOULOUSE-LAUTREC
The Tandem
1899

of Pablo Picasso (1881–1973), the horse has remained a powerful subject. Likewise, in literature, writers from Geoffrey Chaucer (c. 1345–1400) and William Shakespeare (1564–1616) to John Keats (1795–1821) and Anna Sewell (1820–78) have celebrated the horse in prose and verse.

From the time that the horse was first captured and tamed it has played an integral role in the development of civilization. Without the horse, human history might have taken many different courses; without horsepower, great battles, invasions, conquests, and explorations would have been severely impeded. The overland transportation of goods and people, weapons and food, was quicker and easier with the use of the adaptable and agile equine.

In painting and sculpture, the horse most commonly appears in the active service of men, women, or children—whether as

CHADWICK
The White Rider
1999

attribute, conveyance, or entertainment. A degree of anthropomorphism is often employed or implied, the demeanor of the horse telling us something more about its human associate. An agitated, excited horse, its eyes flecked with white, may convey similar emotion in the rider, who may be seen either to empathize with these fears or to conquer them.

The ability of people to utilize the strength and power of the horse for their own purposes has too often led to cruel exploitation of the animal. For example, a type of horse's bridle, the martingale, has a harness strap that links the horse's noseband to its girth, resulting in considerable restriction in mobility. And expressions such as "keeping a tight rein," "breaking in," and "whip hand" are indicators of the way in which horses have been viewed and treated in the past. However, let horse-sense prevail

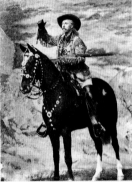

ENGLISH
Buffalo Bill on Horseback
1903

and such practices cease. Long may artists and writers continue to celebrate and revere that most beautiful and enigmatic of creatures, the horse.

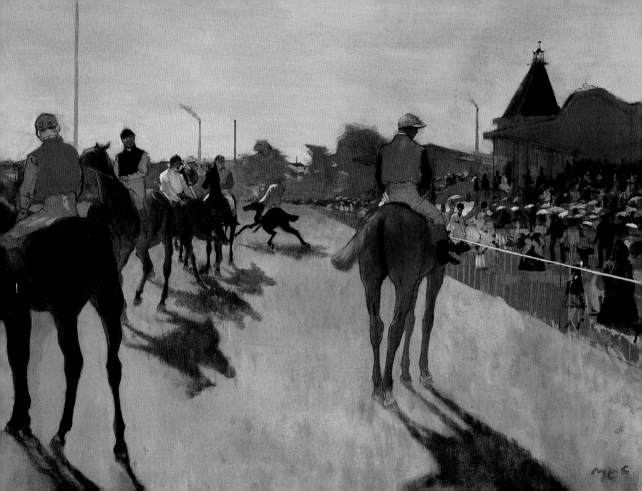

THE THRILL OF THE CHASE

> Dark-brown with tan muzzle, just stripped for the tussle,
> Stood Iseult, arching her neck to the curb,
> A lean head and fiery, strong quarters and wiry,
> A loin rather light, but a shoulder superb.

ADAM LINDSAY GORDON, 1833–70

EDGAR DEGAS
The File Past
c. 1866/8

THE HUNT, THE RACE, THE DISPLAY—THESE ARE THE FEATURES THAT HAVE LONG BEEN ASSOCIATED WITH THE horse in sport. The success of each is dependent upon cooperation between animal and human; from the earliest domestication of the horse, equestrian sports have frequently tested not only the speed and power of the animal but also the bravery of the rider.

ROMAN
Roman Charioteer
Undated

Horses abound on the marble friezes of the Parthenon (447–432 B.C.), illustrating the festival procession of the Great Panathenaea. Daring chariot races were a feature of this festival, in which charioteers leaped from their chariots while the horses were in full flight. In Homer's eighth-century B.C. *Iliad*, we find the earliest known description of a chariot race, as Nestor advises his son, Antilochus, how to drive his horses. These displays of bravery, when staged as funeral games, were seen as a fitting tribute to Patroclus, who was killed in the Trojan Wars of the thirteenth century B.C.

Venery, the hunting of beasts for game, has a long unbroken tradition in many parts of the world. Ancient Egyptian temple reliefs depict the use of horses in the hunting of wild bulls, while Tudor and Elizabethan aristocrats hunting boars, stags, and deer in the ancient woodlands of northern Europe have proved an enduring subject for picture makers, from contemporary tapestries to present-day reproductions. A similar nostalgia surrounds the traditional view of the eighteenth- and nineteenth-century foxhunt. We are all familiar with the scene of the huntsman in pink coat (actually scarlet, but always referred to as "hunting pink"), his thoroughbred mount taking thrilling jumps in the pursuit of hounds and, ultimately, the luckless fox.

WARNER
Halter Ego
1993

Mounted horse racing appeared as early as 644 B.C. at the Olympic Games. The horses were usually stallions and, like modern-day racehorses, the fastest were those that hailed originally from North Africa. There are records of horse racing taking place in Britain during the twelfth century, but it did not become

"the sport of kings" until the time of Charles II (1630–85), who was the first monarch to race horses under his name. This trend continued with subsequent monarchs, notably Queen Anne (1665–1714), who imported Arab breeding stock, including the stallion known as the Darley Arabian.

SHERRIFFS
Untitled
20th Century

Many of today's famous English racetracks, such as Doncaster, Epsom, and Newmarket, date back to the eighteenth and nineteenth centuries. The Jockey Club was founded in 1750, just a few years prior to George Stubbs (1724–1806) arriving in London. Stubbs is arguably the finest horse painter—equine studies making up the greater part of his oeuvre. In 1770 he painted Eclipse, the most famous of all racehorses, which ran for only two seasons and yet remained unbeaten, winning a total of twenty-one races. The American Jockey Club dates back to 1893.

GRANT
*Queen Victoria
Riding with the Quorn*
19th Century

Toward the end of the eighteenth century, steeplechasing was introduced as a new equestrian sport. This was a race across country, the ultimate goal being a faroff church steeple. To reach the target, all intervening obstacles had to be jumped, setting repeated tests of bravery and skill for horse and rider alike. Such races are still run today, but sadly they lack the picturesque element of their original destination.

There had long been dispute among horse watchers and artists as to whether all four legs of a horse actually leave the ground simultaneously at full gallop. To settle a wager, in 1872 the governor of California asked the photographer Eadweard Muybridge (1830–1904) to provide photographic evidence. This he did in 1877, in his now-famous sequential studies of moving horses, which were published under the title *The Horse in Motion* the following year. These records of frozen speed contrast with the split-second precision displayed by the horse in the art of dressage.

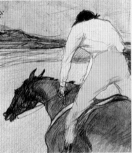

TOULOUSE-LAUTREC
The Jockey
1899

15

EUROPEAN
*Chariot Pulled by
Four Horses*
Undated

This low-relief sculpture was originally part of a metope, the panel between the triglyphs (vertical divisions) on the entablature in classical architecture. As well as the two horses pulling the chariot, two rearing horses flank the sides, making a harmoniously balanced composition.

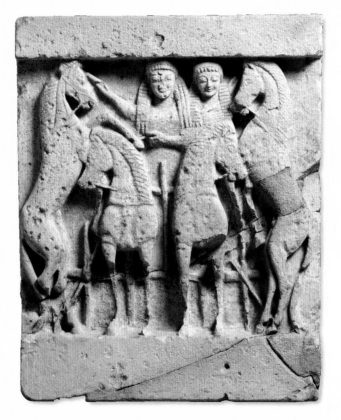

GREEK
*Procession of Horsemen,
the Parthenon*
447–432 B.C.

The horses on the Parthenon friezes are exquisitely modeled in marble. This scene shows horsemen leading the Panathenaic procession—Athena Parthenos being the goddess to whom the temple on Athens's Acropolis was dedicated.

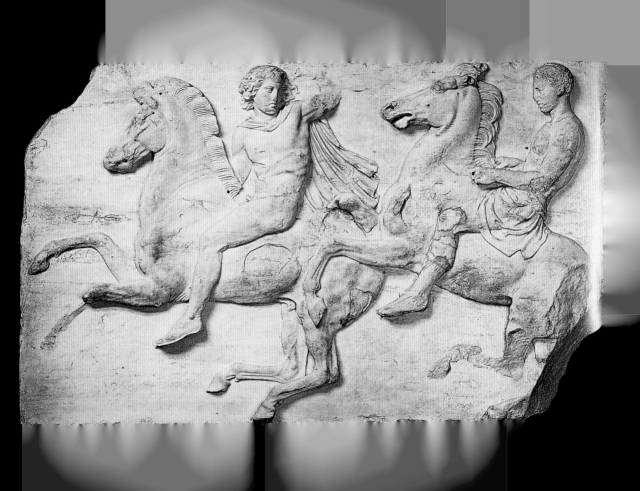

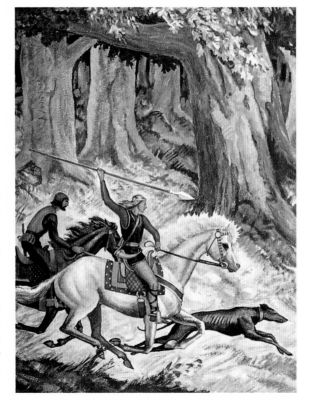

66
There is a passion
for hunting something
deeply implanted in
the human breast.
99

CHARLES DICKENS, 1812–70

HURD
The Hunt in the Odenwald
20th Century

An accurate aim was needed
to hunt prey successfully using a
spear at speed. The negotiation
of the rough ground of the
forest adds further difficulties,
surmounting which requires
all the innate agility of these
horses. This illustration was
taken from *The Story of
Siegfried* by James Baldwin.

Peter Hurd, 1904–84

DREUX
The Hunter
1831

The contrast between the
rider's pink coat and the
dappled hunter animates this
typical hunting scene. The
practice of docking a horse's
tail, as shown here, was a
sign of immaculate grooming.

Alfred de Dreux, 1810–60

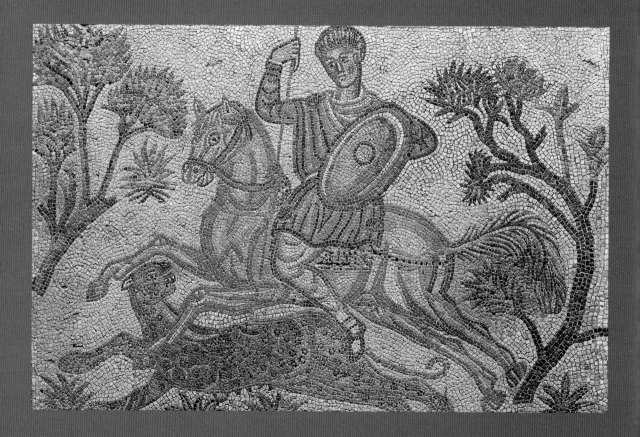

GREEK

Leopard Hunt
A.D. 180

Scenes of hunting were a popular subject for floor mosaics. Here, a leopard is the defeated prey, its remarkable speed being no contest on this particular occasion for the horse and its rider.

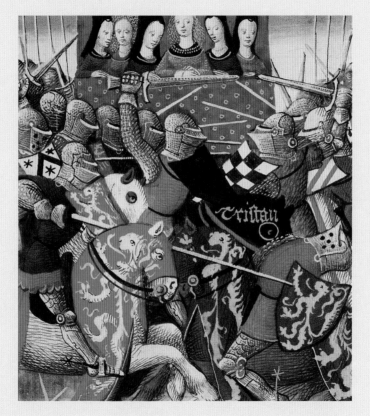

FRENCH

Roman de Tristan
15th Century

In this romance of Tristan, the opponents are wearing the classic jousting helms (helmets) with narrow eye-slits and the lower part protruding over the upper. To be able to see the approaching fray, a knight had to hunch his shoulders and bend his head. Due to their froglike appearance, these helms are sometimes referred to as "frog-mouthed" helms.

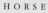

POLLARD

*Coursing, A View
in Hatfield Park*
1824

In this picture the Hatfield Park Hunt has the luckless fox firmly in its sights—nothing short of a miracle will save it now. The lady riding sidesaddle, dressed in blue, is the marchioness of Salisbury, who was master of the hunt for many years.

James Pollard, 1792–1867

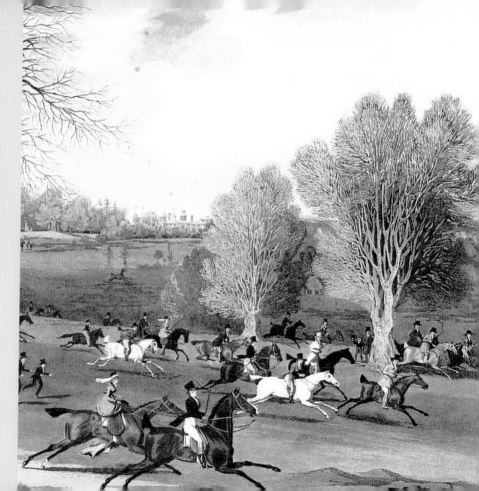

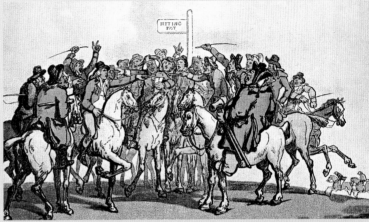

ROWLANDSON

Betting Post

1789

While the jockeys in the background are intent on winning their race, a less athletic-looking group of horsemen gathers around the betting post. The besieged turf accountant struggles to record the simultaneously shouted wagers.

Thomas Rowlandson, 1756–1827

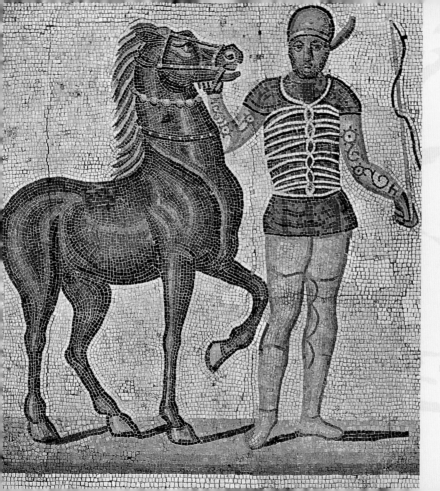

ROMAN
Roman Charioteer
Undated

This lively horse and its helmeted rider are one of a set of four Roman mosaics depicting Roman charioteers sporting their racing colors. This one wears the Prasina livery.

LEECH
*A Frolic Home
after a Blank Day*
1860

This somewhat shambolic scene, taken from Leech's satirical *The Noble Science of Incidents of the Hunting Field*, is the return home—or should we say the retreat—after a fruitless day in the field. Here, the fox has been triumphant, leaving the horses and riders in various states of disarray.

John Leech, 1817–64

> 66
> 'Unting is all that's worth living for . . .
> it's the sport of kings, the image of war
> without its guilt, and only five-and-
> twenty percent of its danger.
> 99

R.S. SURTEES, 1803–64

GRANT

Queen Victoria Riding with the Quorn
19th Century

When Queen Victoria (1819–1901) "ran
with the hounds," she was conveyed
with the utmost dignity in a carriage, not
astride a horse. The Quorn hunt still
meets regularly in Leicestershire, England.

Sir Francis Grant, 1803–78

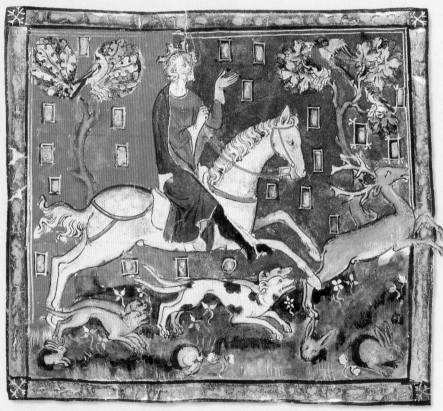

ENGLISH

King John Stag Hunting
14th Century

This illuminated manuscript shows King John (1167–1216) in pursuit of a stag, hounds at his side—a traditional pastime for both monarchs and aristocrats. Note the detail of the burrowing hares.

EUROPEAN

Tournament
14th Century

Tournaments and jousting were popular at the time of the Crusades during the eleventh to thirteenth centuries. The blue knight in this manuscript painting wields a particularly vicious-looking lance, with three balls and chains at its extremity.

moit parole intreus in conte al.
Gnd colp lui dona droite esple poignal.

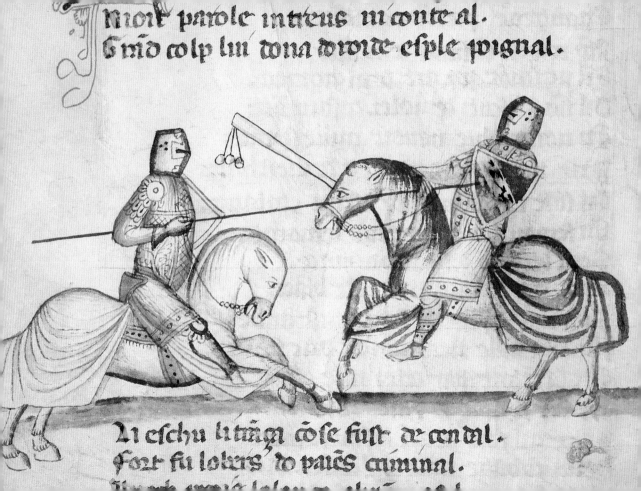

Li eschu litrag cose suit de cendal.
Fort fu lobers do paues criminal.

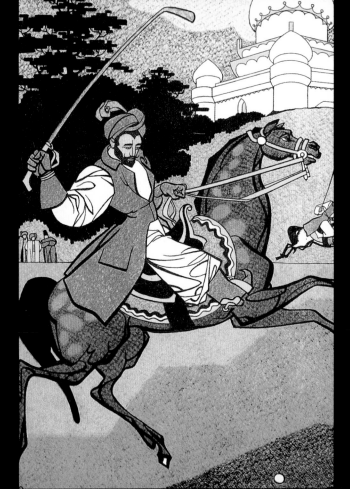

previous pages
POUSSIN
The Calydonian Boar Hunt
1637–8

A great sense of narrative drama is achieved in this painting. The white horse is central to the composition as the action moves from right to left. When planning a painting Poussin would often create a miniature stage on which he then arranged small wax figures in experimental groupings.

Nicolas Poussin, 1594–1665

SHERRIFFS
Untitled
20th Century

The accompanying quote to this twentieth-century illustration from *The Rubáiyát of Omar Khayyám*, which was most famously translated by Edward Fitzgerald (1809–83) in 1859, reads:

"The Ball no question makes of Ayes and Noes, But Here and There as strikes the Player goes; And He that toss'd you down into the field, He Knows about it all —HE knows—HE knows!"

Robert Stewart Sherriffs, 1906–60

“

Be ye not as the horse, or as the mule,
which have no understanding: whose
mouth must be held in with bit and bridle,
lest they come near unto thee.

”

PSALM 32: 8–9

GOYA

A Mounted Picador

c. 1797–9

In 1799 Goya became the principal painter
to the king of Spain and this painting shows a
quintessentially Spanish subject. In the sport
of the bullfight, a picador such as this one,
resplendent in elaborate costume and mounted
on a horse with braided and plaited mane, would
provoke the bull into retaliation with his lance.

Francisco de Goya, 1746–1828

AMERICAN

Ben-Hur

1959

On screen the chariot race between Ben-Hur, driving a team of white horses, and Massala, driving a team of black, lasts for a nerve-racking twenty minutes. In the studio in Rome where it was filmed it actually took three months to shoot.

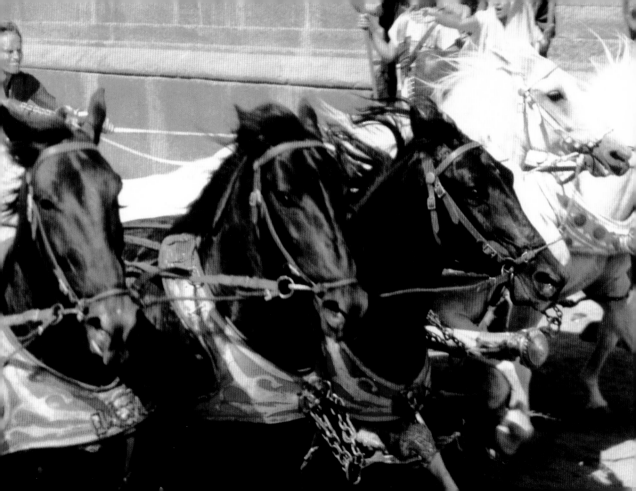

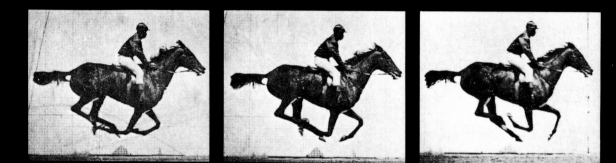

> **"**
>
> A *dark* horse, which had never been
> thought of . . . rushed past the grandstand
> to sweeping triumph.
> **"**

BENHAMIN DISRAELI, 1804–81

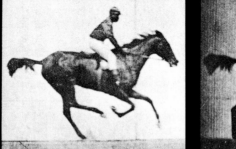
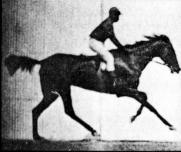

MUYBRIDGE

Galloping Racehorse

1878

This sequence of photographs comes from *The Horse in Motion*, published in 1878. Muybridge was the director of photographic surveys for the American government and conducted many photographic experiments. His primary

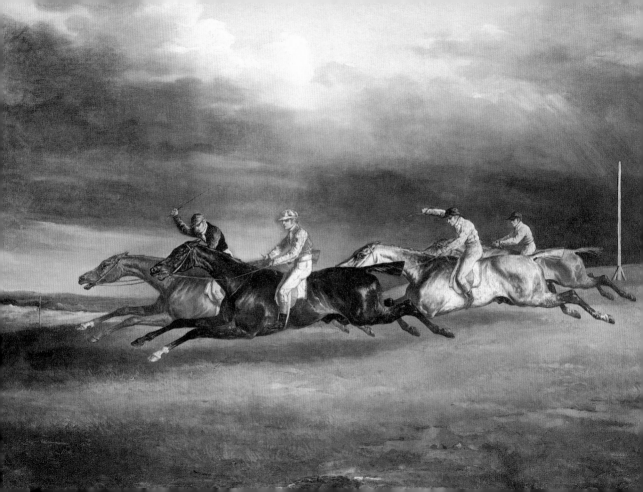

GÉRICAULT

The Derby at Epsom in 1821
1821

Géricault visited England in 1820–2 and, among the paintings and lithographs he produced at this time, were many of racing and working horses. He was strongly influenced by fellow French artist Baron Gros (1771–1835) in his choice of contemporary subjects.

Théodore Géricault, 1791–1824

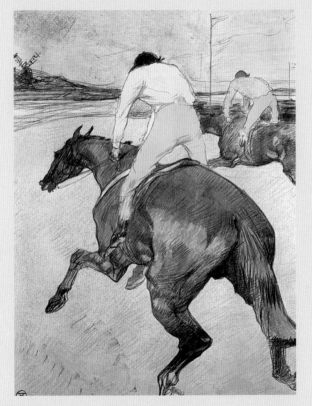

66

Horse-sense is something a horse has that prevents him betting on people.

99

FATHER MATHEW, 1790–1856

TOULOUSE-LAUTREC

The Jockey
1899

Lautrec's first teacher encouraged him to paint animals, particularly horses, and in this lithograph we see the artist returning to the subject in later life. The sense of recession, as the horses gallop away from the viewer, creates a great feeling of movement and speed.

Henri de Toulouse-Lautrec, 1864–1901

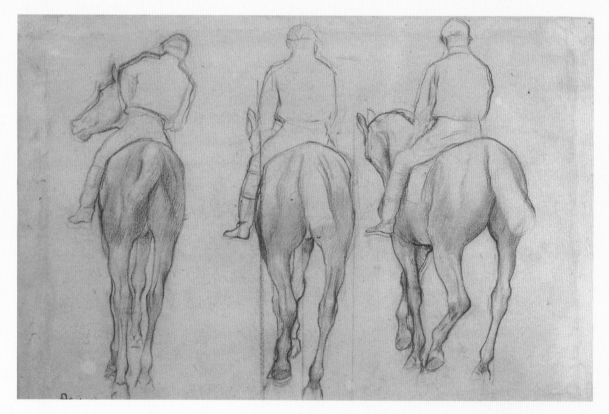

DEGAS

Jockeys

19th/20th Century

Everyday scenes of dancers, laundresses, and the races were Degas's favored subjects. This pencil drawing of mounted jockeys is one of numerous studies that he would make in preparation for the finished canvas.

Edgar Degas, 1834–1917

WRIGHT

At the Race 4

1998

Following in the tradition of nineteenth-century artists like Toulouse-Lautrec and Degas, Wright finds much that is visually arresting at the races. This monotype is one of a series based on the races at Del Mar, California.

Curtis Wright, b. 1963

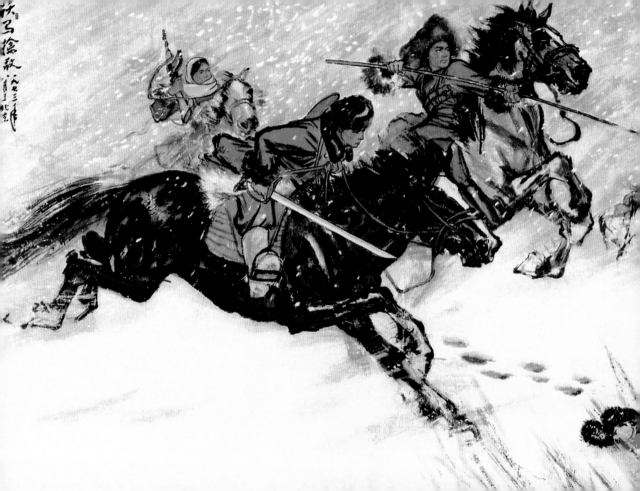

> 66
> They have in themselves what they value
> in their horses, mettle and bottom.
> 99

RALPH WALDO EMERSON, 1803–82

CHINESE

Hunting Scene

1973

The speed and agility required to complete
a successful hunt are hindered by the deep
snow underfoot in this inhospitable landscape.
A huntsman needs a skillful aim to avoid
inadvertently injuring his helper, the dog.

43

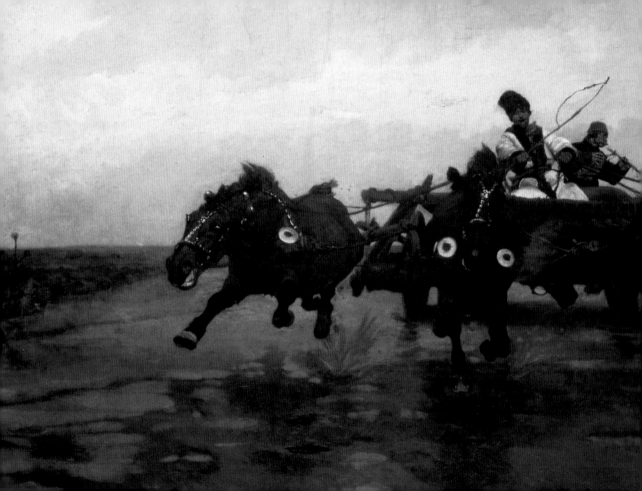

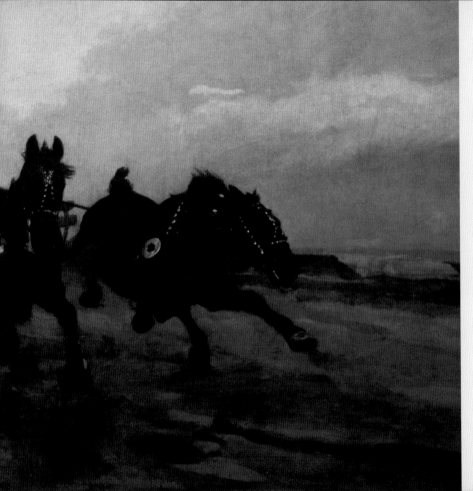

CHELMONSKI

Four in Hand

1881

The dynamic viewpoint of the advancing team of four horses creates a powerful, yet rather unsettling spectacle for the viewer in this painting, as the animals thunder over the ground toward us.

Joseph Chelmonski, 1849–1914

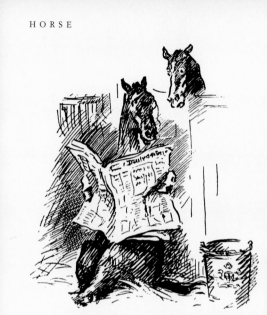

ENGLISH

Reading Horse

19th Century

When not actually running in a race, this
racehorse studies the form in the newspaper
and swaps hot tips with his stable companion,
in this illustration taken from *Punch* magazine.

MILLER

Steeple Chase

1990

In this painting Miller successfully captures the daunting approach of a high jump on a cross-country race. He cleverly employs a viewpoint that places the spectator within the action of the picture.

Paton Miller, b. 1953

WARNER
Halter Ego
1993

The punning title of this picture by American artist Warner is a comment on these two bickering jockeys, each of whom is striving for control of the indifferent-looking horse.

Christopher Warner, b. 1953

BEVAN
Under the Hammer
20th Century

Intense concentration is evident amid this group of jockeys and horse owners at a racehorse sale. A good buy could prove lucrative for the owner. Note the jockey on the right wearing the orange cap.

Robert Polhill Bevan, 1865–1925

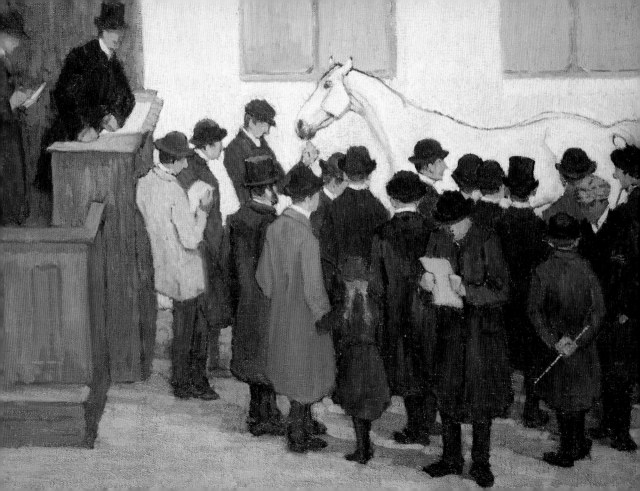

STUBBS

Eclipse
1770

This is the famous racehorse Eclipse, which remained unbeaten in its career. Other famous racehorses painted by Stubbs were Gimcrack and Hambletonian. Payment for the latter painting was only settled after a court ruling in favor of Stubbs. The owner disliked the artist's compassionate depiction of the exhausted horse at the end of his grueling race.

George Stubbs, 1724–1806

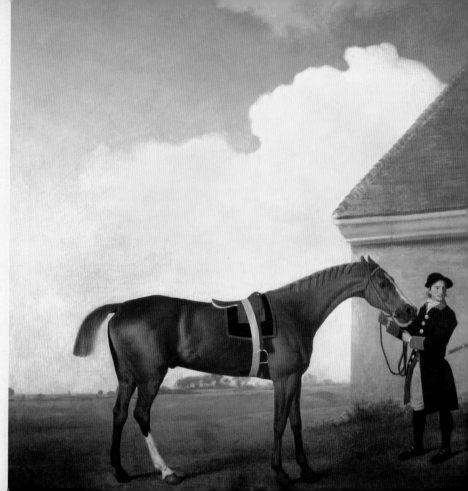

ENGLISH

Chequered Horse

19th Century

Both for ease of identification and display a jockey always sports the chosen colors of the horse's owner during a race. However, this team of horse and jockey have taken the notion of corporate branding a step too far!

I remember how merry a start we got,

When the red fox broke from the gorse,

In a country so deep, with a scent so hot,

That the hound could outpace the horse;

I remember how few in the front rank show'd,

How endless appeared the tail,

On the brow hill side, where we cross'd the road,

And headed towards the vale.

ADAM LINDSAY GORDON, 1833–70

ZOKOSKY

Hunt

1988

Californian artist Zokosky has here
produced a wonderful panoramic view
of the hunt in full cry. The leaping rider
and horse appear to fly through the air
in their eagerness to pursue the chase.

Peter Zokosky, b. 1957

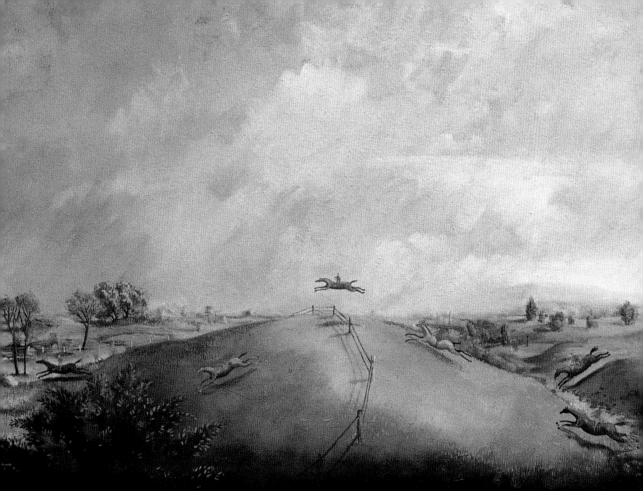

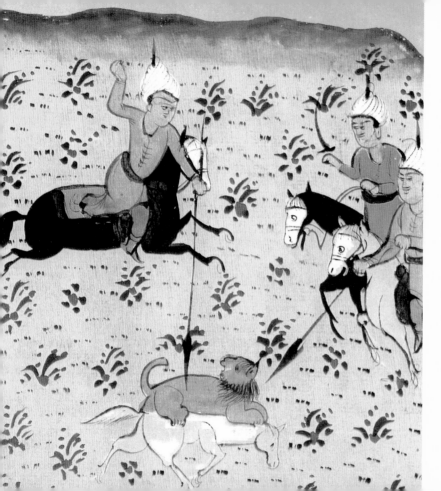

PERSIAN
Hunters Attacking a Lion
16th Century

The three hunters in this Persian miniature have come to the rescue just in time! A savage lion has leaped onto a struggling pony and is about to wrestle it to the ground.

INDIAN
*Princes and Princesses
Playing Polo*
19th Century

The game of polo illustrated in this Indian miniature becomes a beautiful spectator sport, graced as it is by elaborately costumed members of the aristocracy mounted on ornate and colorful mounts.

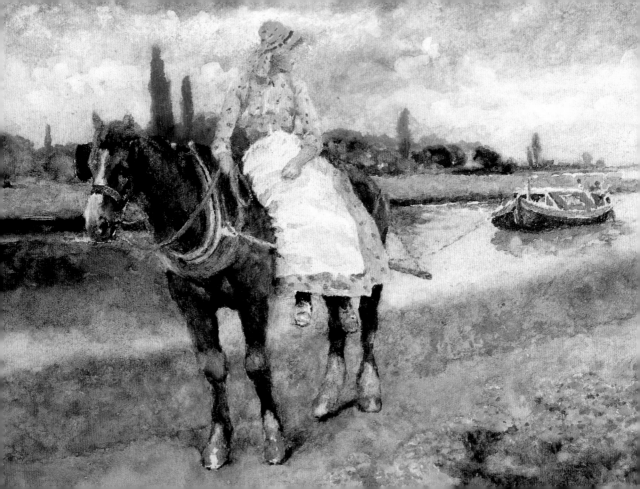

BEASTS OF BURDEN

> 66
> Though Patience be a tired mare,
> yet she will plod.
> 99

WILLIAM SHAKESPEARE, 1564–1616

DAVID WOODLOCK
Towing the Barge
19th Century

THE PICTORIAL IMAGE OF THE WORKING HORSE IS OFTEN REDOLENT OF ROMANCE. FROM THE NOSTALGIA THAT we feel for a vanished rural idyll, and the imagined thrill of the stagecoach journey pursued by a masked highwayman, to the lone cowboy drovers of the Wild West—all are scenes dependent on the horse. But these pictures hide the very real misery suffered by countless horses in the service of agriculture, transport, and industry.

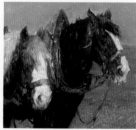

KEUSCHDEN
Plowing
19th Century

The term "horsepower," used to calculate the power of an engine, still persists, long after steam and locomotive power has superseded the horse in the production of industrial might. The heavy horses that were bred during the medieval period for military use were also found to be useful in agriculture. In northern Europe they largely replaced cattle for the purposes of plowing and traction, as they were far quicker. The invention of the horse collar further improved efficiency in the pulling of heavy loads.

Heavy, working horses require large quantities of food—summer and winter—so their use was restricted until improved food-production methods were developed during the seventeenth century. Poor winter yields of fodder in Scandinavia, Iceland, and Great Britain led to the breeding of small, hardy ponies, such as the original Shetland. These animals were used for haulage, peat cutting, and mining, their diets being supplemented with seaweed during the winter.

LA THANGUE
The Last Furrow
1895

In contrast, the progenitor of the giant Midlands shire horse was bred by the English agriculturist Robert Bakewell (1725–95) in Leicestershire. He produced a black horse with a thick carcass and a short, straight back and legs, which was said to be as strong as an ox but as agile as a pony. Such massive working horses were a favorite subject of the French artist Théodore Géricault (1791–1824) during his stay in England in 1820, following the furor the previous year over his picture *The Raft of the Medusa*.

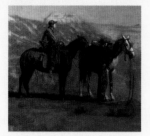

EAKINS
Cowboys in the Badlands
1888

The horse was able to carry a rider over rough roads that it was impossible for a wheeled vehicle to traverse. The improved highways of eighteenth-century Britain brought the stagecoach and the mail coach, along with such legendary highwaymen as Dick Turpin (1705–39) on his trusted mare, Black Bess. Coaches at this time were a mixture of extreme internal discomfort and high external display. They sported dashing names, such as Lightning, Comet, and Rocket. The journeys proved less enthralling for the team of four pulling the coach, known as "cattle." A working Hackney or Cleveland Bay horse rarely survived a working life longer than three years. Sadly, the fate that met Ginger in Anna Sewell's story *Black Beauty* (1877) had less to do with fiction than with fact.

The work of artists such as Thomas Gainsborough (1727–88) and John Constable (1776–1837) frequently shows horses as an

VAN GOGH
*Caravan and Encampment
of Gipsies near Arles*
19th Century

integral feature of their landscape scenes. These animals form part of a countryside that is a workplace, not a leisured pleasure-ground. With increased industrialization during the nineteenth century, and the migration of people from the country to the towns, artists began to represent the rural life in opposition to the urban. The country was seen as more natural, more wholesome—even more moral. In the portrayal of animals this produced a sentimental anthropomorphism that remains unsurpassed in the work of Sir Edwin Landseer (1802–73). In *Adversity*, the overworked nag is left, still harnessed, without food and water, while the negligent driver indulges his own appetites.

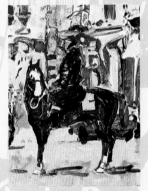

WARNER
Untitled
1991

Although working horses continued to be used in rural areas longer than in the towns, the early years of the twentieth century saw the noisy, polluting arrival of motorized transport. It could only be a matter of time before the horse was usurped by the now ubiquitous four wheels in most areas of the world.

" Under a spreading chestnut-tree
The village smithy stands;
The smith a mighty man is he,
With large and sinewy hands;
And the muscles of his brawny arms
Are strong as iron bands. "

HENRY WADSWORTH LONGFELLOW, 1807–82

FRENCH

Blacksmith Shoeing a Horse
13th Century

This stained-glass window from Chartres Cathedral in France shows the blacksmith in the process of nailing the shoe to the horse's hoof. The first nailed iron horseshoes in Europe appeared around the fifth century B.C. and were in wide use by the eleventh century.

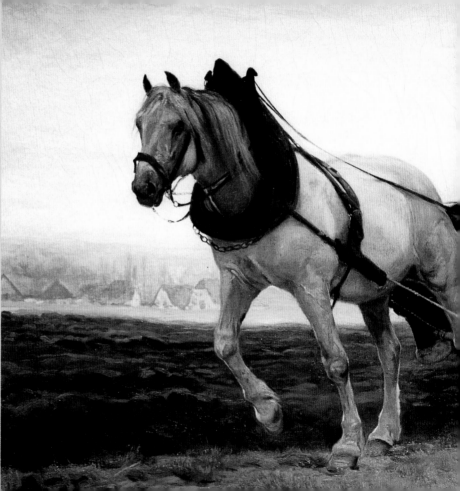

KOLLER
The Plow
1870

This hard ground needs ox- as well as horsepower. Koller was known for his scenes of rustic farm life. He believed that animals represented a dignified and pure image of nature and that this made them deserving of our respect.

Rudolf Koller, 1828–1905

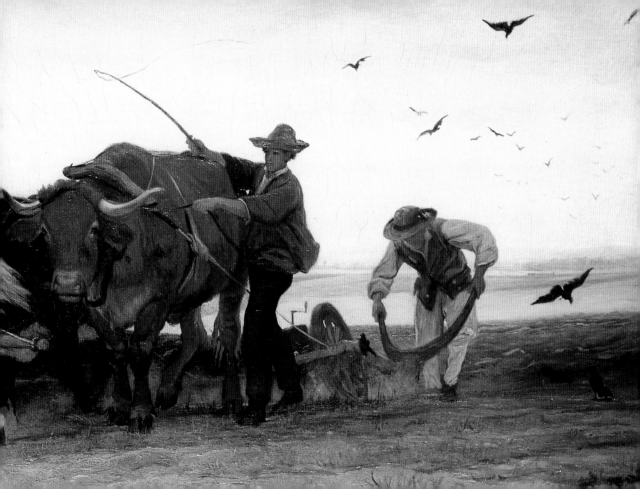

SMYTHE
In the Forge
19th Century

The first horseshoe was probably the Roman hipposandal, a metal sole that was tied to the hoof with leather straps. However, this forge is full of the Victorian technology and tools necessary to meet the demands of many worn hoofs.

Edward Robert Smythe, 1810–99

LA THANGUE
The Last Furrow
1895

La Thangue's treatment of this subject escapes the sentimentality that we might find in other Victorian painters; instead, he creates a work that is extremely moving. The aged plowman has died in the field, alone except for his team of two horses. The poignancy of the scene is heightened by the inquisitive turning head of the blinkered white horse.

Henry Hubert La Thangue, 1859–1929

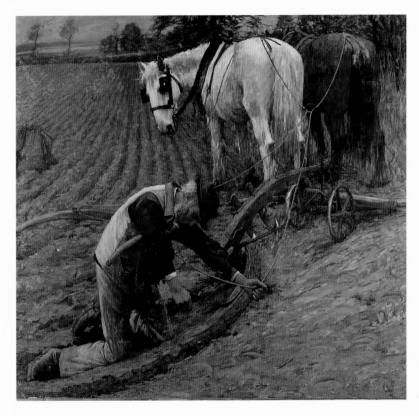

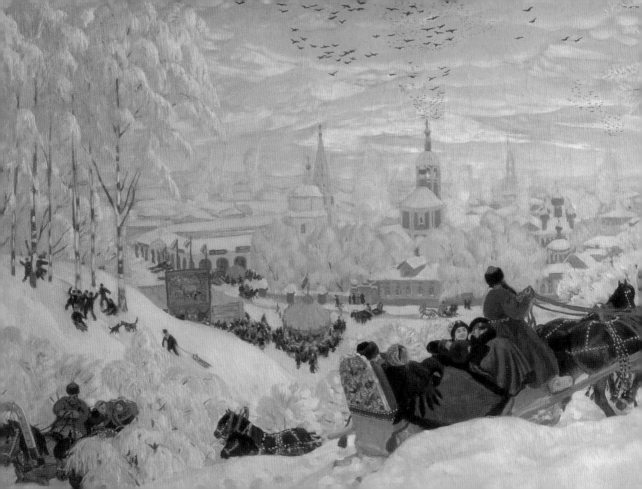

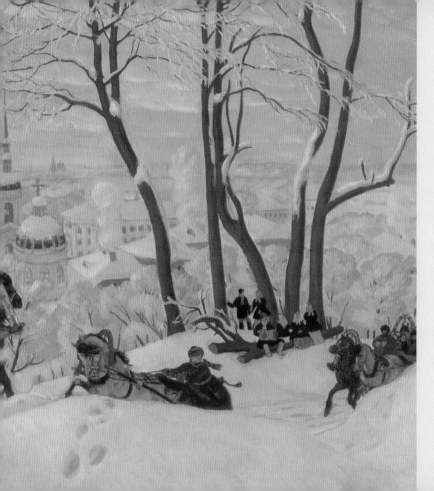

KUSTODIEV

Shrovetide

1916

The valiant horses in this picture are almost lost to view as they struggle through the deepening snow. The combination of the pastel-colored sky and the whitened townscape lends this scene a fairy-tale magic.

Boris Kustodiev, 1878–1927

> 66
>
> This is the way the gentlemen ride,
>
> Gallop-a-trip,
>
> Gallop-a-trot;
>
> This is the way the gentlemen ride,
>
> Gallop-a-gallop-a-trot!
>
> 99
>
> NURSERY RHYME

ENGLISH
Untitled
19th Century

A satirical look is taken at what it can mean to be a beast of burden in these cartoons from the English magazine *Punch*, which was also called *The London Charivari* (first published in 1841). The moral of these pictures appears to be that a horse's stature should be appropriate to its task, unless the load is as light as a feather!

ALDIN
"The wheels had stuck . . ."
20th Century

One of the most moving
and poignant depictions of
the hardship suffered by the
working horse is Anna Sewell's
children's classic *Black Beauty*.
Aldin's illustrations to the text
are among the finest, being
a perfect vehicle for his
particular talent for portraying
horses and dogs.

Cecil Aldin, 1870–1935

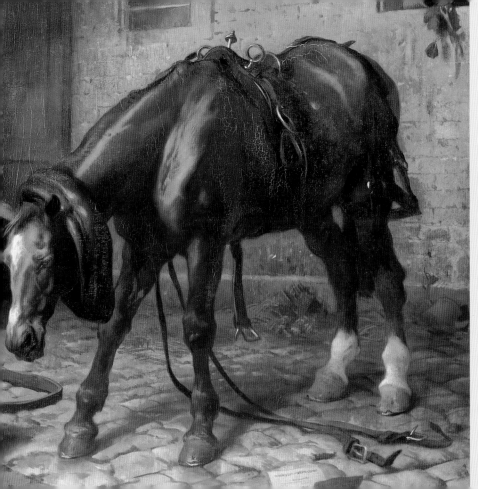

LANDSEER

Adversity

19th Century

The moral undertones
of Landseer's picture are
reminiscent of many
seventeenth-century
Dutch genre paintings.
The poor harnessed horse,
ill nourished, his wounds
untreated, is left among
the broken flowerpots and
upturned pail, with only a
mouse for solace, while
the driver looks after his
own needs.

Sir Edwin Landseer, 1802–73

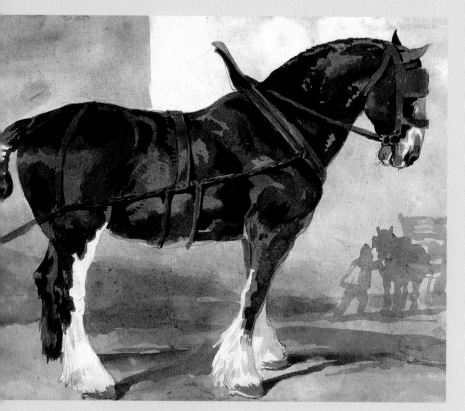

GÉRICAULT
Harnessed Black Horse
19th Century

The careful watercolor painting of this fine black horse contrasts with the economic rendering in wash of the background figure with the horse and wagon. The bound tail of the shire horse prevented it from getting entangled with the cart behind.

Théodore Géricault, 1791–1824

EUROPEAN
Saint Eloi Replacing the Horseshoe of a Possessed Horse
15th Century

The French saint Eloi is the patron saint of goldsmiths, blacksmiths, and farriers, his principal emblem being the horseshoe. As can be seen in this manuscript painting, he is sometimes depicted shoeing a horse, whose leg he first removes and then miraculously restores.

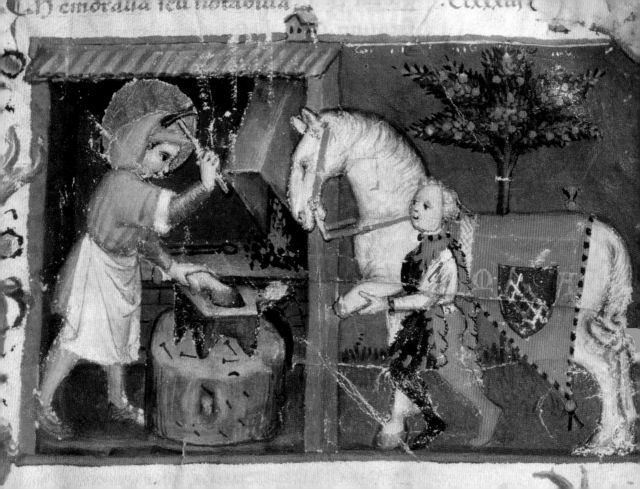

> "
> Only a man harrowing clods
> In a slow silent walk
> With an old horse that stumbles and nods
> Half asleep as they stalk.
> "

THOMAS HARDY, 1840–1928

KEUSCHDEN
Plowing
19th Century

Before the arrival of motorized transport, the horse was essential on the farm for plowing, harrowing, sowing, haymaking, and harvesting. Here, Keuschden's use of thick impasto, especially in the foreground, helps us appreciate just what strength it takes to plow through such heavy soil.

F.E. Keuschden, 19th Century

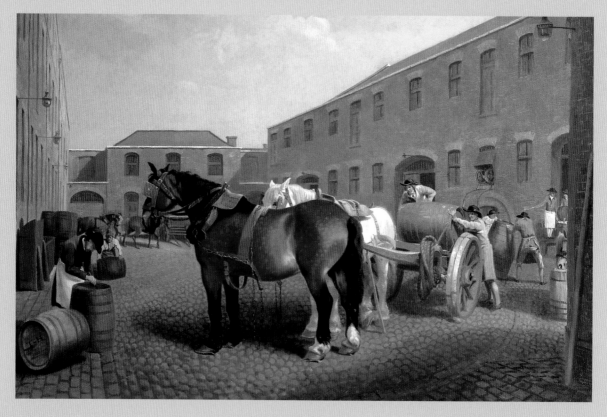

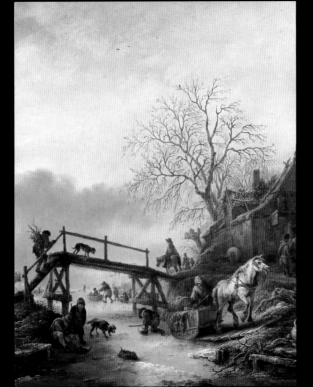

GARRARD
Loading the Drays
1783

The draymen loading their carts
at the Whitbread Brewery in
Chiswell Street, London, obviously
took great pride in the appearance
of their horses. A shine on a
horse's coat such as this was
often produced by adding special
ingredients to the feed, such
as bryony root or tansy leaves.

George Garrard, 1760–1826

VAN OSTADE
A Winter Scene
1640

Isack van Ostade, like his brother
Adriaen (1610–85), painted
scenes of peasant life and
hardship. This area of the frozen
river is populated with people
and animals, all intent on survival
in inauspicious surroundings.

Isack van Ostade, 1621–49

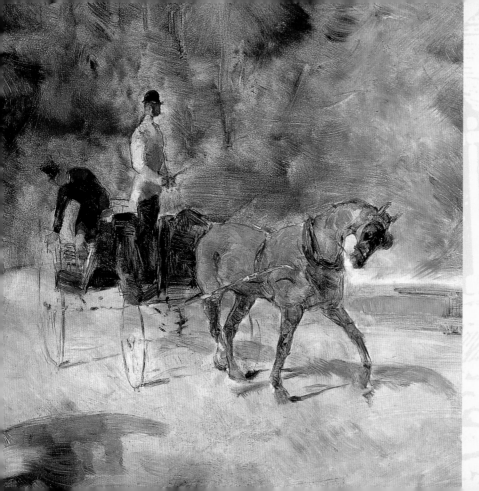

TOULOUSE-LAUTREC
A Dogcart
1880

A high-prancing horse draws
two men in a conveyance
known as a dogcart: a small,
high-wheeled carriage, which
has two seats back-to-back,
with a space in between.

Henri de Toulouse-Lautrec,
1864–1901

PENFIELD
Farm Horses
1901

This illustration from the
charmingly titled *The Big Book*
of Horses and Goats portrays
two very contented-looking
working horses. These animals,
surrounded by traditional
haystacks, enjoy a preferable
environment to their urban
counterparts.

Edward Penfield, 1866–1925

> O saddle me my milk-white steed,
> And go and fetch me my pony, O!
> That I may ride and seek my bride,
> Who is gone with the wraggle taggle gypsies, O!
>
> O he rode high, and he rode low,
> He rode through wood and copses too,
> Until he came to an open field,
> And there he espied his a-lady, O!

ANONYMOUS

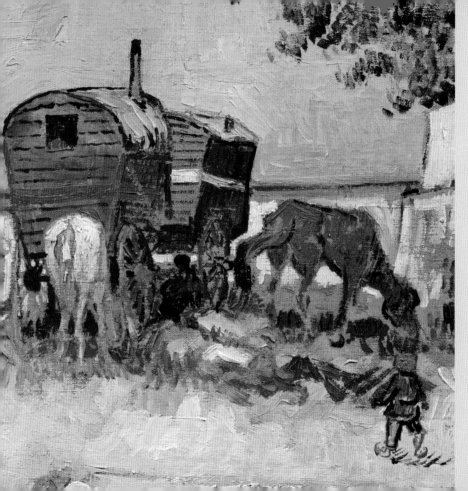

VAN GOGH

*Caravan and Encampment
of Gypsies near Arles*
Detail
19th Century

Van Gogh went to Arles in the
south of France in 1888 and was
later joined by Paul Gauguin
(1848–1903). He painted mainly
landscapes and portraits there,
with a heightened use of color
and light. This painting, which
seems to celebrate life, shows
no presentiment of the tragedy
ahead. During his time at Arles,
Van Gogh became ill, spending
some time in the asylum there.
In July 1890 he shot himself
at Auvers.

Vincent Van Gogh, 1853–90

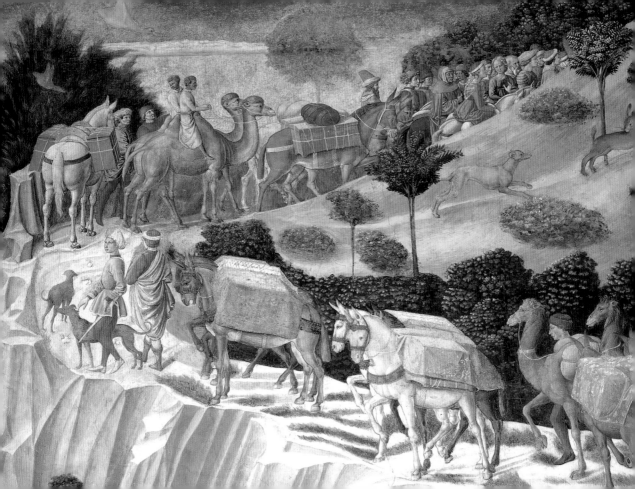

GOZZOLI
Journey of the Magi
Detail
c. 1460

This detail comes from a fresco cycle, *The Medici Family as Magi*, in the chapel of the Palazzo Medici-Riccardi, in Florence, Italy. It shows a caravan of heavily laden pack animals, including horses, camels, and mules, ascending a hill behind members of the Medici family.

Benozzo Gozzoli, c. 1421–97

WARNER
Untitled
1991

The working horse most likely to be seen on the streets of modern-day cities and towns is the police horse. This attentive and alert horse graces the streets of Paris as its rider patrols the neighborhood.

Christopher Warner, b. 1953

66

There was a snapping and ripping and rending, and amid
a shower of falling leaves a horse burst through the screen.
On its back was a pack, and from this trailed broken vines
and torn creepers. The animal gazed with astonished eyes
at the scene into which it had been precipitated, then
dropped its head to the grass and began contentedly to
graze. A second horse scrambled into view, slipping once
on the mossy rocks and regaining equilibrium when its
hoofs sank into the yielding surface of the meadow. It was
riderless, though on its back was a high-horned Mexican
saddle, scarred and discoloured by long usage.

99

JACK LONDON, 1876–1916

CONSTABLE

The White Horse

1819

Typical of the work of Constable, the horse that appears in this painting is employed as part of the working life of the countryside, rather than being seen grazing peacefully in a field.

John Constable, 1776–1837

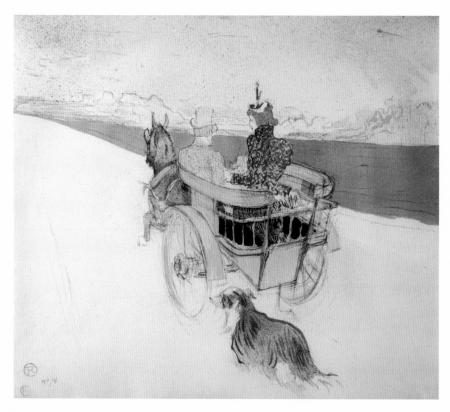

TOULOUSE-LAUTREC
*Couple Riding
in a Yellow Wagon*
19th Century

Not all scenes of working horses need be sad. In this lithograph an air of jollity surrounds the horse as he trots along bearing the yellow cart and its passengers, with a dog following behind.

Henri de Toulouse-Lautrec, 1864–1901

ROUSSEAU
Père Junier's Cart
1908

Claude Junier was an amateur horse trainer, but here his cart is being pulled by the most docile-looking of white ponies. His family are all in the back of the cart, while alongside Junier sits Rousseau himself, resplendent in straw hat.

Henri Rousseau, 1844–1910

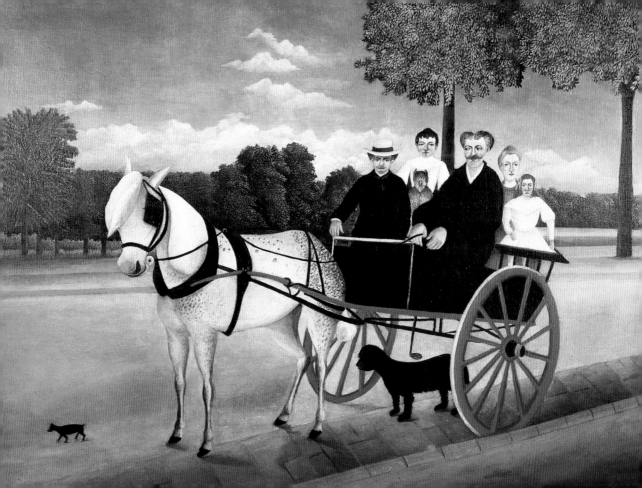

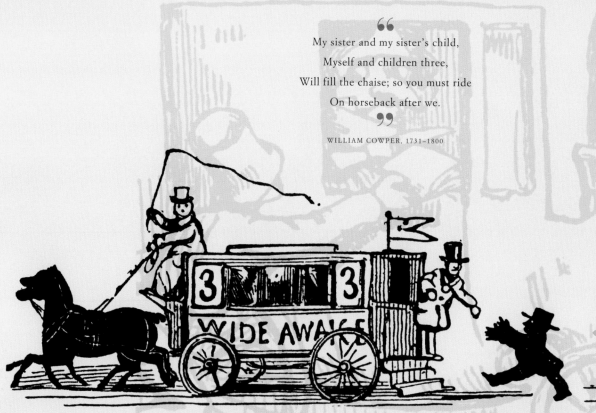

66

My sister and my sister's child,
Myself and children three,
Will fill the chaise; so you must ride
On horseback after we.

99

WILLIAM COWPER, 1731–1800

ENGLISH
Untitled
19th Century

In the great days of horse-drawn coach travel, comfort very much took second place to speed. On the much-traveled London–Brighton run the departure and arrival times were quoted to the half-minute. This regime allowed for no tolerance of late-arriving passengers. You did indeed need to be "wide awake" to catch these coaches!

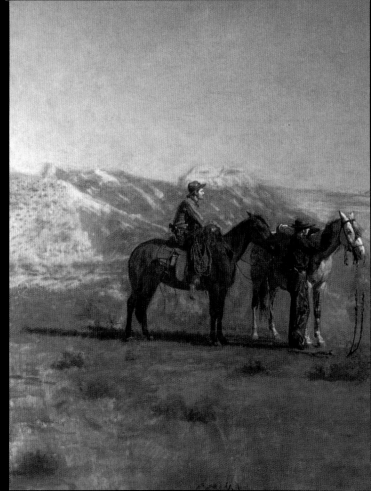

66

In the course of the day I was amused by the
dexterity with which a Gaucho forced a restive
horse to swim a river. He stripped off his
clothes, and jumping on its back, rode into the
water till it was out of its depth; then slipping
off over the crupper, he caught hold of the tail,
and as often as the horse turned round, the man
frightened it back, by splashing water in its face.
As soon as the horse touched the bottom on the
other side, the man pulled himself on, and was
firmly seated, bridle in hand, before the horse
gained the bank. A naked man, on a naked
horse, is a fine spectacle; I had no idea how well
the two animals suited each other.

99

CHARLES DARWIN, 1809–82

EAKINS
Cowboys in the Badlands
1888

Influenced by the realism of many nineteenth-century French artists, and particularly Édouard Manet (1832–83), Eakins manages to portray in this painting both the solitary nature and the grandeur of cowboy life.

Thomas Eakins, 1844–1916

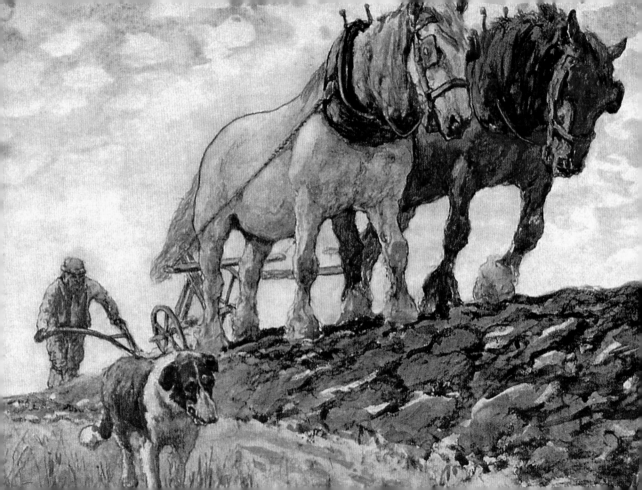

NOBLE
Plow Horses
1914

This once-common rural sight is now seen mostly at country fairs and shows, where demonstrations of plowing by shire horses are offered as nostalgic entertainment. In the past, a man with a working team of horses like these would have done well to plow an acre a day.

Edwin Noble, b. 1876

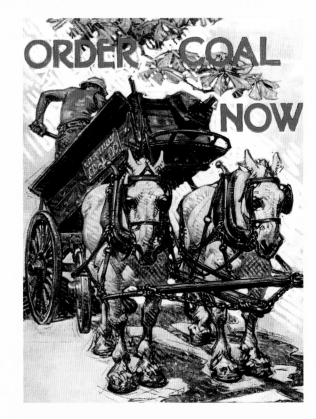

LEYENDECKER
Order Coal Now
20th Century

The mighty power of the plow horse is harnessed for propagandist effect in this forceful poster produced by the United States Fuel Administration. Coal, as a "natural" fuel, is both identified with the rural scene and with the potent strength of horsepower.

Joseph Christian Leyendecker, 1874–1951

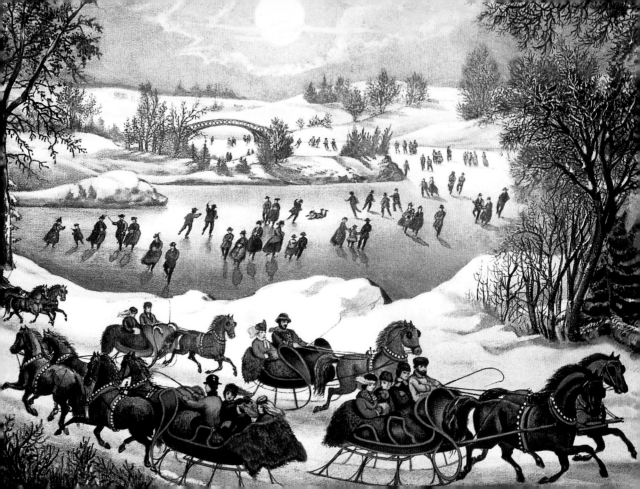

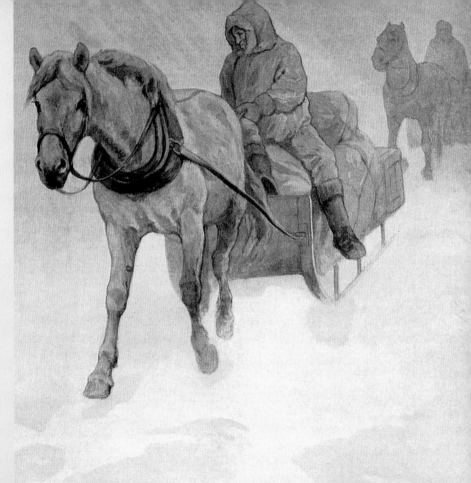

AMERICAN
Snow Scene
19th Century

While wintry weather provided entertainment, the conditions underfoot would simply have added to the burden on the horses drawing the sleighs in this lithographic print published by Nathaniel Currier (1803–87) and James M. Ives (1824–95).

NOBLE
Helpers Without Hands
1914

The human suffering endured on Captain Scott's failed expedition to the Antarctic in 1911 is well known, but the tragic story of his ponies is rather less familiar. Only seventeen survived the sea journey, and his reliance on them may have contributed to the expedition's failure.

Edwin Noble, b. 1876

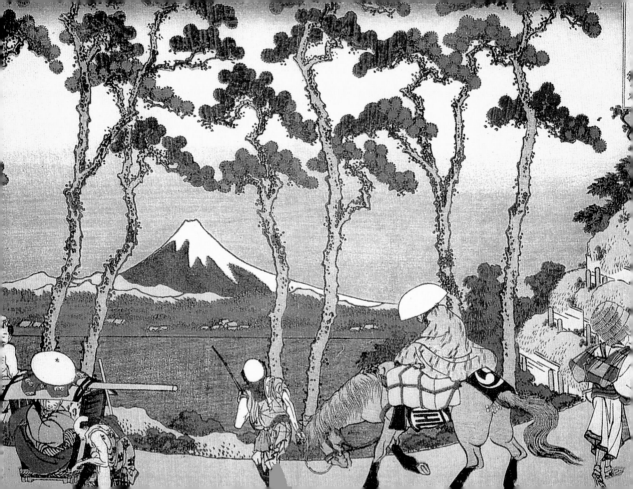

HOKUSAI

Hodo Gaya on the Tokaido
1831

Taken from *Thirty-Six Views of Fuji*
(1831), this woodblock print shows
how essential the horse was for
transport in the mountainous region
around Fuji, although, as we can see, a
version of the sedan chair also appears
to have been utilized. The terraced
landscape on the right gives some
indication of how uneven the terrain is.

Katsushika Hokusai, 1760–1849

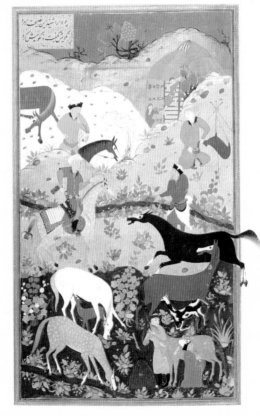

PERSIAN

King Darius and Herdsmen
1522–3

This illustration from *Bustan*, the
manuscript of Saidi, presents a delightful
landscape full of industrious incident.
The horses obviously play an integral
role in this working scene.

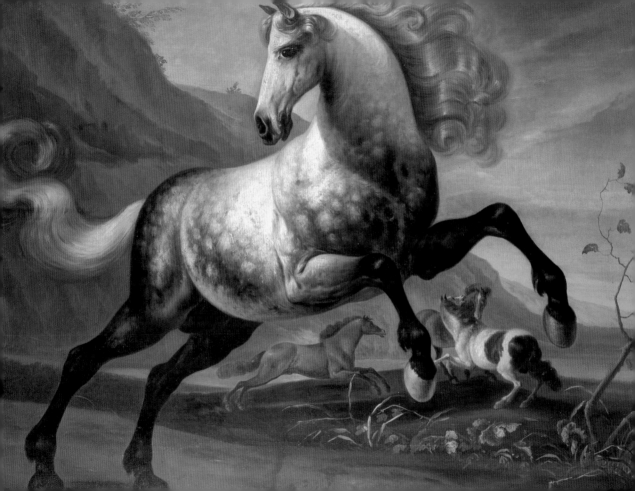

WILD HORSES

> Now the great winds shorewards blow;
> Now the salt tides seawards flow;
> Now the wild white horses play,
> Champ and chafe and toss in the spray.

MATTHEW ARNOLD, 1822–88

ENGLISH
A Prancing Stallion with
Stallions Fighting
17th Century

THERE ARE PAINTINGS OF THE TRULY WILD HORSE MADE ABOUT 15,000 YEARS AGO BY PREHISTORIC PEOPLE, WHO ground manganese, carbon, and natural ocher to make pigments of black, red, brown, and yellow, which they used to create beautiful animal images of astounding verisimilitude. The exact purpose and meaning of the cave paintings found at Lascaux and Niaux in France and at Altamira in Spain will never be known. Most probably the creation of the image of the animal—the prey—was a way of gaining power over the creature, of possessing it, thus ensuring a successful hunt.

ROUSSEAU
Horse Attacked by a Jaguar
1910

Wild horses were hunted the breadth of the northern hemisphere for meat and hides, although they became extinct in North America 10,000 years ago, due to overhunting and climatic change; they survived longer in Europe, but were gradually forced east into central Asia. Many present-day breeds have a fascinating history and are derived

from wild descent. The American Appaloosa, for example, is said to be descended from the feral mustangs of the native Nez Percé tribe of North America. These mustangs were in turn the descendants of the Spanish horses brought over by the explorers of the New World. The Przewalski horse (Mongolian wild horse) is probably the only wild horse not descended from domestic stock and surviving into the twentieth century; the last reliable sighting in the wild was in 1967. It has bred successfully in captivity and is now being reintroduced into the wild in Mongolia and China.

WRIGHT
Horse/Light and Snow
1998

Most artists, however, when portraying the "wild" horse have been less interested in the zoological definition of wild than in exploring notions of the untamed, the unbridled, the unfettered, and the free. It is interesting that, just as refinements in the breeding of the thoroughbred were being so faithfully recorded by painters during the eighteenth and nineteenth centuries, other,

quite different, pictures of the horse were being made. These showed the horse as part of the disordered and often savage world of nature. *Boa Serpent Seizing His Prey*, for example, by James Ward (1769–1859) shows man and horse as equal victims in this violent world, while George Stubbs (1724–1806) painted a lion attacking a horse. Later, the French primitive painter Henri Rousseau (1844–1910) explored the same theme, but in his twentieth-century version it is a jaguar that attacks a white horse.

McGARY
Free Spirit at Noisy Water
20th Century

ZOKOSKY
Storm
1984

Artists have also expressed the essentially wild nature of the horse by showing untamed horses in captivity. This creates an immediate tension and sense of drama. Favorite themes are wild-horse races and horse fairs. *The Horse Fair* by Rosa Bonheur (1822–99) was for fifty years the most popular picture of its time. To enable her to make adequate studies for the picture, she

dressed as a man and visited abattoirs and the horse fair in Paris. The result is a frieze-like melee of moving horses and men.

Some depictions of wild horses show them fighting—something unlikely to be seen in captivity. In the wild, a stallion is not territorial and will only display aggression to another stallion in order to defend his mares. Feral horses live in groups comprising one stallion accompanied by his mares (one to six in number) and their young. Within the group a strict hierarchy is observed. When on the move, the stallion drives the group from the rear, with the dominant female leading and the foals following their mothers, the youngest closest to them.

MARC
Horse in a Landscape
1910

This order has been exploited by man for military purposes: in a cavalry charge, a rider would assume the position of the dominant leader. In this way the instinctive behavior of the wild horse is cruelly subverted by humans for their own ends.

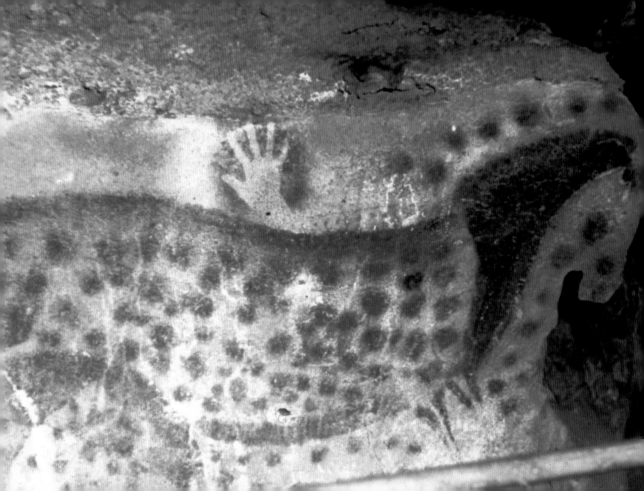

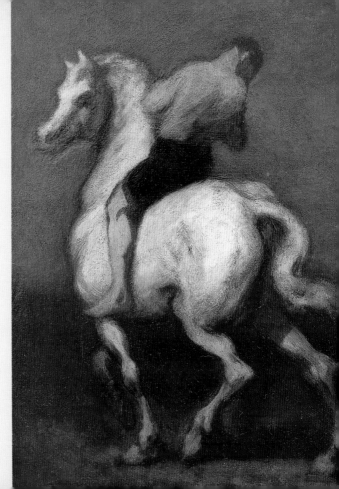

FRENCH

Speckled Horse

c. 24,640 B.C.

This wild horse appears to leap from the very wall of this cave of Pech-Merle, near Cabrerets in southwest France. Could the outline print of the human hand above the horse be the hand of the animal's creator?

DAUMIER

A Man on a White Horse

c. 1855

Not just the free handling of paint and the dynamic pose of the horse, but also the semi-naked appearance of the rider and the lack of any restraining reins help create the sense of wild freedom in this picture.

Honoré Daumier, 1808–79

'Bitzer,' said Thomas Gradgrind. 'Your definition of a horse.'
'Quadruped. Graminivorous. Forty teeth, namely
twenty-four grinders, four eyeteeth, and twelve incisive.
Sheds coat in the spring; in marshy countries, sheds hoofs,
too. Hoofs hard, but requiring to be shod with iron. Age
known by marks in mouth.' Thus (and much more) Bitzer.

CHARLES DICKENS, 1812–70

ROMERO

Pingo (Purple Background)
1998

This Californian artist has
captured much of the wild
spirit of this whinnying horse,
known as Pingo to Chicanos.
A champion of Hispanic art,
Romero's use of vivid color
is typical of his palette.

Frank Romero, b. 1941

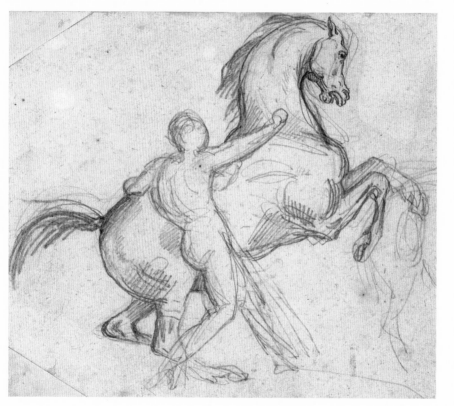

GÉRICAULT
*Rearing Stallion Held
by a Nude Man*
19th Century

In Géricault's dynamic pencil
study the untamed nature of the
horse is mirrored in the natural,
unclothed state of the man.
A keen horseman himself, his
early death was the result of a
riding accident.

Théodore Géricault, 1791–1824

GÉRICAULT
The Wild Horse Race at Rome
c. 1817

This event shows the wild horse
as spectacle. An excited crowd
looks on as the horses are led to
the starting point of the race. The
horses and the men are equally
monumental and the composition
echoes sculpted classical reliefs.

Théodore Géricault, 1791–1824

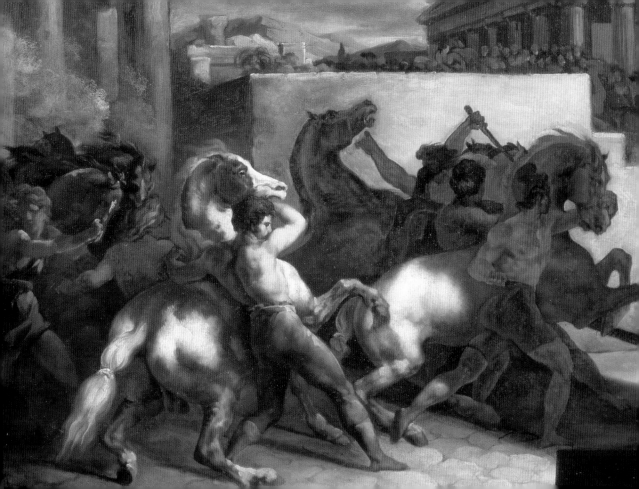

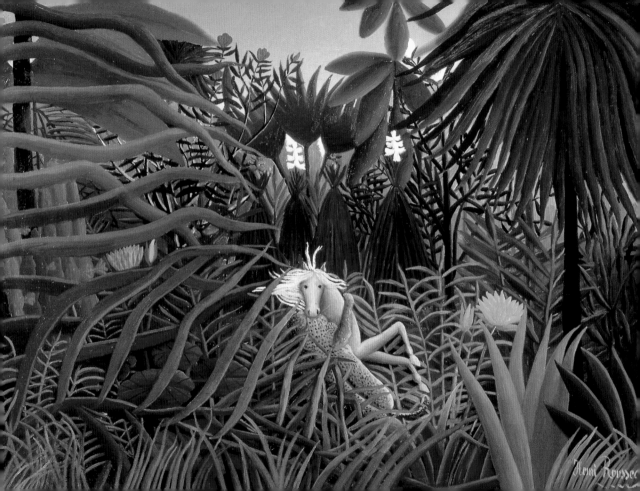

ROUSSEAU
Horse Attacked by a Jaguar
1910

This horse has wandered into the wilds of the jungle, with unfortunate results. Painted in the last year of his life, this picture embodied a theme that Rousseau had explored many times. Similar paintings show big cats attacking a man, a buffalo, and an antelope.

Henri Rousseau, 1844–1910

WRIGHT
Horse/Light and Snow
1998

The solitary survivor of the infamous American battle of Bull Run in 1861 was not a Native North American or a white man, but a horse. Wright shows the determined survivor having returned to the wild and glowing heroically in light and snow.

Curtis Wright, b. 1963

ROMERO

Horse (2)

1995

The strong blocks of textural color achieved by monoprinting are perfect for expressing the sense of unfettered freedom in this wild horse. The technique is one that was often practiced by Edgar Degas (1834–1917).

Frank Romero, b.. 1941

ROMERO

Appaloosa

1992

The technique of silkscreen painting enables Romero to create a saturation of color and pattern. The vigorous, broad handling of the medium reflects the essential nature of this free spirit.

Frank Romero, b. 1941

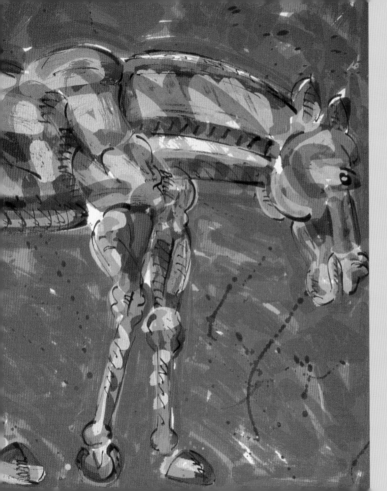

I shouldn't like to think that horses (and dogs) cannot think of anything in the long hours and days when they appear to have nothing to do. But if they do think, I am afraid their thoughts must be very painful ones sometimes. Who has not seen the best-natured old horse give a sudden stamp, with vexation—or a whisk of his tail, with disgust perhaps—at the foolish way which you persist in misunderstanding him.

RICHARD JEFFERIES, 1848–87

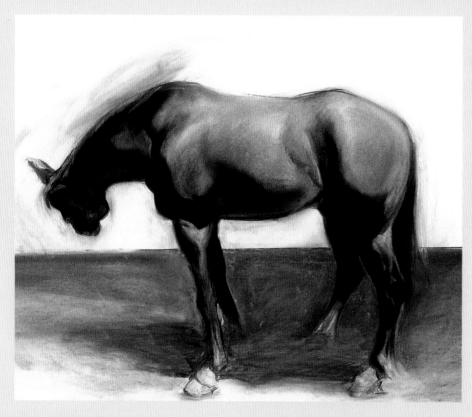

NEMESIO

El Caballo/El Caballo 2
2000

Here we see something of the artistic process—and progress—in Nemesio's charcoal study for the finished oil painting *El Caballo 2*. The simplicity of the composition focuses the viewer's attention on the characteristic pose of the horse, touchingly unaware of our gaze.

Ernesto Nemesio, b. 1978

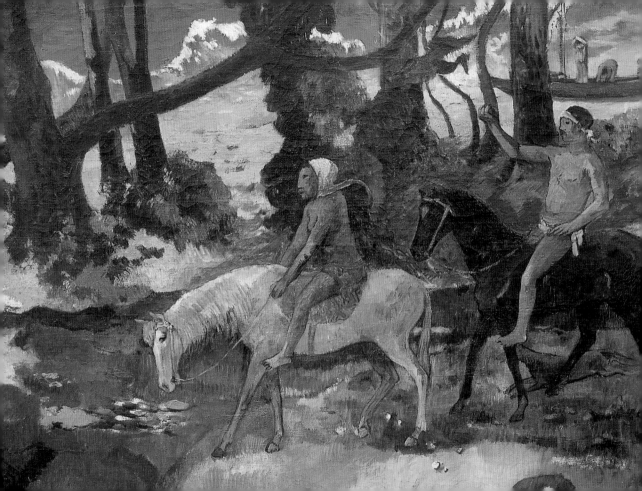

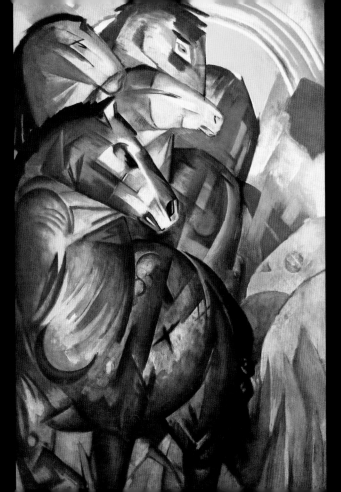

GAUGUIN
The Flight
1901

Painted toward the end of his life, while he was living on the South Sea Islands, Gauguin here re-creates an idyllic Eden, with men, women, and animals coexisting in harmony. This is very much a nineteenth-century Western view, suggesting that both the people and the horses are only just removed from their wild, primitive state.

Paul Gauguin, 1848–1903

MARC
The Tower of Blue Horses
1913

In 1911 Franz Marc and Wassily Kandinsky (1866–1944) chose the name Der Blaue Reiter (The Blue Rider) for their group of Munich artists. They claimed that this was because Marc liked horses, Kandinsky liked riders, and they both liked blue! Certainly Marc reworked the theme of the blue horse many times. *The Tower* is one of the most famous examples, with the wild horses arranged as a column of intersecting planes and curves.

Franz Marc, 1880–1916

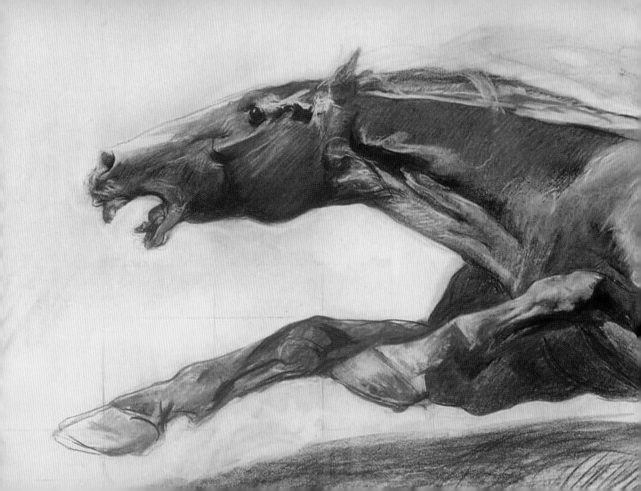

G A Sartorio Roma

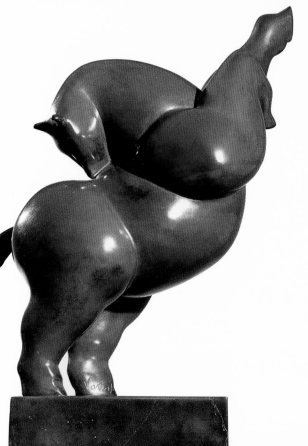

VARI

Small Horse

1983

There is a sensual delight in the playful, curving posture of this unfettered horse. The solidity of the bronze belies the lightness of touch that is so characteristic of Greek painter-turned-sculptor Vari's work.

Sophia Vari, b. 1940

previous pages

SARTORIO

Running Horse

c. 1908

One can almost hear the sound of this horse's galloping hoofs as it extends itself to the very limits of its length, then for a moment appears literally to fly across the ground.

Giulio Aristide Sartorio, 1860–1932

MARC

Horse in a Landscape

1910

Here, the horse is viewed from an unexpected angle and becomes part of the undulating landscape, part of nature. Marc tried to paint animals through their own eyes, rather than as we view them.

Franz Marc, 1880–1916

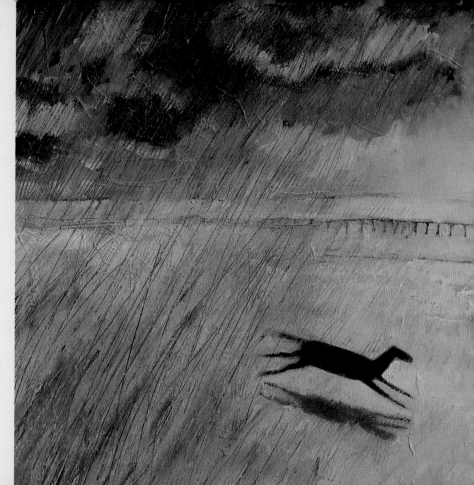

ZOKOSKY

Storm

1984

In this oil painting the wildness
of the weather, with the storm
clouds just breaking and the
first sheets of rain beginning to
fall, is mirrored in the speedy
flight of the galloping horse.

Peter Zokosky, b. 1957

> **❝**
> Shoe a little horse,
> Shoe a little mare,
> But let the little colt
> Go bare, bare, bare.
> **❞**
>
> NURSERY RHYME

CHINESE
Horse
1800

The fluid technique of traditional Chinese brush painting beautifully expresses the untamed nature of this horse. The animal seems completely at one with its environment, as both are rendered with the same economy of color and marks.

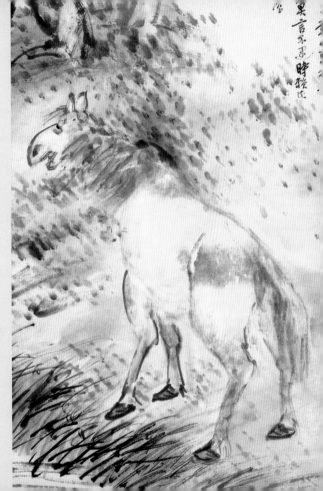

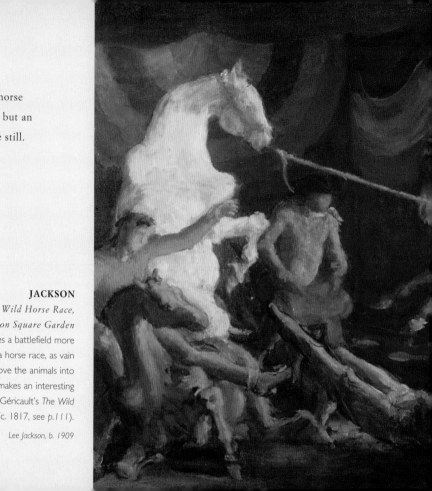

> 66
> A fly, Sir, may sting a stately horse
> and make him wince; but one is but an
> insect, and the other is a horse still.
> 99

SAMUEL JOHNSON, 1709–84

JACKSON
Wild Horse Race,
Madison Square Garden
This scene resembles a battlefield more
closely than it does a horse race, as vain
attempts are made to move the animals into
the starting pens. It makes an interesting
companion picture to Géricault's *The Wild
Horse Race at Rome* (c. 1817, see *p.111*).

Lee Jackson, b. 1909

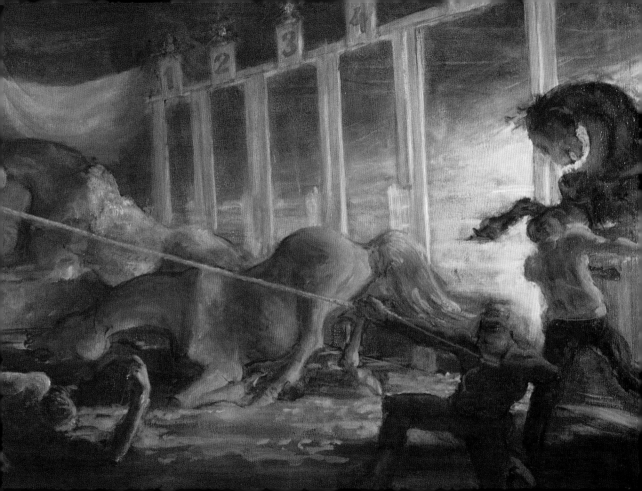

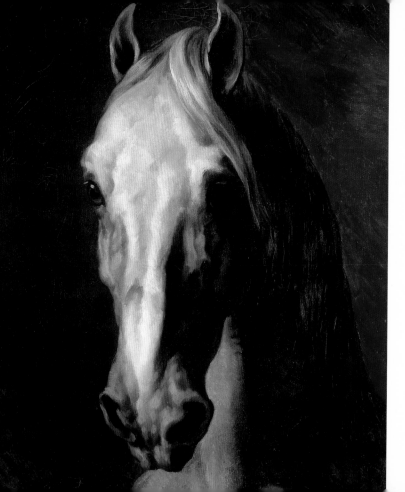

GÉRICAULT
Head of a White Horse
c. 1815

In this extremely focused study, the artist explores the untamed spirit of the animal. Like many of Stubbs's most powerful images of horses, Géricault's work strives simply to present something of the essential nature of the horse.

Théodore Géricault, 1791–1824

WARD
Boa Serpent Seizing His Prey
19th Century

In this nightmarish scene the massive boa is constricting man and horse in the same overpowering coil, which ends with the horse and snake in face-to-face combat. The sinuous curls in the horse's mane and tail—and even the branches of the tree—mirror the movement of the serpent.

James Ward, 1769–1859

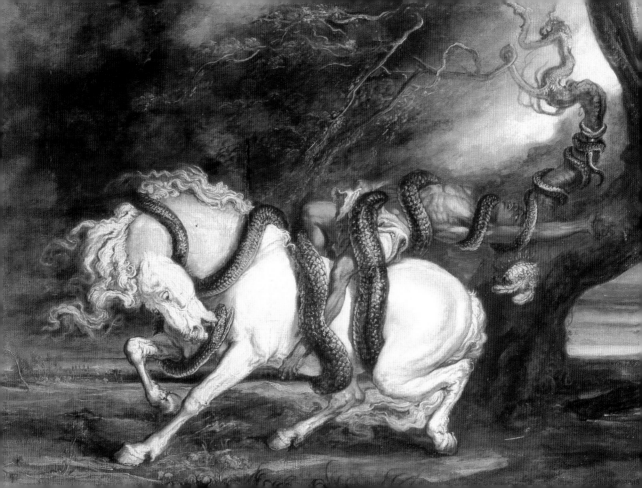

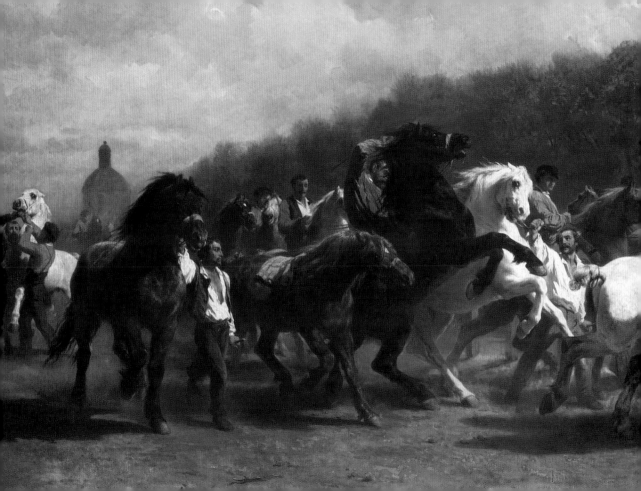

> "
> You can keep your litter and your hay
> and your oats. Long live the thistles of
> the field, for there you can play the stallion
> to your heart's content.
> "
>
> FRANÇOIS RABELAIS, 1483/94–1553

AFTER **BONHEUR**
The Horse Fair
c. 1855

Both in her choice of subject matter and scale, Bonheur transgressed the expectations of her gender when she painted *The Horse Fair*. Due to the success of the painting (the original is now in the Metropolitan Museum, New York), this copy was made and an engraving produced. The engraver was Thomas Landseer (1798–1880), brother of Sir Edwin Landseer (1802–73) another celebrated animal painter. The dome that is visible is that of La Salpetrière in Paris.

Rosa Bonheur, 1822–99

131

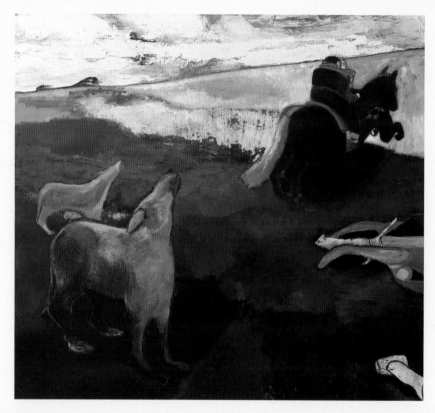

MILLER
There She Goes
1987

Though this jumping horse has been tamed and mounted, the other elements in the painting—the baying coyotes, the white cat, landed fish, and primitive club—allude to its wild origins.

Paton Miller, b. 1953

VERNET
The Race of the Riderless Horses
c. 1820

The fact that this canvas was never finished in no way detracts from the drama of the action. Like his father Carle (1758–1836), Horace Vernet specialized in popular paintings of horses in racing and battle scenes.

Horace Vernet, 1789–1863

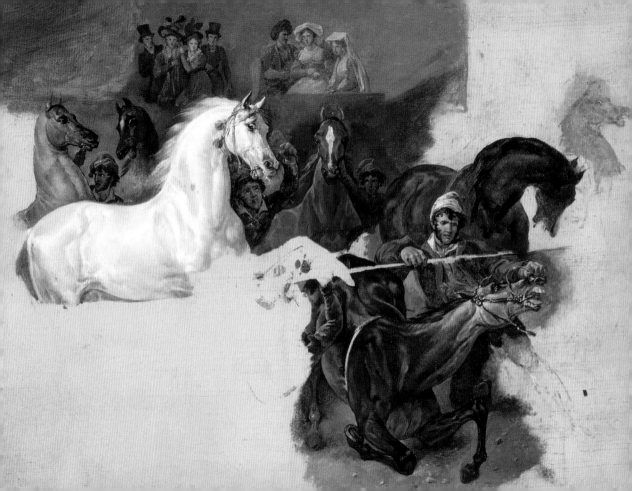

66

Fast, fast, with heels wild spurning, The dark-gray charger fled:
He burst through ranks of fighting men; He sprang o'er heaps of dead.
His bridle far out-streaming, His flanks all blood and foam,
He sought the southern mountains, The mountains of his home.

99

LORD MACAULAY, 1800–59

McGARY
Free Spirit at Noisy Water
20th Century

These stunning sculptural feats of balance miraculously create frozen movement—and embody the unbridled nature of the wild horse—in the New Mexico landscape at the Museum of the Horse.

Dave McGary, 20th Century

far left
CHINESE
Fleeing Horse
2nd Century B.C.

In this perfectly balanced bronze statue of a galloping horse, found in Wu-Wai in Kansu province, the sculptor displays great sympathy and understanding of the wild nature of the animal.

JANOSOVA
Coming of Age
1993

Janosova has adopted the art-historical tradition of narrative painting to portray these two adolescent girls on the eve of puberty. The advancing wild horses are symbolic of the unstoppable forces of nature.

Anita Janosova, b. 1951

WARNER
The Ice Field
1991

These feral horses appear as mere details on the vast, frozen plains. The large expanse of white-and-gray sky that is reflected in the ice-covered ground creates an atmosphere of lonely isolation.

Christopher Warner, b. 1953

66

When once he has taken up
his position he stands as
still as if carved out of
wood or stone. Young
horses will sometimes trot
or canter about to keep
themselves warm. An old
horse knows that he cannot
trot about forever, and that
when he stops he will be
colder than before. So he
stands perfectly still.

99

RICHARD JEFFERIES, 1848–87

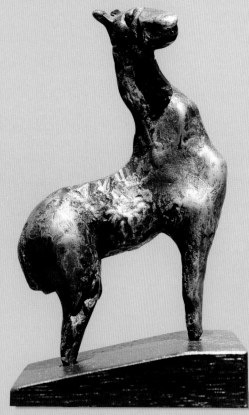

MOORE
Rearing Horse
1959

This beautiful bronze sculpture seems
to embody the very spirit of the
wild horse. Unlike much of Moore's
later monumental work, this piece
measures just five inches high.

Henry Moore, 1898–1986

PERSIAN
Grazing Horses
14th Century

A charming simplicity characterizes
these two grazing feral horses,
taken from the fourteenth-century
Persian manuscript *The Miracle of
Creation*. The repetitive treatment
of the vegetation lends the design
a decorative quality.

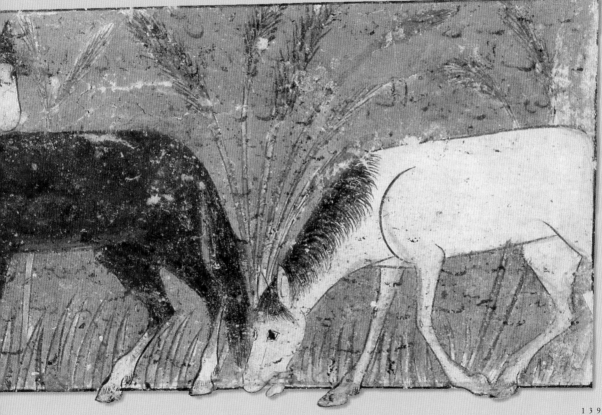

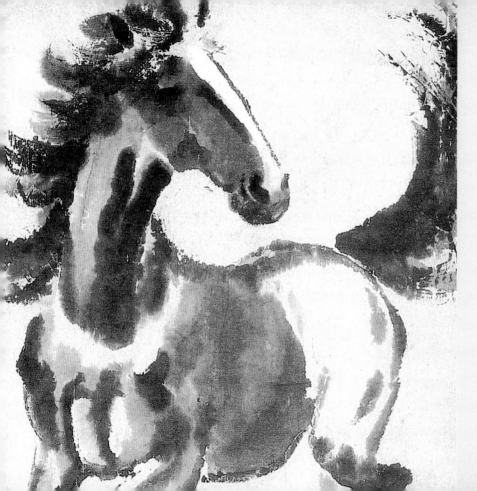

PEI-HUNG
Running Horse
20th Century

The skillful handling of the free and expressive brushwork of this painting makes it the perfect medium for capturing the joyful movement of this young wild horse. Such is the artist's expertise that we can almost feel the wind lifting its mane and tail.

Hsu Pei-Hung, 1895–1953

STUBBS
The Combat
1779

A clue to the cause of these two stallions fighting one another appears in the background on the right of the painting—for the conflict is most probably in defense of the mare and her foal.

George Stubbs, 1724–1806

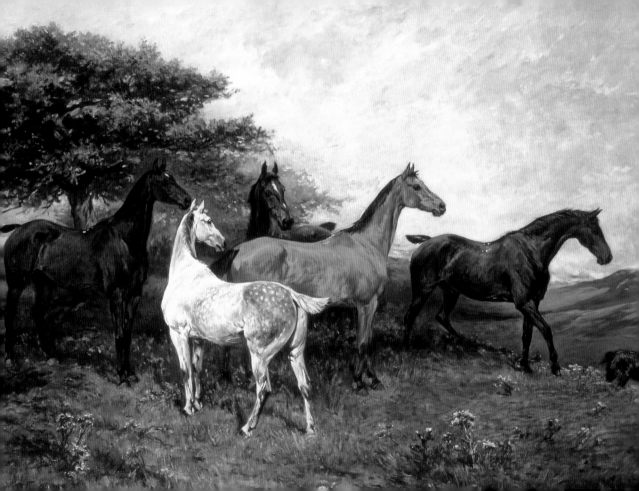

GOOD COMPANIONS

> My horses understand me tolerably well; I converse
> with them at least four hours every day. They are strangers
> to bridle or saddle; they live in great amity with me,
> and friendship to each other.

JONATHAN SWIFT, 1667–1745

JOHN EMMS
Mares and Foals with a Sheepdog
18th/19th Century

ONE RARELY SEEMS TO PASS A FIELD OF HORSES WITHOUT OBSERVING THEIR INCLINATION TO BE TOGETHER. THEY APPEAR to be a companionable species, licking and rubbing each other's noses, whinnying to one another, grazing the same area of paddock together. A sad sight is a horse alone, for horses like to be with other horses. As in life, so it is in art. Rare is the image of a horse that is devoid of either animal or human company. Where these do occur, they usually fulfill the purpose of creating a record, visually cataloging the highbred characteristics of a very particular animal. But even some of these pictures include the groom or stable lad, often inadvertently producing a touching double portrait.

WILKIE
Man and Horse
19th Century

One of the most intense studies of horses in a group was painted by George Stubbs (1724–1806) in about 1762. His *Mares and Foals Without a Background* are shown against a plain backdrop, creating a rhythmic relationship with one another. It was a subject that Stubbs, along with artists such

as John F. Herring (1795–1865) and John Emms (1843–1912), was to return to many times. Artists have also often portrayed horses together within the stable. These pictures present an opportunity to focus on the relationship of horse to horse with greater intimacy than exterior scenes. Théodore Géricault's drawing *Mare and Foal* presents the mare suckling her young, with sympathetic observation but without sentimentality. A quite different depiction is Franz Marc's *Stables*, but despite the abstract dissembling of the surface of the canvas, the relationship between the animals and their form remains evident.

SOROLLA
Washing the Horse
1909

MARC
Horse and Mare
1907

As all horse lovers will verify, a horse can also prove a good companion to human friends. Literature is rich in faithful horse-and-rider teams, such as Brigadore and Sir Guyon in Edmund Spenser's *Faerie Queene*, but perhaps the most famous equestrian partnership is that of Alexander the Great (356–323 B.C.) and his

(reputedly) black mount Bucephalus. Astride this horse Alexander conquered two million square miles of the ancient world. Bucephalus met his death in the final battle against the Indian king Porus, who fought with a cavalry of elephants. Alexander honored his brave friend with an elaborate burial and even founded a city named Bucephala (which is now lost) in his name. On the Alexander sarcophagus in Syria, the king is shown riding a rearing Bucephalus in a triumphant attack on the Persian horsemen.

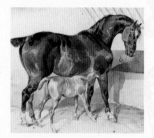

GÉRICAULT
Mare and Foal
19th Century

As long ago as the fourth century B.C. it was recognized that little was achieved by handling a horse with brutality. The Greek historian Xenophon (c. 435–c. 354 B.C.) wrote an enlightened treatise *On Horsemanship*, which advised the use of a soft bit and minimal force in the training and riding of horses. During the Renaissance, Leonardo da Vinci (1452–1519) wrote a treatise on the anatomy of the horse (now lost) and

RACKHAM
The Wind in the Willows
1939

produced many powerful studies of horses and riders, often expressing a real sense of communication between the two. Perhaps it is this spirit of collaboration that has made the horse so popular with women and children. There is inherent appeal in an animal of such size and strength that is also capable of displaying loyalty and gentleness.

Many wonderful portraits of women mounted on their horses have been made over the years. During the nineteenth century, few physically active sports were actually open to women, but horse riding (albeit sidesaddle) was perfectly acceptable. In Édouard Manet's *Portrait of Marie Lafebure on Horseback* we see the easy elegance and freedom of mobility that a woman could achieve on a horse. And despite the fact that all sports are now available to women, equestrian events such as showjumping, cross-country, dressage, and, more recently, horse racing continue to enjoy an enduring popularity among women.

MARC
Horses Resting
c. 1911/12

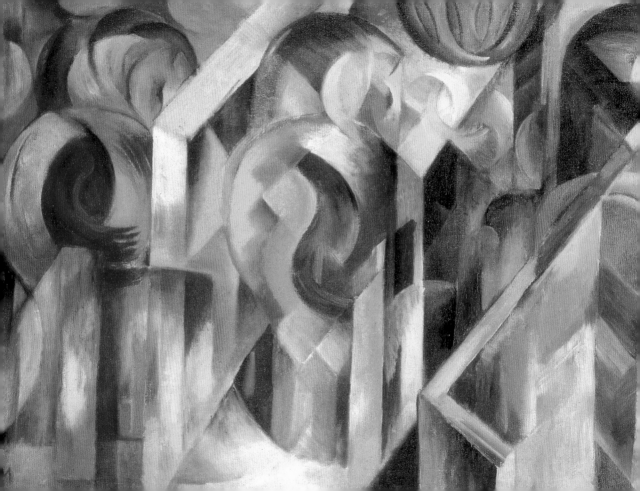

> **"** Art will liberate itself from the needs and desires of men. No longer will we paint a forest or a horse as we like or as they appear to us, but as they really are. **"**

FRANZ MARC, 1880–1916

MARC
Stables
1913

Here Marc reworks a familiar subject in horse painting, the depiction of horses at rest in their stables. Marc subscribed to Wassily Kandinsky's theory that art should reveal the spiritual essence of natural forms through abstraction. In this painting the rhythmic repetition of the curving flanks and necks of the horses relates and connects one to another.

Franz Marc, 1880–1916

> *The gypsy remarked*
> *in a careless way,*
> *'Want to sell that*
> *horse of yours?'*

KENNETH GRAHAME, 1859–1932

RACKHAM

The Wind in the Willows

1939

Although the best-known illustrations to Kenneth Grahame's tale *The Wind in the Willows* are by Ernest H. Shepard (1879–1976), Rackham illustrated an edition shortly before his death. So convincing are his drawings that there seems little implausibility in Toad riding sidesaddle on this old nag.

Arthur Rackham, 1867–1939

SOROLLA

Washing the Horse

1909

Spanish painter and graphic artist Sorolla shows that no fear or distrust exists between these two as they emerge from the waves onto the beach—only the innocence of carefree childhood and cooperative obedience.

Joaquin Sorolla y Bastida , 1863–1923

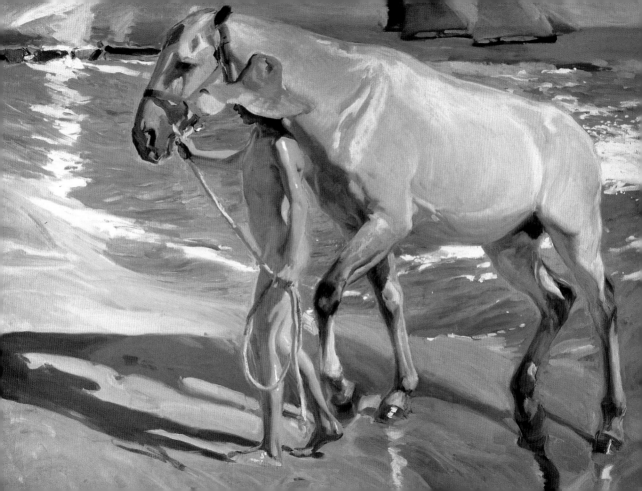

HOLDSWORTH
Green and Golden
1980

The colors of the title are the names of these two horses, but they also aptly describe the sunlight-flooded atmosphere of this Northern Californian stable. By showing the horses at rest in and around their stable, Holdsworth is continuing in the tradition of Théodore Géricault and Franz Marc.

Anthony Holdsworth, b. 1945

HOLDSWORTH
Nuzzling
1979

An intimate and affectionate moment is captured by British-born American artist Holdsworth in this typically companionable scene, as two horses at rest nuzzle one another.

Anthony Holdsworth, b. 1945

REMINGTON
Arizona Cowboy
19th/20th Century

This archetypal cowboy and horse are set to ride off into the dusty Arizona desert. A cowboy would often be completely dependent upon his horse for survival, as without reliable transport he could be stranded indefinitely in a vast, deserted landscape.

Frederic Remington, 1861–1909

WELCH
Partners
1997

Here, Welch reworks what almost became a twentieth-century advertising cliché of the tough "Marlboro Man" mounted on his horse. However, as the title of the painting suggests, it also refers to a much older American tradition, that of the lone cowboy and his horse.

William John Welch, b. 1929

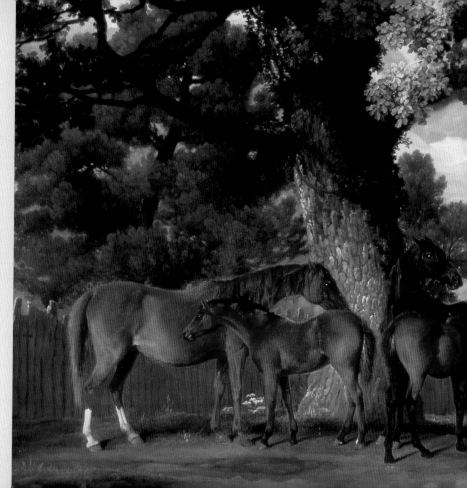

STUBBS

Mares and Foals Beneath
Large Oak Trees
18th/19th Century

The prominence of the ancient
oak trees in this painting seems to
suggest that this scene of peaceful
coexistence between the mares
and foals has recurred throughout
generations of equines.

George Stubbs, 1724–1806

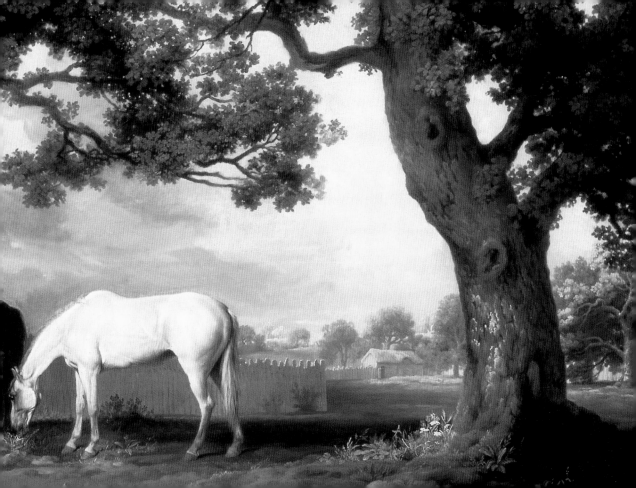

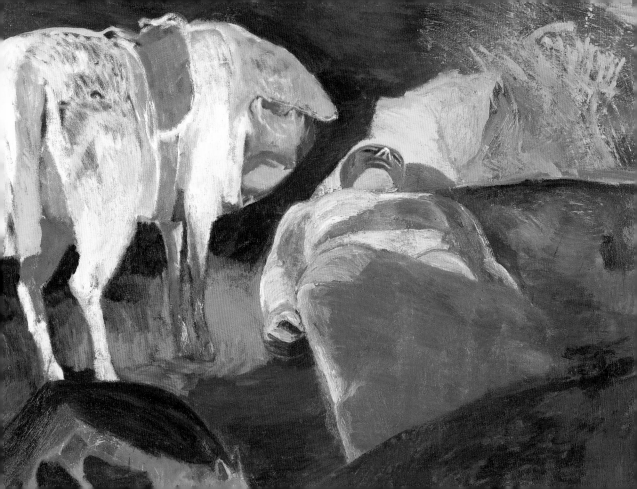

MILLER

Sleeping Man

1986–7

Miller links the man and
horse in this painting through
his repeated use of color.
However, a strangely
claustrophobic atmosphere
prevails as the figure sleeps
alfresco, unaware of the
other living beings at his side.

Paton Miller, b. 1953

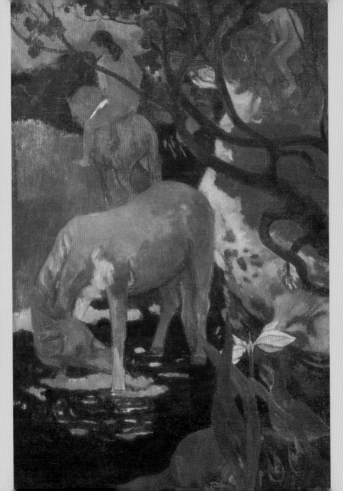

GAUGUIN

The White Horse

1898

Painted after Gauguin's
return to the South Seas, this
portrait shows man and horse
living in a kind of primitive
Eden. Just as the artist is
freed from the traditions of
naturalistic representation, so
these people have no need to
conform to the restraints of
Western modes of behavior.

Paul Gauguin, 1848–1903

WILKIE
Man and Horse
19th Century

In this informal study Wilkie portrays a relaxed rapport between man and horse. His free handling of his media, the fluid line, and restrained use of tone seem appropriate to the recording of this intimate moment.

Sir David Wilkie, 1785–1841

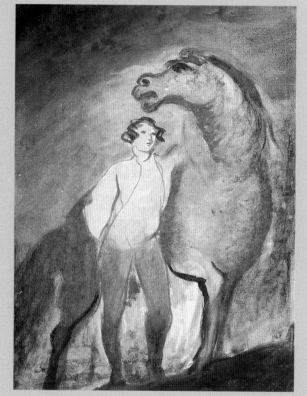

MANET
*Portrait of Marie
Lafebure on Horseback*
c. 1870

Resplendent in black, Marie Lafebure and her alert horse make a dramatic silhouette against the forest behind. Very much a painter of everyday life, Manet shows his subject in a contemporary setting. A little later, partly influenced by Berthe Morisot (1841–95), he adopted the Impressionist technique and with it a lighter palette, abandoning his characteristic use of black.

Édouard Manet, 1832–83

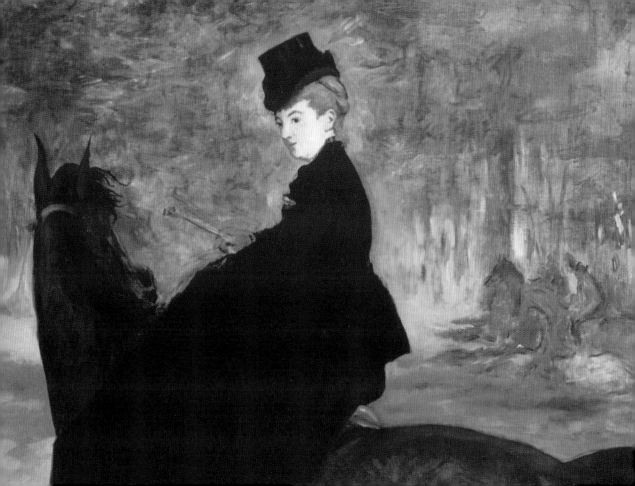

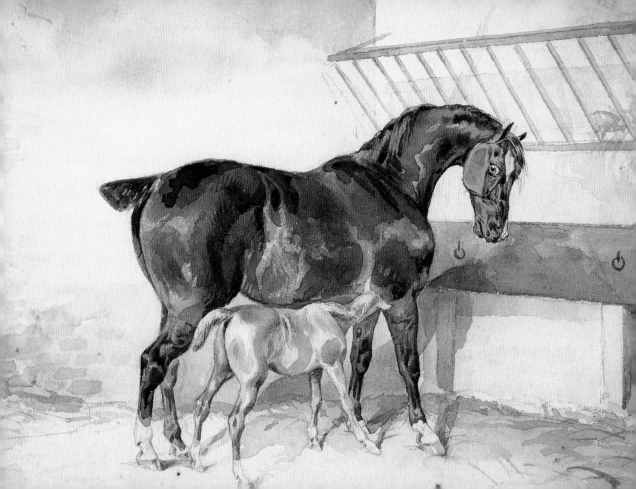

GÉRICAULT

Mare and Foal
19th Century

This sepia drawing observes an intimate moment between mare and foal. The clean, neat condition of the stall shows that these animals were prized and valued, the foal being unlikely to meet the fate of many less fortunate nineteenth-century working beasts.

Théodore Géricault, 1791–1824

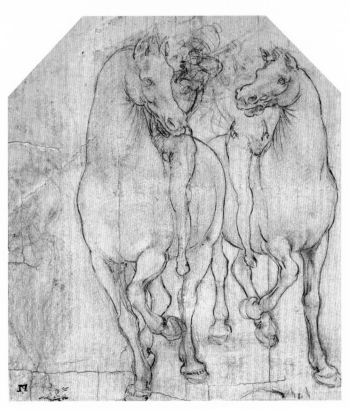

LEONARDO

Two Horsemen
15th/16th Century

This masterly study shows the subtle, yet indelible, effect that can be achieved in a metal-point drawing. Leonardo has molded the riders and their horses into one coherent sculptural mass.

Leonardo da Vinci, 1452–1519

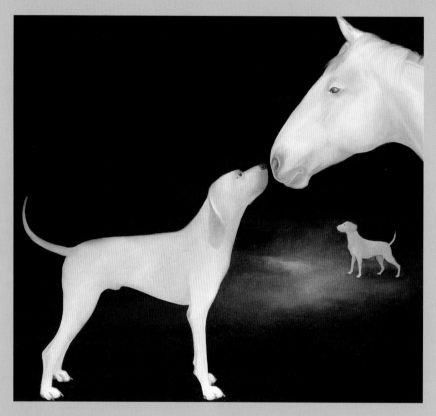

SORF
Magical Realism
1999

Beautiful silhouettes are here created
by the light-on-dark shapes of horse
and dogs, intensifying the focus on this
moment of tender intimacy between
animals. Sorf also explores the interest
created by the relative changes in
scale of the three protagonists.

Zdenek Sorf, b. 1965

MARC
Horse and Mare
1907

Marc believed that nonhuman forms
were most able to express the
essential force of nature, and we see
nature and animals at one in this
simple scene of two horses together.
The impasto surface of the canvas is
applied to horse and landscape alike.

Franz Marc, 1880–1916

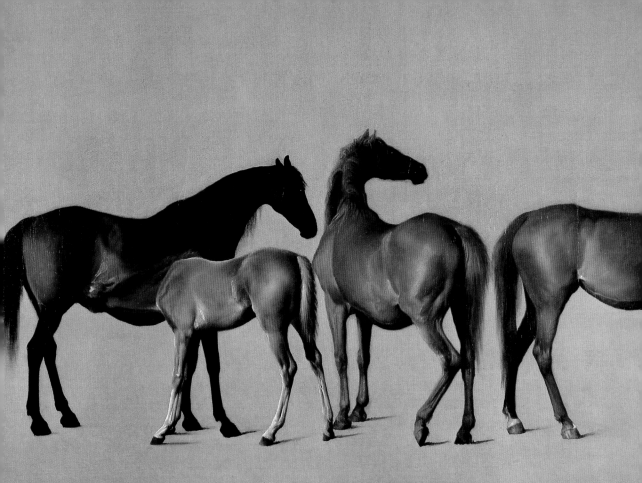

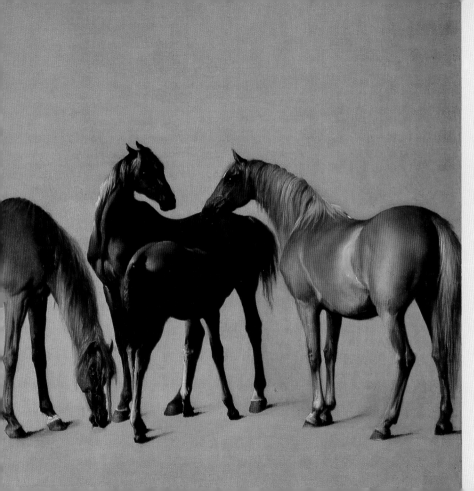

STUBBS

Mares and Foals
Without a Background
c. 1762

This group portrait remains
unsurpassed in the history of
the horse in art. Stubbs is able
to dispense with the distraction
of a background, as the animals
remain in a timeless space.
His precise anatomical
knowledge is tempered by a
unique sensitivity to the living
forms of mares and foals.

George Stubbs, 1724–1806

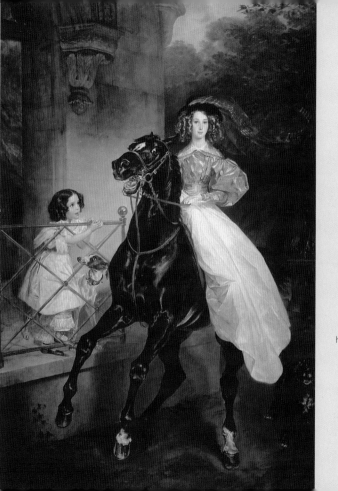

BRÜLLOW
Rider
1832

This is a delightful portrait
of two sisters Giovanna
and Amazilla, daughters
of the Italian composer
G. Paccini, with their horse
and dogs. Brüllow has
chosen to portray the
sisters captured in an
informal domestic moment.

Karl Pawlowitsch Brüllow,
1799–1852

COLLYER
Her Favorite Pets
19th/20th Century

This painting of a golden-
tressed girl astride her
favored pony, faithful dog at
her side, just avoids indulging
in oversweet sentimentality.
Instead, the triangular
composition formed by the
three reinforces their
relationship to one another.

Margaret Collyer, fl. 1893–1910

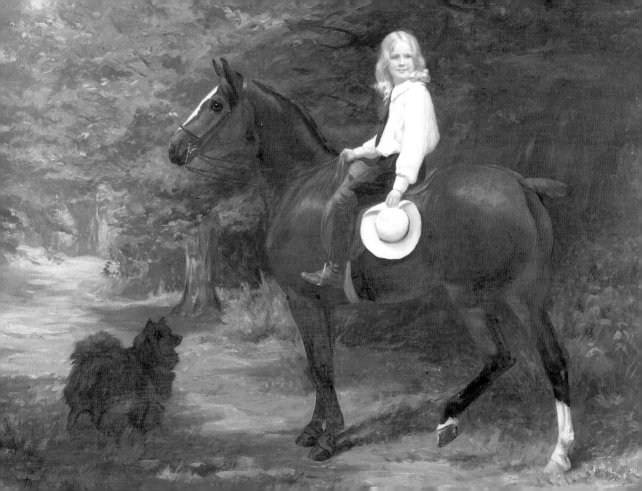

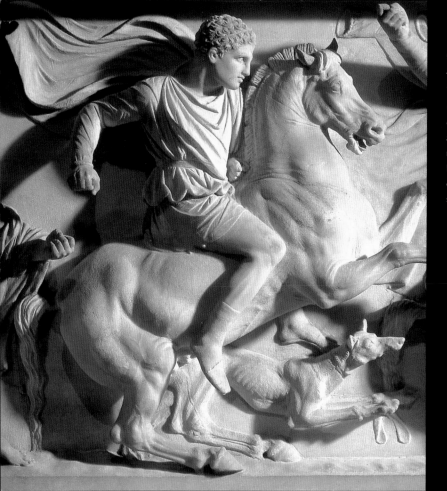

GREEK
Sarcophagus of a Sidonian Ruler
c. 330 B.C.

On what is known as the sarcophagus
of Alexander the Great (356–323 B.C.)
appears this relief sculpture of Alexander
riding his beloved horse Bucephalus.
Note how the billowing cloak of the great
conqueror appears to transform him into
some mythic winged figure.

MARC
Horses Resting
c. 1911/12

The graphic boldness of line and the
restrictive use of colors in this woodcut
produce a pattern-like quality, as one
horse merges with and overlaps another.
The unity of design creates a sense of
companionship among the group.

Franz Marc, 1880–1916

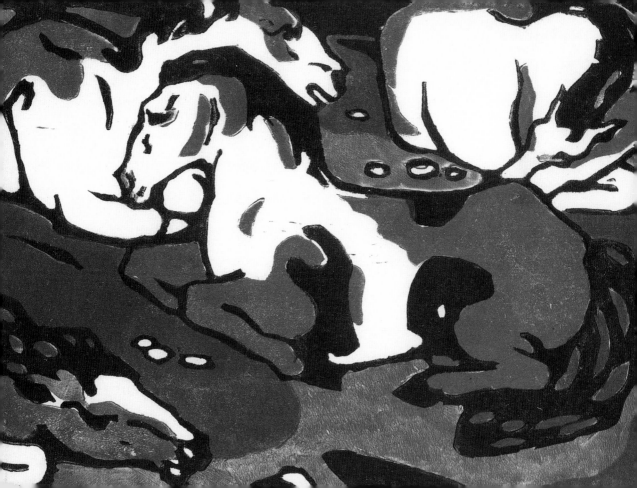

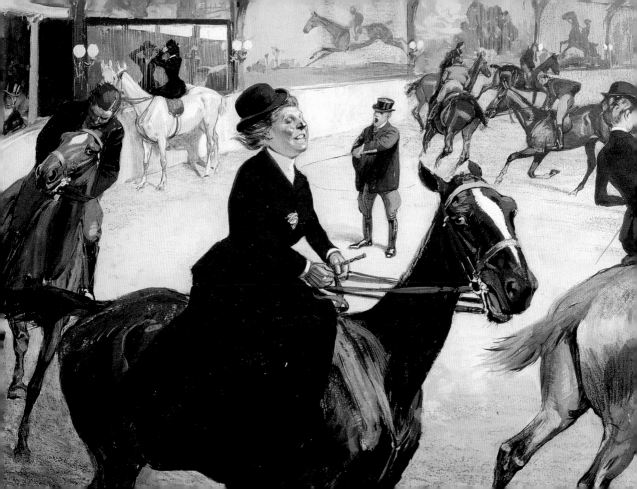

KUPKA
The Equestrian
1894

After leaving his native Czechoslovakia, Kupka lived in Vienna, where he painted this the year before he went to Paris and there became one of the founders of abstract art. He takes a comic delight in portraying the various pursuits of the riders in the practice ring. Something of the atmosphere of the circus prevails, as a blush rises on the cheeks of the bowler-hatted lady as she trots by. Her horse engages us with a wry glance, the ringmaster yawns and the lady at the rear readjusts her hair.

Frantisek Kupka, 1871–1957

66
There is no secret
so close as that between
a rider and his horse.
99

ROBERT SMITH SURTEES,

1803–64

KEMP-WELSH
"She chose me for her horse . . ."
1918

This companionable scene illustrates the happy ending of Anna Sewell's *Black Beauty*. A special relationship often develops between a girl and her horse or pony. The animal can both fulfill her instincts to nurture and give her freedom of mobility.

Lucy-Elizabeth Kemp-Welsh, 1869–1958

> A good horse sholde have three propyrtees of a man, three of
> a woman, three of a foxe, three of a hare, and three of an asse.
>
> Of a man. Bolde, prowde, and hardye.
>
> Of a woman. Fayre-breasted, fair of haire, and easy to move.
>
> Of a foxe. A fair taylle, short eers, with a good trotte.
>
> Of a hare. A grate eye, a dry head, and well rennynge.
>
> Of an asse. A bygge chynn, a flat legge, and a good hoof.

WYNKYN DE WORDE, d. c. 1535

PALANKER

Amo, Amas, Amat

1994

Under the title of the Latin conjugation
"I love, you love, he/she/it loves," Palanker
explores the emotional bond between these two
male racehorses. The work was produced for the
literary anthology *Ribot*, which was named after a
famous French racehorse that refused to run in a
race unless his male equine lover was at the track.

Robin Palanker, b. 1950

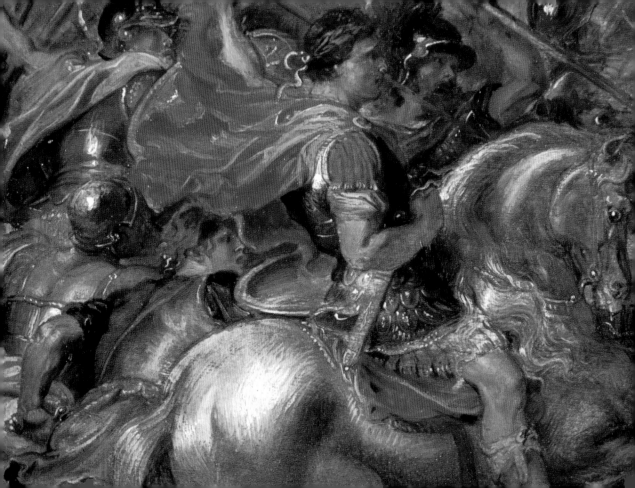

WARHORSES

> "
>
> Not a word to each other; we kept the great pace
> Neck by neck, stride by stride, never changing our place;
> I turned in my saddle and made its girths tight,
> Then shortened each stirrup, and set the pique right,
> Rebuckled the cheek-strap, chained slacker the bit,
> Nor galloped less steadily Roland a whit.
>
> "

ROBERT BROWNING, 1812–89

SIR PETER PAUL RUBENS
*Battle of Constantine
and Maxentius*
Detail
1622

FROM MANY OF HUMANKIND'S FIRST RECORDED CONFLICTS TO THE EARLY YEARS OF THE TWENTIETH CENTURY THE HORSE has played a crucial role in warfare. Most of the references to the horse in the Old Testament are in connection with armies and battles. The recurring visual attribute of the great military leaders of history is the strong and powerful horse: the might of the animal both physically and metaphorically

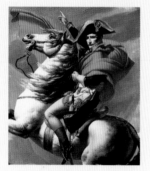

DAVID
Napoleon on Horseback
at the Saint Bernard Pass
1801

elevates the man. From the fierce, galloping Samurai warriors of Japan, and the mounted and stately Emperor Marcus Aurelius (A.D. 121–180) in Rome, to the idealized Napoleon Bonaparte (1769–1821), resplendent on his rearing mount carrying him across the Alps in the footsteps of Hannibal, all are ennobled and aggrandized by their chargers.

Developments in equestrian skill and equipment have directly affected the course of warfare. The use of the stirrup by Greek and Roman cavalry was unknown until the first centuries A.D. Metal

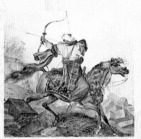

VERNET
Marmeluke Archer on Horse
19th Century

stirrups have since been unearthed in archeological finds dating from fourth-century China and seventh-century Europe. Considerable skill is required to remain on a galloping horse while shooting a bow without the aid of stirrups. The expert horsemen of ancient Parthia developed the legendary "Parthian Shot," shooting their arrows backward as they galloped away from the battle in feigned retreat—a skill displayed much later on by the Native North Americans. However, once the stirrup was in wide use, the greater stability that it afforded enabled less skillful mounted soldiers to wield a lance, or bowmen to shoot from the saddle, with little training.

RADIONOV
Kozak and Girl
1994

The key tenets of feudal society—warfare, hunting, and chivalry—were built upon the horse. The pageantry and pomp displayed by the mounted elite during jousting tournaments at court were in effect a training ground for

the skills that were needed in battle. During the First Crusade of 1099, mounted knights traveled the vast distance from northern Europe to the Levant to capture Jerusalem from the Muslims. Similar distances were covered by the fearsome Genghis Khan (c. 1162–1227) and his 30,000-strong cavalry, each member of which was backed by two horses. This army broke through the Great Wall of China and conquered lands from Korea to the Caspian Sea. The importance of the horse for military might was further illustrated when the terra-cotta army of China's first emperor, Shi Huangdi (c. 259–210 B.C.), was excavated in 1974. Among the life-size replica ceramic figures were found not only a war chariot, cavalry soldiers, and horses, but also the emperor's stable boys.

Such highly armed forces left both the soldier and his horse quite vulnerable to injury. Thus weighty protective armor was

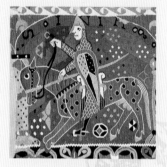

NORWEGIAN
*Norman Cavalier
on a Piebald Horse*
13th Century

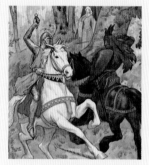

THEAKER
*Guinevere Watches
Lancelot and Arthur Fight*
20th Century

introduced for horse and rider. This in turn led to the breeding of larger, stronger horses. The use of gunpowder firearms in the seventeenth century made the sturdy warhorse redundant, to be replaced by lighter, more mobile cavalry horses, equipped for greater speed and agility and resembling more closely the modern-day hunter.

The First World War (1914–18) was the last large-scale conflict during which animals played a major role, with horses used alongside the new armored tanks and trucks. The RSPCA (Royal Society for the Prevention of Cruelty to Animals) Animal War Memorial at Kilburn Park in London touchingly honors the "484,143 horses, mules, camels and bullocks and many hundreds of dogs, carrier pigeons and other creatures" that perished at the front. This is a poignant reminder of the terror, the cruelty, and the hardship that were suffered by the horse in the service of humans in times of war.

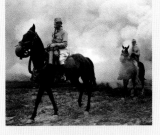

BRITISH
Cavalry Horses
with Gas Masks
c. 1941

RUSSIAN
Saint Demetrius
18th Century

This beautiful icon depicts the Christian martyr Demetrius, the warrior saint and the patron saint of Salonika; the cult of Demetrius was confined to the East. He is usually shown in armor and, as here, holding a lance.

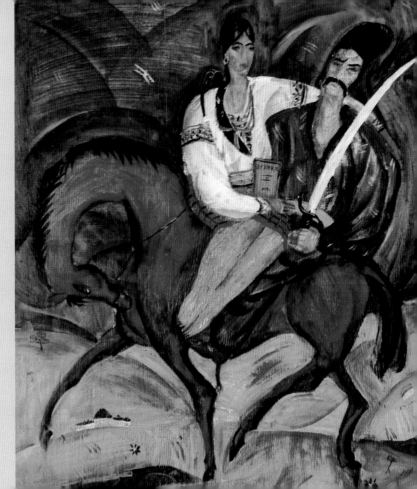

RADIONOV
Kozak and Girl
1994

A painting that presents horse
and rider as dashing freedom-
fighters! Kozak is the Ukrainian
equivalent of the English folk
hero Robin Hood, and in
defense of a free country he
robbed the rich Polish barons.
Here, he has rescued a damsel
in distress, carrying her to safety
on his delightful red horse.

Gregory Radionov, b. 1971

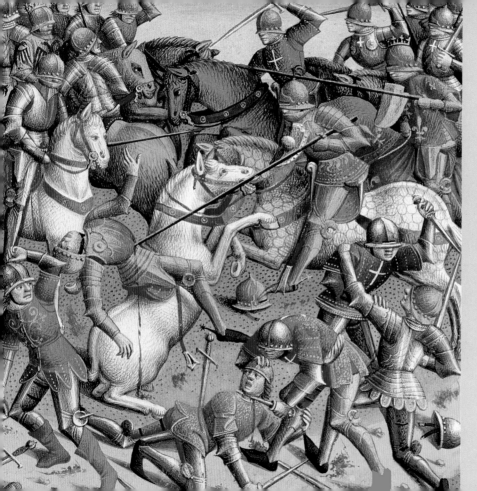

VINCENT DE BEAUVAIS
Battle Between Knights
13th Century

This battle scene comes from the *Speculum Historiae* and shows little restraint in its depiction of bloodletting. The basin-shaped helmets worn here were called basinets, but they afforded less protection than those developed later, as much of the face was left exposed.

Vincent de Beauvais, c. 1190–1264

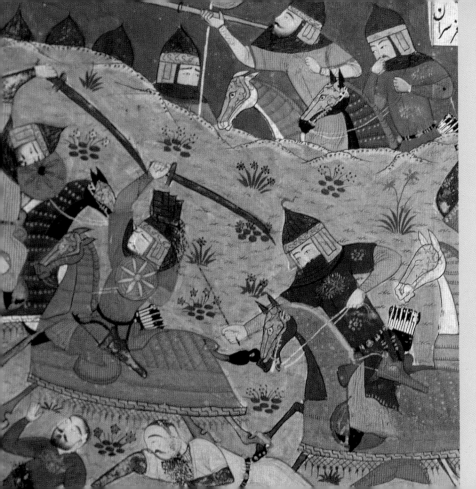

PERSIAN
Illuminated Manuscript Page
Undated

The beautiful colors of this illuminated Persian manuscript belie the violence inherent in the scene. The supremacy of the mounted combatants is evident as they mercilessly hack down the men on foot.

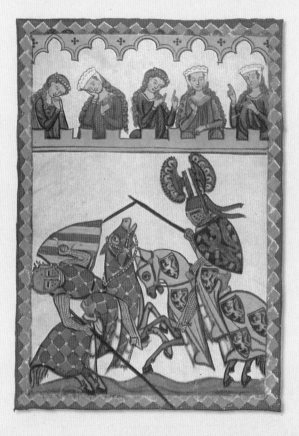

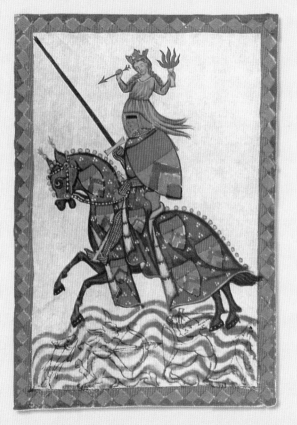

> " O, what can ail thee, knight-at-arms,
> Alone and palely loitering?
> The sedge has wither'd from the lake,
> And no birds sing. "

JOHN KEATS, 1795–1821

GERMAN
The Minnesingers
Undated

The horse played an integral role in the young life of a knight-to-be and was seen as an indispensable part of his life and education. Once a nobleman had sufficient expertise in horse management, as well as in the handling of weapons and in appropriate courtly behavior, he became a squire and donned silver spurs. After further service he would exchange the silver spurs for the much-coveted golden, or gilded, spurs of knighthood.

THEAKER
*Guinevere Watches
Lancelot and Arthur Fight*
20th Century

In their battle over Guinevere, King
Arthur and Sir Lancelot resort to
swords as their wooden lances lie
broken and useless, in this illustration
from *King Arthur and His Knights*.
The rightful Arthur is the image of
purity on a white horse; the deceitful
Lancelot on a black one.

Harry Theaker, 1873–1954

NORWEGIAN
*Norman Cavalier
on a Piebald Horse*
13th Century

The horse on this tapestry from
Baldishol has, to the modern eye,
more of the pantomime neddy
about it than the fierce charger of a
knight going into battle. Its spots are
reflected in the background pattern.

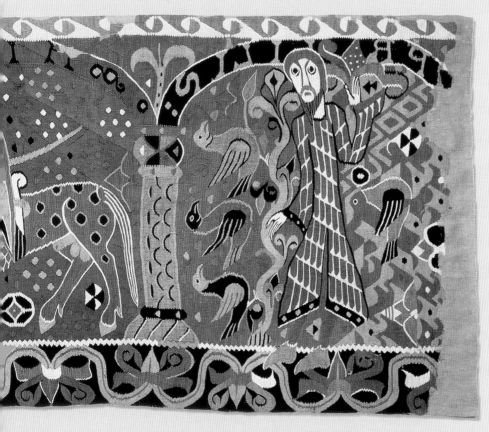

following pages
ENGLISH
Horsemen Bringing
William His Horse
c. 1070–80

The duke of Normandy's
horse is only one of the
202 horses and mules that
appear in the 200-foot-long
Bayeux Tapestry. Half the
Norman army was mounted,
which made it a superior
fighting force against the
Anglo-Saxon soldiers who
fought on foot. Elsewhere
the tapestry depicts the
Norman ships, loaded with
ten horses apiece.

47.

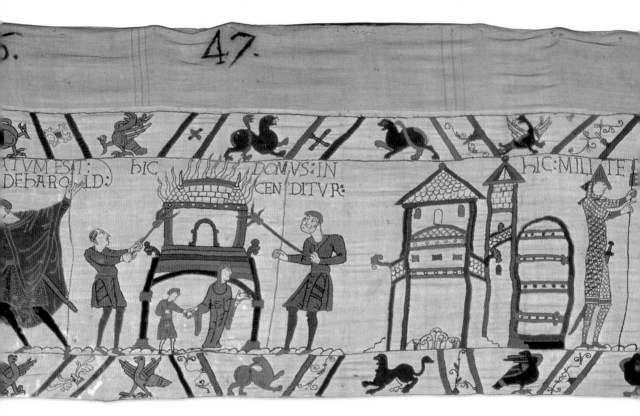

ATVM EST: hIC DOMVS:IN
DEHAROLD: CEN DITVR: HIC:MILITE

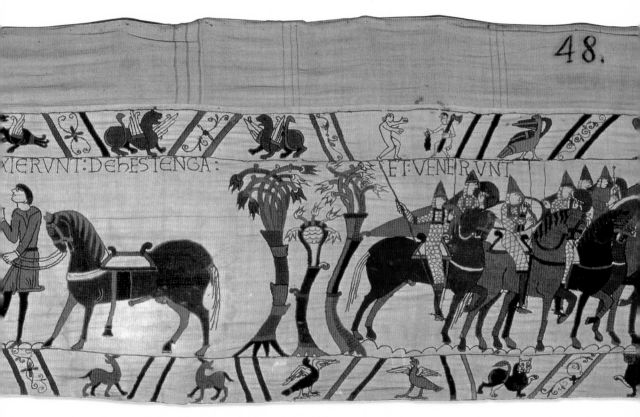

48.

XIERVNT:DEHESTENGA: ET:VENERVNT

DÜRER

The Italian Joust

1516

Dürer chooses to focus on the harsh realities of a joust for both man and horse. Note the fierce stag's horns and lion's head attached to the helmets, which would have added further terror to the advancing attack.

Albrecht Dürer, 1471–1528

DÜRER

Knight, Death and Devil

1513

Like soldiers throughout history, this knight's companions as he goes into battle are not only his horse and dog, but also the specters of Death and the Devil. Death carries the hourglass of time and rides a horse with a bowed head.

Albrecht Dürer, 1471–1528

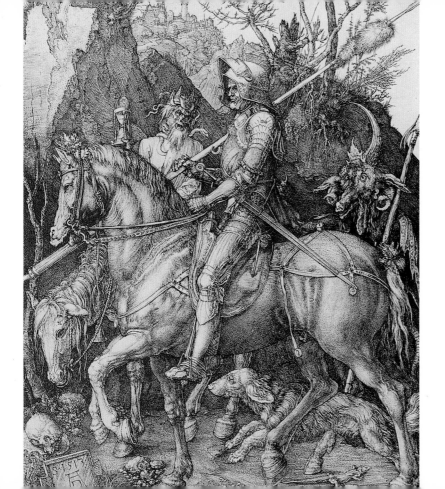

> His horse—whether terrified by
> the shock he had suffered,
> or feeling freed from the burden
> of the spear which the Palsgrave
> had cast from him—came
> down on his knees and
> fell right over squeezing
> the rider so sorely in his high
> saddle that a portion of his
> spine was damaged.

LUDWIG VON EYB THE YOUNGER,
16TH CENTURY

AMERICAN
Untitled
19th Century

The artist of this picture has chosen to depict a particularly alarming and disturbing scene of battle. The kidnapped woman raises her hands to the skies in a gesture of despair as a Native South American carries her off on his charging steed. The poses of the main protagonists would not seem out of place in a classical history painting.

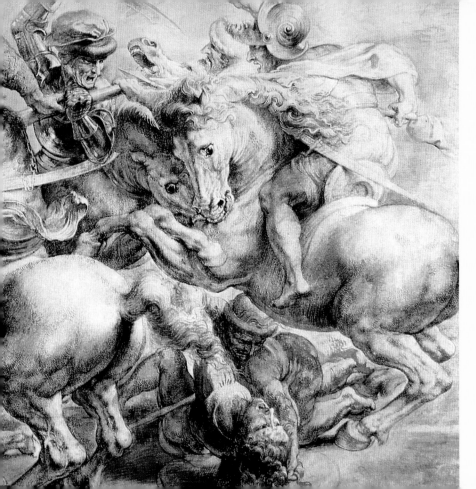

RUBENS

The Fight for the Standard
17th Century

This is one of several copies
that were made by other artists
of the central part of Leonardo
da Vinci's masterly cartoon *The
Battle of Anghiari* (1505). As
well as Rubens, Michelangelo
(1475–1564), and Raphael
(1483–1520) also made copies.

Sir Peter Paul Rubens, 1577–1640

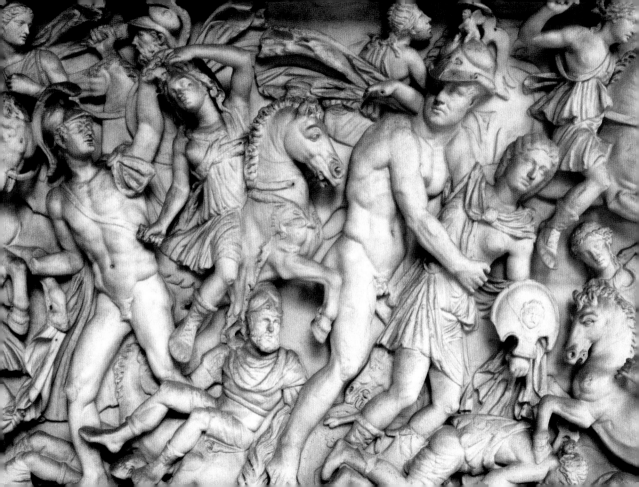

> 66
>
> To fight aloud, is very brave,
>
> But gallanter, I know,
>
> Who charge within the bosom
>
> The Cavalry of Woe.
>
> 99

EMILY DICKINSON, 1830–86

ROMAN

Battle Scene with Amazon Warriors
Undated

This Roman relief sculpture depicts the
legendary Scythian female warriors in battle
with Athenian soldiers, lead by Theseus. The
Amazons were reputedly skilled horsewomen
and are usually shown with bow and arrow,
although these warriors are armed with daggers.

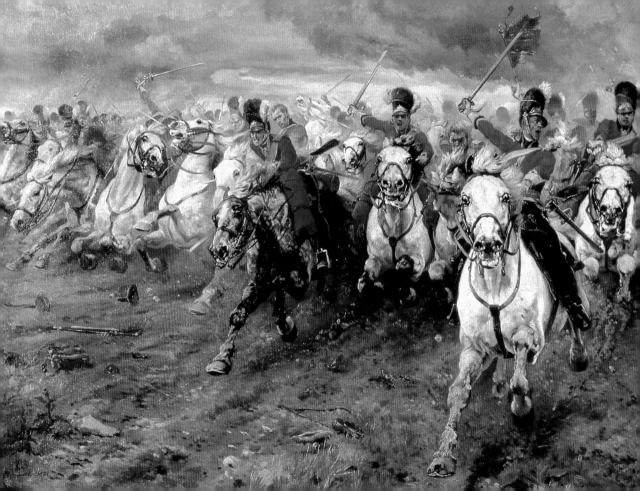

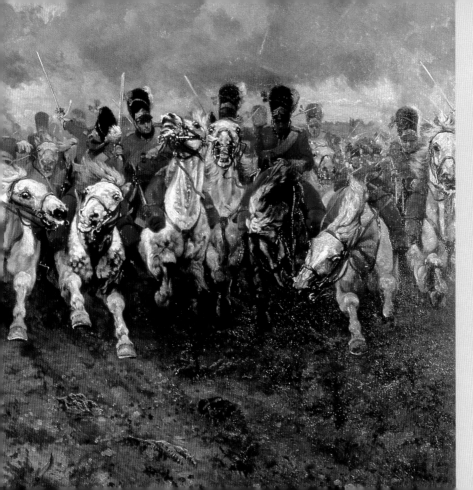

BUTLER

Scotland Forever
1881

Butler places the spectator directly in the path of the oncoming charge of the Second Royal North British Dragoons, the Scots Greys, at the battle of Waterloo (1815). Although the painting has most often been read as a patriotic celebration, Butler herself always insisted that she did not paint "for the glory of war." The brilliance of the horses' coats was achieved using a special white pigment (its manufacturing process a secret), which the artist obtained from a widow in Seville, Spain.

Lady Elizabeth Southerden Butler (née Thompson), 1846–1933

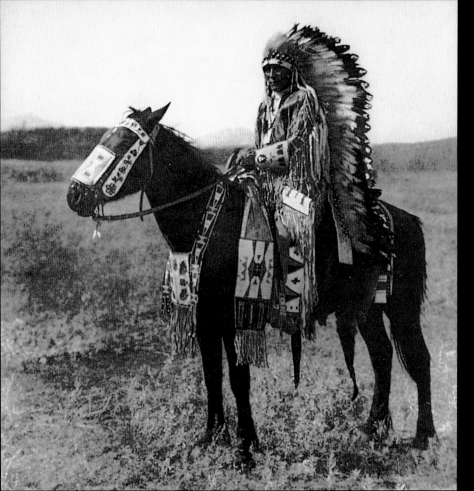

CURTIS
Chief Hector—Assiniboin
20th Century

This Native North American chief and his horse are resplendent in traditional attire. Just like other military leaders, the combined effect of costume and horse elevates the status of the chief.

Edward Sheriff Curtis, 1869–1955

CURTIS
Oglala War Party
20th Century

Curtis's documentary photographs of Native North Americans help us understand the powerful visual effect that an advancing mounted tribe would have had on white settlers. The horses in this picture are as resplendently adorned as the warriors.

Edward Sheriff Curtis, 1869–1955

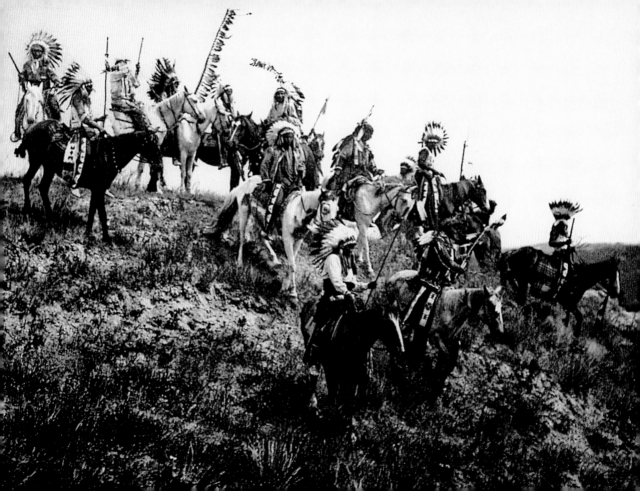

> Half a league, half a league, Half a league onward,
> All in the valley of Death Rode the six hundred.
> 'Forward, the Light Brigade! Charge for the guns!' he said;
> Into the valley of Death Rode the six hundred.

ALFRED, LORD TENNYSON, 1809–92

MACKE
Riders
1912

Although Macke was associated with
Wassily Kandinsky (1866–1944), Franz Marc
(1880–1916), and Der Blaue Reiter group, his
work remained largely representational. This
colorful gouache shows a group of cavalry
soldiers. Sadly, Macke was killed at the front in
the early part of the First World War.

August Macke, 1887–1914

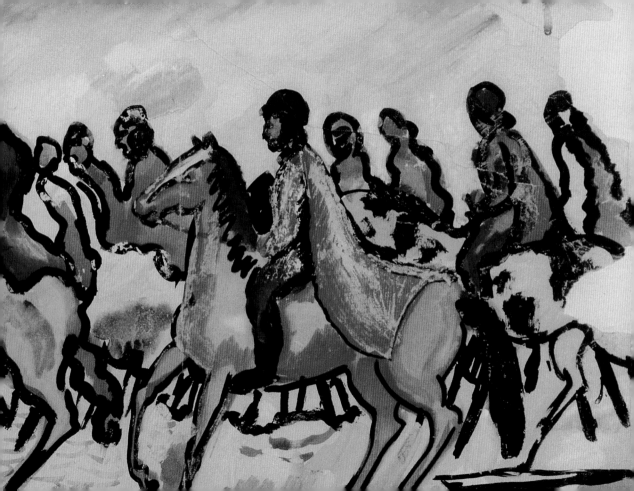

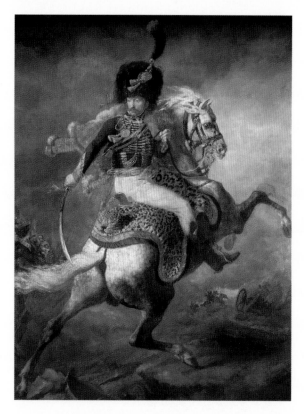

GÉRICAULT

*An Officer of the Chausseurs
Commanding a Charge*
1812

A vibrant exemplar of the mounted military portrait, this life-size painting was the first that Géricault exhibited at the Salon in Paris. Painted during Napoleon's Russian campaign, it was well received. However, its less positive sequel, *Wounded Cuirassier Leaving the Field*, painted in 1814 while Napoleon was imprisoned on Elba, proved not so popular.

Théodore Géricault, 1791–1824

VERNET
Marmeluke Archer on Horse
19th Century

Considerable skill is required to shoot an arrow backward whilst mounted on a horse—or at least to meet your target with any accuracy! Vernet specialized in painting horses, as well as vast battle pictures of Marengo (1800) and Austerlitz (1805) for Napoleon. A marmeluke was a mounted Egyptian soldier whom the Crusaders encountered.

Carle Vernet, 1758–1836

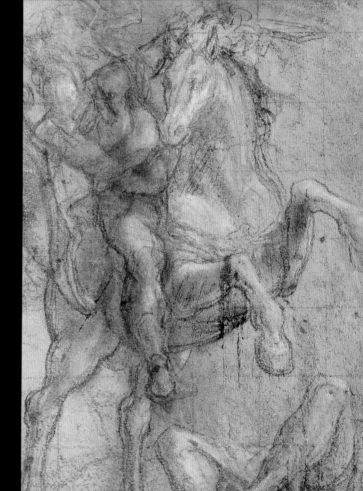

"
And broader still became the blaze,
and louder still the din,
And fast from every village round
the horse came spurring in.
"

QUARTERLY MAGAZINE, 1842

TITIAN
Rider and Fallen Soldier
16th Century

Titian's wonderful chalk sketch focuses on a single violent moment in battle, as the mounted soldier lets his sword fall upon his opponent. The thundering hoofs of the rearing horse are about to descend on the fallen soldier, further ensuring his ultimate defeat.

Titian (Tiziano Vecellio), c. 1488/9–1576

PEALE
Washington before Yorktown
1824–5

Painted a quarter of a century after George Washington's death, this portrait illustrates the power exerted by the formal mounted military portrait. The stately Washington (1732–99) is as much a master of the situation as he is of his horse. Peale's work shows the neoclassical influence of fellow American Benjamin West (1738–1820), under whom he worked in England.

Rembrandt Peale, 1778–1860

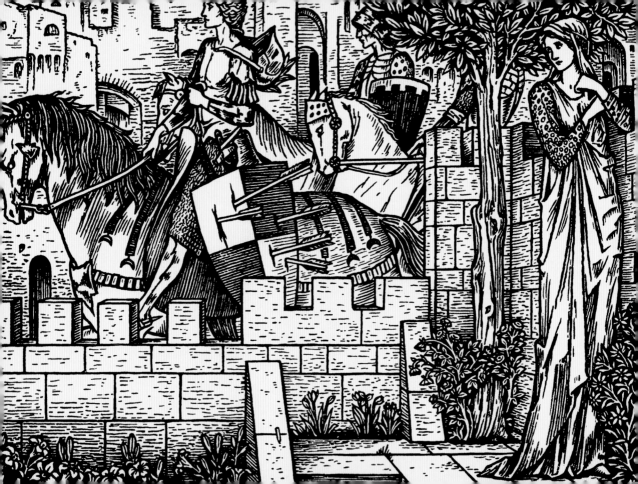

BURNE-JONES
Troilus and Criseyde
1896

In this illustration from the Kelmscott Press edition of *The Works of Geoffrey Chaucer* we see just how dangerous medieval warfare could be. The arrows that pierce the knight's shield are worn like a badge of honor. William Morris founded the press, which did much to elevate the standards of book design and printing, in 1890.

Sir Edward Burne-Jones, 1833–98

RIVERA
Fall of the Aztec Empire
20th Century

In this mural painting Rivera uses a familiar vocabulary influenced by Paul Gauguin (1848–1903) and by Aztec and Mayan sculpture. The solidity of the form of the horse anchors the figures against the multilayered elements of the background.

Diego Rivera, 1886–1957

DAVID

*Napoleon on Horseback
at the Saint Bernard Pass*
1801

This is one of a series of
portraits of Napoleon
(1769–1821) by David.
The artist abandons all
neoclassical restraint in this
unashamedly propagandist
view. Everything in this
painting aggrandizes and
reflects the power of the
dashing Bonaparte—the
dynamic, swirling mane and
tail of the horse being
repeated in the drama of
cloak and sky.

Jacques-Louis David, 1748–1825

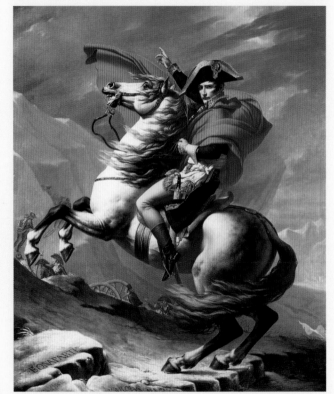

ROOD

*Roosevelt and the
Rough Riders*
1898

Theodore Roosevelt
(1858–1919) bravely leads
the cavalry regiment, the
Rough Riders, a charging
melee of men, horses,
swords, and exploding shells.
The battle of Santiago in
Cuba in 1898 was a victory
for the US regiment in the
Spanish-American War.

W.G. Rood, fl. 19th Century

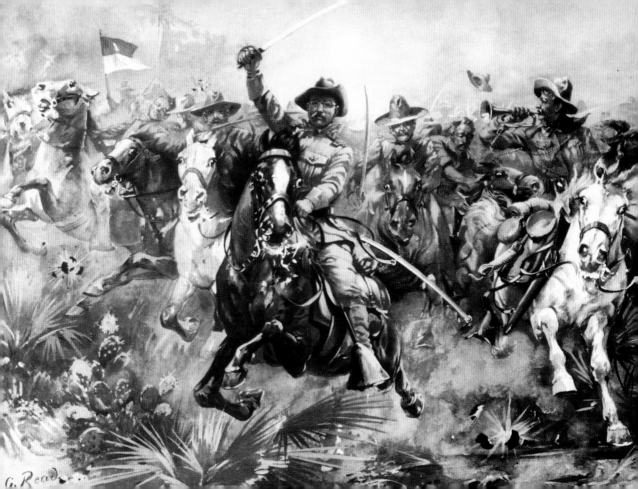

G. Read

CHINESE
War Cry!
19th Century

One can almost hear the war cry and the accompanying
pounding of galloping hoofs as these Chinese children
training to be warriors give chase to the "enemy."

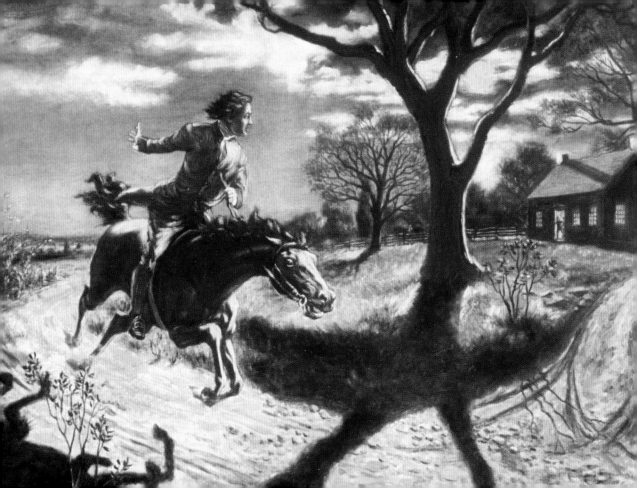

UNKNOWN ARTIST
*The Midnight
Ride of Paul Revere*
1913

One of the most famous
incidents in the American War
of Independence is illustrated in
this painting. On 18 April 1775
the pony-express rider Paul
Revere (1735–1818) set out on
a midnight ride to Lexington,
Massachusetts. His mission
was to warn Samuel Adams
(1722–1803) and John Hancock
(1737–93) of the approaching
British troops, whose purpose
was to arrest both men. As can
be seen in the picture, he raised
the alarm at all the houses
along the way.

LENZ
*"Subscribe to
the Sixth War Loan"*
c. 1914–17

Here, we have the image of the
mounted hero exploited for a
propagandist war purpose: to
raise money for the German
war chest during the First World
War. The imagery shows a
combatant knight slaying
the symbolic demon monster.

Maximilian Lenz, 20th Century

UCCELLO

Battle of San Romano
1454/7

One of three versions of this subject that Uccello painted for the Medici family. This one can be found in Florence, the others in London and Paris. Uccello was influenced by the early Renaissance interest in perspective, particularly foreshortening, but his paintings always contain a strong decorative element.

Paolo Uccello, c. 1396/7–1475

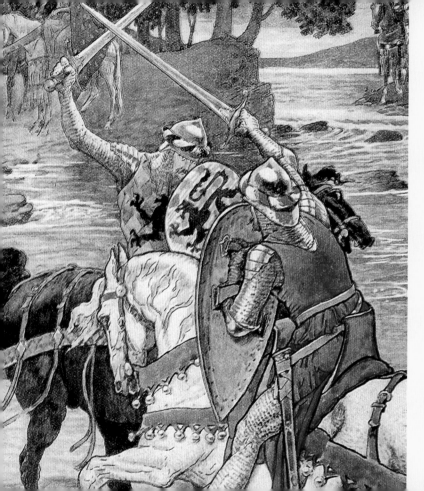

CRANE

*Beaumains Wins the
Fight at the Ford*
19th Century

This illustrates one of the most dramatic scenes
from the tales of *King Arthur's Knights*. Crane,
along with Randolph Caldecott (1846–86), and
Kate Greenaway (1846–1901), elevated the
standards of illustrations in children's books
to new heights in the nineteenth century.

Walter Crane, 1845–1915

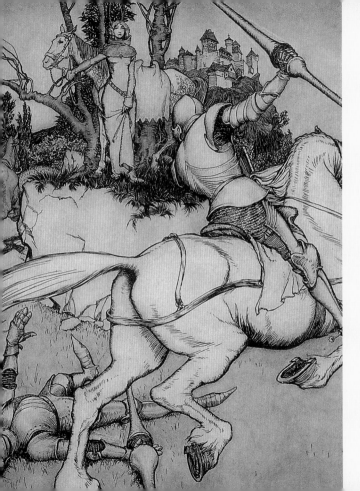

> All in the blue unclouded weather
> Thick-jewelled shone the saddle leather,
> The helmet and the helmet-feather
> Burned like one burning flame together,
> As he rode down to Camelot.

ALFRED, LORD TENNYSON, 1809–92

RACKHAM

Romance of King Arthur

1920

Though in many ways Lancelot, strongest and most valiant of the Knights of the Round Table, was the very embodiment of chivalric virtues, it was his inappropriate love for Guinevere that led to the destruction of the Round Table.

Arthur Rackham, 1867–1939

KARPELLUS
*"Subscribe to the
Seventh War Loan"*
c. 1914–17

In this propagandist German
poster we see a knight in
repose, reaching out to the
dove of peace. The demeanor
of the horse is appropriate to
the particular message that is
being conveyed.

Adolf Karpellus, 20th Century

BRITISH
*Cavalry Horses
with Gas Masks*
c. 1941

This is a poignant image of
modern-day warfare. Like their
First World War counterparts,
these cavalry horses were
at threat from gas attacks,
although this time it was from
sophisticated chemical warfare
rather than mustard gas.

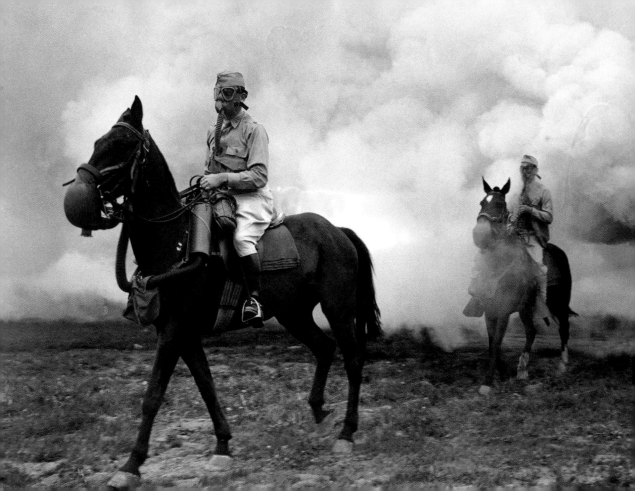

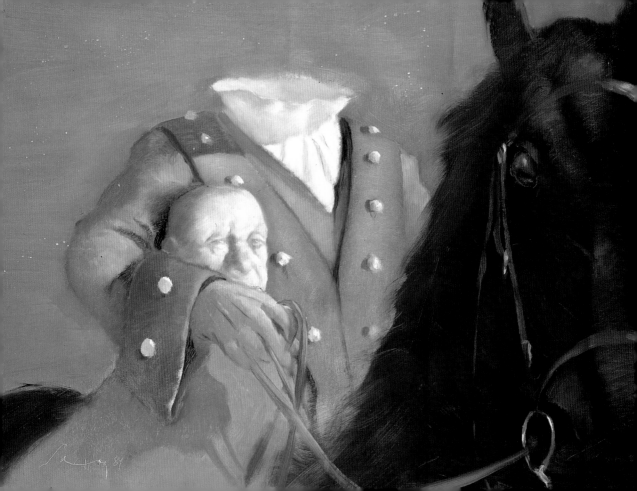

MYTHICAL HORSES

> Do not trust the horse, Trojans. Whatever it is,
> I fear the Greeks even when they bring gifts.

VIRGIL, 70–19 BC

JULIO LARRAZ
The Headless Horseman
1984

PAINTERS HAVE LONG EXPLOITED THE BEAUTY, STATURE, AND DYNAMIC MOVEMENT OF HORSES WHEN PORTRAYING dramatic scenes from myth and legend. The enduring attraction of these myths is apparent in the numerous reworkings of the same subject matter by artists from different periods and cultures. For example, Saint George slaying the dragon appears on Byzantine reliefs, in the work of Tintoretto (1518–94) and in a design for a series of stained-glass windows by the Pre-Raphaelite painter Dante Gabriel Rossetti (1828–82).

CARPACCIO
Triumph of Saint George
1502–8

The Christian tale of the Four Horsemen of the Apocalypse has also been portrayed by very diverse hands. The most famous depiction, a series of woodcuts entitled *Apocalypse*, was produced in 1498 by Albrecht Dürer (1471–1528). This was the first book to be created by one artist: Dürer illustrated, printed, and published the book—only the text was not his own work. *Apocalypse* vividly shows the four horsemen, the

agents of divine wrath, whose avenging horses trample men under their hoofs. The white horse is ridden by the Conqueror, who is crowned by an angel and carries a bow. War, brandishing a sword, rides a red horse. Famine is appropriately seated on a black horse and carries scales, while Death rides a sickly pale horse. William Blake (1757–1827) was also to show *Death on a Pale Horse* in his watercolor drawing of c. 1800.

SLONEM
Savior
1983

PETROV-VODKIN
The Bath of the Red Horse
1912

Many artists have obviously taken great pleasure in creating imaginative and often fantastic portrayals of classical equines, such as the centaur and Pegasus. The brutal, drunken, and lecherous centaur, with the head and torso of a man but the body and legs of a horse, proved a rich visual stimulant for the carvers of the Parthenon friezes (447–432 B.C.) and Sandro Botticelli (1445–1510) alike. Homer (fl. eighth century B.C.) referred to these creatures as "wild beasts."

Not surprisingly, the centaur in art symbolizes man's baser instincts and occasionally it is shown drawing the triumphal chariot of the intoxicated god of fertility, Bacchus.

Pegasus, the soaring winged horse, was said to have sprung from the blood of Medusa at the moment when Perseus beheaded her.

UCCELLO
Saint George and the Dragon
c. 1460

He was ridden by both Perseus and Aurora. The image of the winged horse is not confined to classical mythology, however. We find Buddha riding a flying horse on the walls of the Temple of Yongju in South Korea, while much earlier (c. A.D. 535–556) a winged horse was painted on the walls of a cave in Dunhuang province, China.

YOUNG
The Unicorn
1998

Surely the most beautiful (if apocryphal) horse ever painted is the unicorn. This pure-white horse, with its goat's beard and strange horn, appears in early Mesopotamian art, in the ancient myths of India and China, as well as in the Greek bestiary *The Physiologus*. The unicorn of

legend is a fierce beast that can only be captured and tamed if a virgin maiden is thrown before it. The creature is then suckled by the virgin and passively led to the king's palace. The unicorn's horn has the power to purify whatever it touches and this mythical beast is often painted dipping its horn into a stream. The creature was adopted into Christian iconography as a symbol of female chastity and appears in much art of the medieval period.

The mythic and symbolic use of horse imagery continued right into the twentieth century. Odilon Redon (1840–1916), for instance, produced a series of imaginative paintings on the subject of Pegasus. Likewise, Pablo Picasso (1881–1973) powerfully exploited the potency of the horse as symbol in such works as *Guernica*. However, it is in the latter years of the eighteenth century that we find the image of the horse exploited as a powerful psychological and sexual symbol in Henry Fuseli's unforgettable painting *The Nightmare*.

FUSELI
The Nightmare
1781

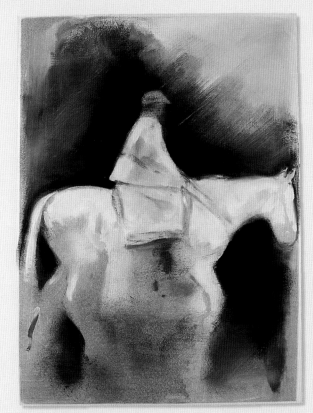

PETROV-VODKIN
The Bath of the Red Horse
1912

The startling color and composition of this painting immediately arrest the viewer and are open to symbolic interpretation. The horse that fills the forefront of the canvas is saturated by a deep, solid red. Was the horse that is being led out of the water once similarly red, but is now cleansed white?

Kuzma Sergeyevich Petrov-Vodkin, 1879–1939

66
And I saw heaven opened, and behold a white horse; and he that sat upon him was called Faithful and True, and in righteousness he doth judge and make war.
99

REVELATION 19: 11

CHADWICK
The White Rider
1999

The ghostly figures of this horse and rider seem to emerge from the background and then dissolve back into it, challenging our perception of the real and the ethereal, the moving and the still.

Gregg Chadwick, b. 1959

CARPACCIO

Triumph of Saint George
Detail
1502–8

This painting forms part of a series relating to the three Dalmatian saints, George, Jerome, and Tryphone, in the Scuola di San Giorgio degli Schiavoni in Venice. The scuola was founded in 1451 to protect the Dalmatian community in Venice, most of whom were sailors. Saint George is the patron saint of the city.

Vittore Carpaccio, c. 1460/5–1523/6

REDON

Apollo's Chariot
1909

The Greek god Apollo's golden chariot was pulled by a team of four horses abreast, known as a quadriga. The embodiment of the cool, classical ideal, Apollo traditionally represents the rational and civilized part of man. Redon shows this by the calm, impassive stance of the rather nineteenth-century-looking figure in the chariot, his demeanor contrasting with the skybound horses.

Odilon Redon, 1840–1916

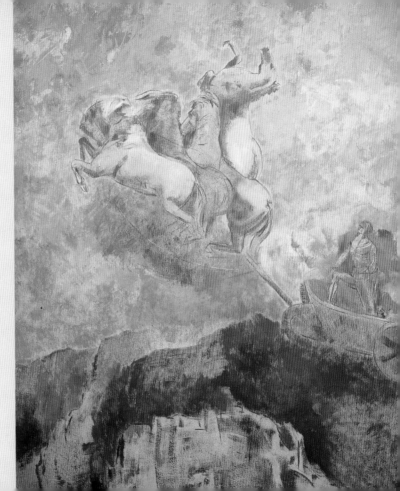

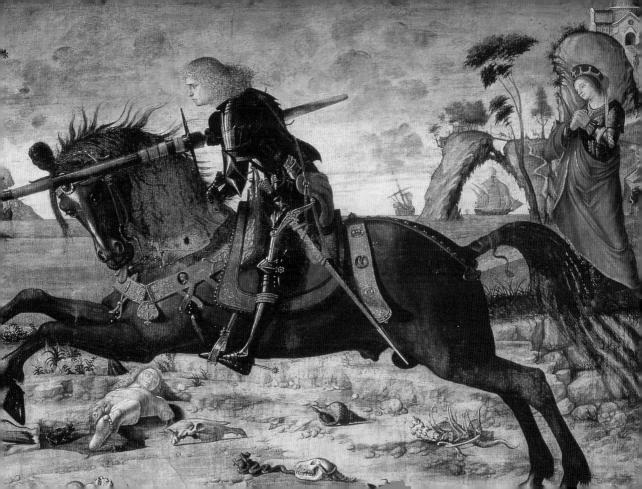

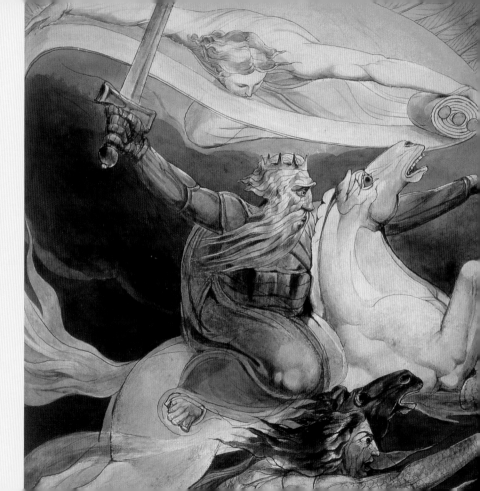

previous pages

CARPACCIO

Saint George Killing the Dragon
1502–8

Naturally the dramatic climax of Carpaccio's cycle *The Triumph of Saint George* is the moment when George slays the dragon. Carpaccio perfectly balances the composition between the charging saint on his horse and the reptile-like dragon.

Vittore Carpaccio, c. 1460/5–1523/6

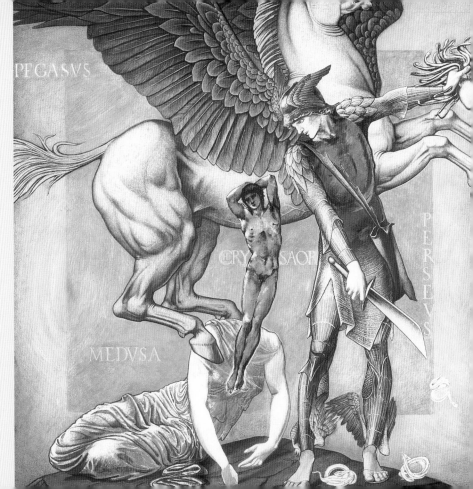

BLAKE

Death on a Pale Horse
c. 1800

The apocalypse legend proved a perfect vehicle for Blake's highly individual and idiosyncratic vision. Death, mounted on a "sickly pale" horse, is shown here followed by Hades, while the figure above unravels the banner of Resurrection.

William Blake, 1757–1827

BURNE-JONES

The Death of Medusa I
c. 1876

One of a series of paintings by this artist on the subject of Perseus. In this gouache the Pre-Raphaelite painter depicts the dramatic moment when Pegasus sprang from the blood of Medusa as Perseus beheaded her.

Sir Edward Burne-Jones, 1833–98

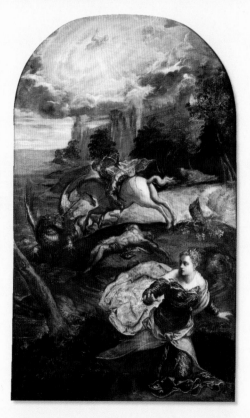

TINTORETTO
Saint George and the Dragon
c. 1550s/1560s

Tintoretto's Saint George contains all the traditional elements of the legend. For Christians, the dragon symbolized evil, and in particular paganism. The slaying of the dragon represents the conversion of a heathen country and is usually shown taking place outside a city, by a seashore. Here, the triumphant George, his white mount a symbol of purity, has rescued the princess from sacrifice to the dragon.

Tintoretto (Jacopo Robusti), 1518–94

UCCELLO
Saint George and the Dragon
c. 1460

One of the most delightful depictions of Saint George slaying the dragon must be this one by Uccello. A surreal air of calm pervades the scene, as the princess gestures toward the tethered and defeated beast while George spears it with precision accuracy. He is usually portrayed wearing the armor of a Roman soldier or, as here, that of a medieval knight.

Paolo Uccello, c. 1396/7–1475

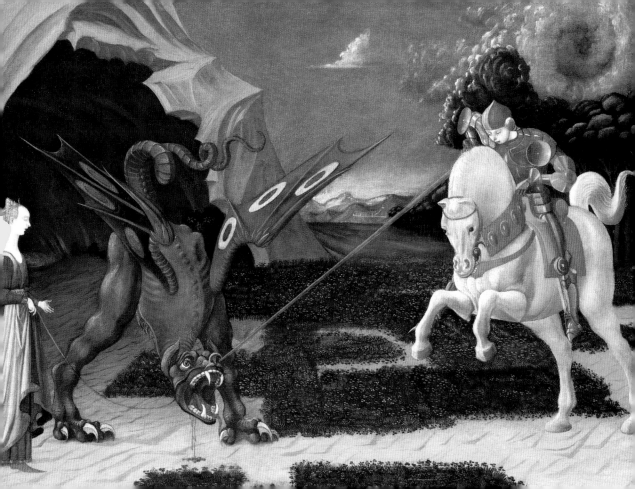

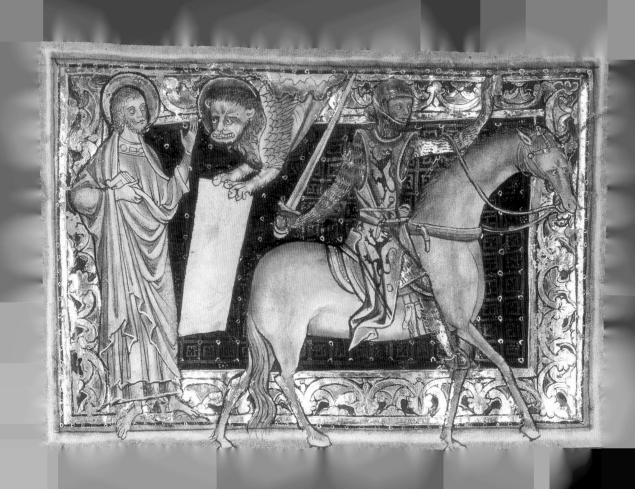

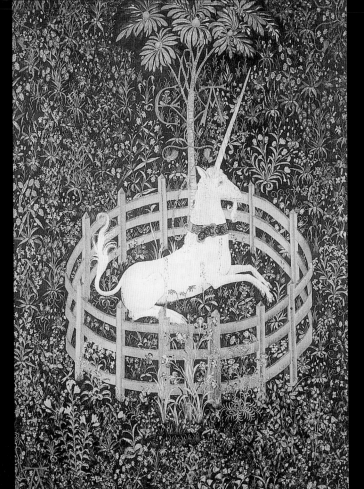

ENGLISH

Horseman of the Apocalypse Riding a Red Horse
c. 1260

This manuscript illustration shows the rider of the red horse who, in apocalypse literature, carries a sword and symbolizes war. The Four Horsemen of the Apocalypse appeared when four of the seven seals were broken on the scroll that contained the secrets of man's destiny.

FRENCH/FLEMISH

Unicorn in Captivity
15th Century

Medieval writers likened the pure-white unicorn to Christ, who raised the horn of salvation for humankind. In this floriferous tapestry the symbolism is reinforced by the bleeding wounds on the body of the creature.

> *And when the rising sun has first breathed*
> *on us with his panting horses, over there the*
> *red evening-star is lighting his late lamps.*

VIRGIL, 70–19 B.C.

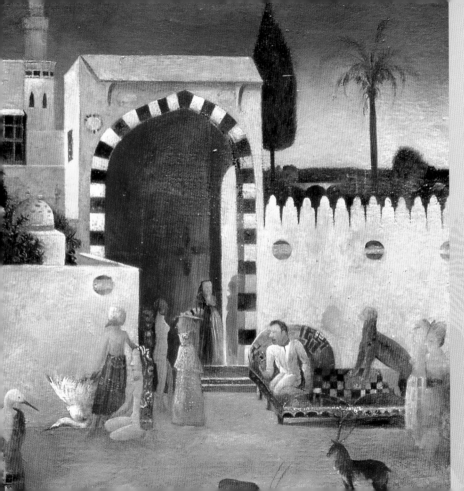

SANCHEZ

A Last Supper 3
1981

One of a series of paintings on biblical subjects that echo medieval depictions of similar themes. Sanchez creates an atmosphere of homage by the inclusion of so many varied types of people and animals.

Stephanie Sanchez, b. 1948

241

FUSELI

The Nightmare
1781

Fuseli reworks the theme of the potent stallion as a powerful sexual symbol in this psychologically charged image. The stallion's head—nostrils flared, eyes burning—bursts through the hanging drapes, leaving little room for doubt in its interpretation.

Henry Fuseli, 1741–1825

CHINESE

Winged Horse
c. A.D. 535–56

The fluid brush strokes that have been used for this cave painting from Dunhuang, China, perfectly express the light and graceful movements of this horse as it magically levitates in midair.

DELACROIX
Ovid Among the Scythians
1855–9

Ovid was banished from
Italy to Tomis, modern-day
Constanza on the Black
Sea, by Augustus in A.D. 8.
Delacroix's inclusion in the
foreground of the mare that
is being milked is derived
from classical statements,
which claimed that the
Scythians fed on mares' milk.

Eugène Delacroix, 1798–1863

OD
Hybrid Two
1996

Inverting the mythical model
of the centaur, Od makes
this bronze figure half-horse,
half-man. Tension is added
by the lasso that the figure
holds. It seems to beg the
question: exactly which half
is in control?

Kira Od, b. 1960

66

O! for a horse with wings!

99

WILLIAM SHAKESPEARE,

1564–1616

YOUNG

Helios

1992

Helios is the Greek sun god, brother of Selene, the moon goddess. Both drive horse-drawn chariots. Just as Helios is finishing his journey across the skies in the evening, Selene is beginning hers.

Sarah Young, b. 1961

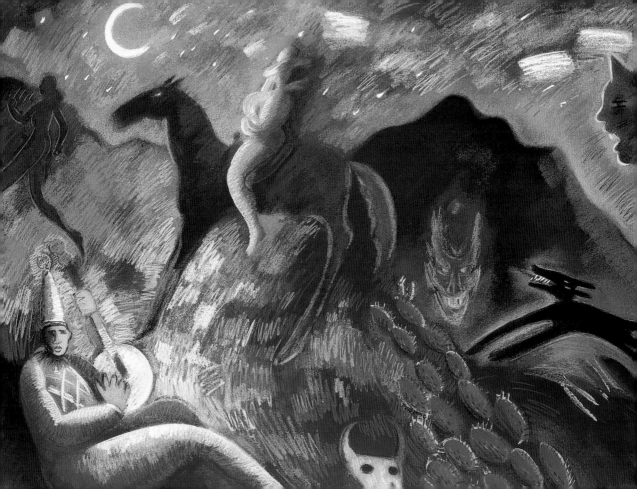

ALMARAZ

Southwest Song

1988

This painting is a nostalgic celebration of the legendary Old West by a city dweller. The pale figure on the dark horse is surrounded by a heady atmosphere of wild dogs, minstrels, fleeing nudes, and menacing masks.

Carlos Almaraz, 1941–89

BILIBIN

Vasilisa the Beautiful

Detail

1902

Horses with fantastic abilities that aid the hero to perform miraculous feats abound in children's literature. Here, a beautiful dappled horse with a straw-colored mane literally flies to the rescue of the maiden in the tower.

Ivan Jakowlewitsch Bilibin, 1876–1942

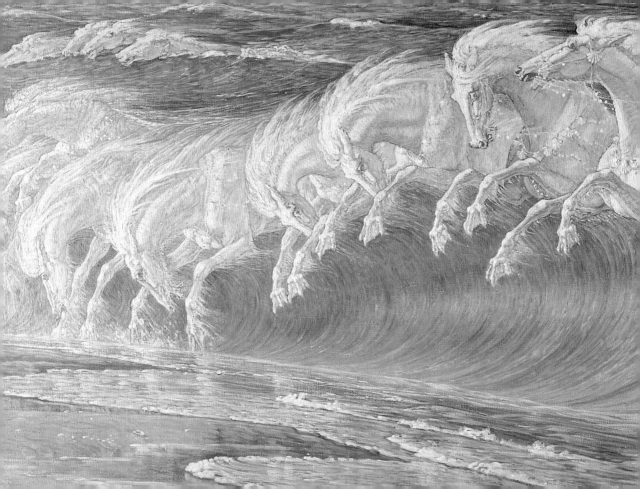

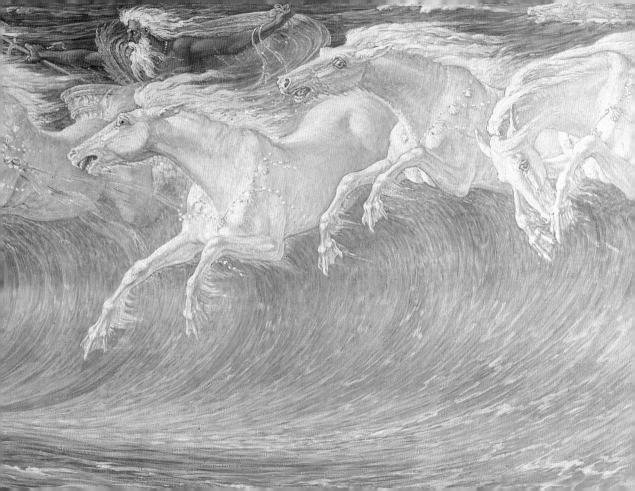

previous pages
CRANE
Neptune's Steeds
1892

There is no doubt that Neptune is the god who rules the sea in this painting, his chariot borne on a foaming wave of white horses. In Greek mythology Neptune's chariot is traditionally drawn by *hippocampi*, or sea horses, whose foreparts are horse and hindparts fish. However, in his version Crane has introduced inventive webbed hoofs and kept the hindparts intact.

Walter Crane, 1845–1915

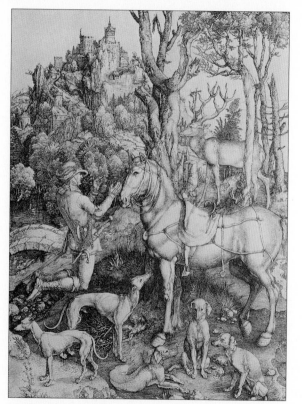

DÜRER
Saint Eustace
c. 1501

The conversion of the Christian martyr Saint Eustace occurred when he was out on his horse hunting. A white stag appeared with a radiant crucifix between its antlers, accompanied by a voice foretelling the many tests of the martyr's faith that lay ahead.

Albrecht Dürer, 1471–1528

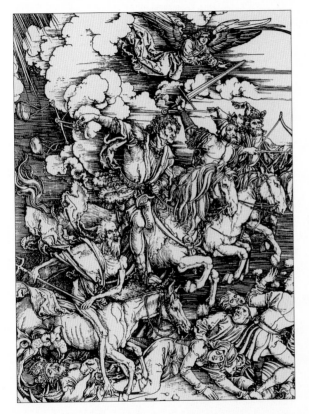

And I looked, and behold a pale horse:

and his name that sat on him was Death,

and Hell followed with him.

REVELATION 6: 8

DÜRER

The Four Horsemen
1498

Perhaps the most terrifying
images of the four avenging
horsemen were those produced
by Dürer for his series of
woodcuts *Apocalypse*. Death,
Famine, War, and the Conqueror
are unstoppable as they advance
on the world.

Albrecht Dürer, 1471–1528

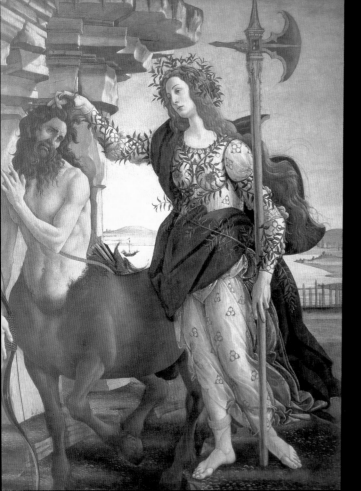

BOTTICELLI
Athene and the Centaur
15th/16th Century

Athene, also known as Minerva, is one of the major deities of ancient Greece and Rome. A symbol of benevolence, she is seen here exerting a civilizing influence on the usually brutal centaur. The origin of the half-man, half-horse centaurs may have been the cowmen of the plains of Thessaly, Greece, the horse-breeding center of antiquity. They tended their herds on horseback and, from afar, may have been mistaken for a strange hybrid creature.

Sandro Botticelli, c. 1445–1510

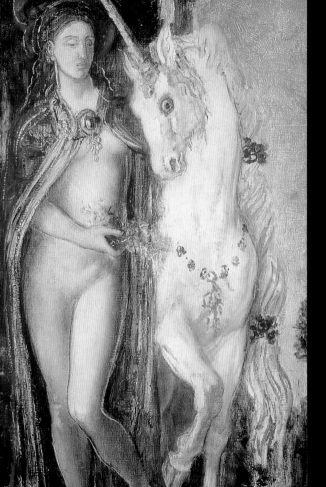

" that unicorn that was so wild

aleyd is of a cheaste;

thou has it itamed and istild

with milke of thy breste. "

WILLIAM OF SHOREHAM?,

EARLY 14TH CENTURY

MOREAU

The Unicorn

1885

Such a beautiful unicorn as this is an appropriate subject for the Symbolist painter Gustave Moreau, who specialized in biblical and mythological fantasies. Here, the unicorn represents female chastity.

Gustave Moreau, 1826–98

YOUNG
The Unicorn
1998

The unicorn sits obediently, its forelegs in the lap of the virgin, in the midst of a peaceful landscape. This illustration forms part of a contemporary alphabet series, proving that the myth of the unicorn remains a potent symbol for modern artists.

Sarah Young, b. 1961

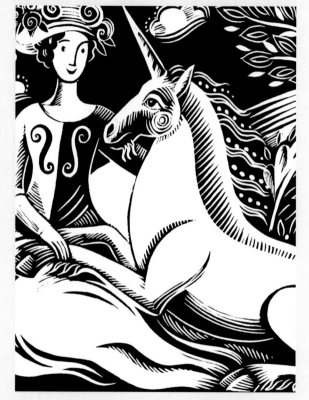

KOREAN
*Buddha on
a Flying Horse*
Undated

In Western art the depiction of a flying horse usually shows the winged Pegasus, but this temple painting from Suwon, South Korea, shows a wingless flying horse as the speedy mount of Buddha.

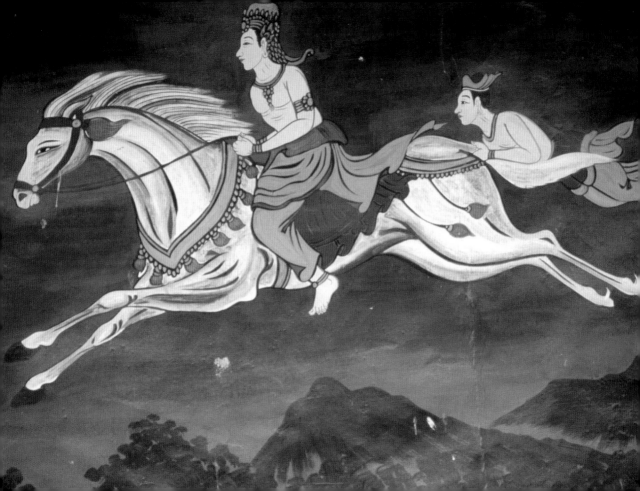

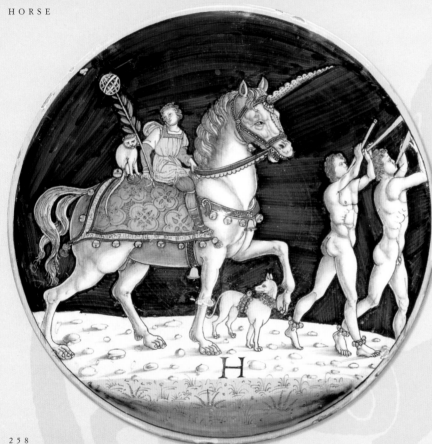

JACOPO DI PIETRO

The Triumph of Caesar
1514

In this triumphal scene, Caesar's mount is primarily a horse in form, yet has finger-like hoofs and a prominent unicorn horn. However, it lacks the goat's beard that is usually associated with this mythical creature. The dish has been fashioned from tin-glazed earthenware.

Attributed to Jacopo di Pietro,
16th Century

SLONEM

Savior
1983

Slonem imbues this white horse with spiritual significance, placing it in front of the faint blue godhead with the all-seeing eyes. The monkeys add an exotic atmosphere, typical of Slonem's work.

Hunt Slonem, b. 1952

> Hast thou given the horse strength? hast thou clothed his neck with thunder?
> Canst thou make him afraid as a grasshopper? the glory of his nostrils is terrible.
> He paweth in the valley and rejoiceth in his strength: he goeth on to meet the armed men.
> He mocketh at fear, and is not affrighted; neither turneth he back from the sword.

JOB 39: 19–22

SCHOONOVAR

Saint Joan
1920

"Forward! They are ours!" is the cry of Joan of Arc as she leads on her advancing army. In a picture full of clashing diagonals and horizontals, Schoonovar creates a dynamic sense of tension, as the maiden saint seems poised between restraining her eager troops and releasing their tremendous rush forward.

Frank Schoonovar, 1877–1972

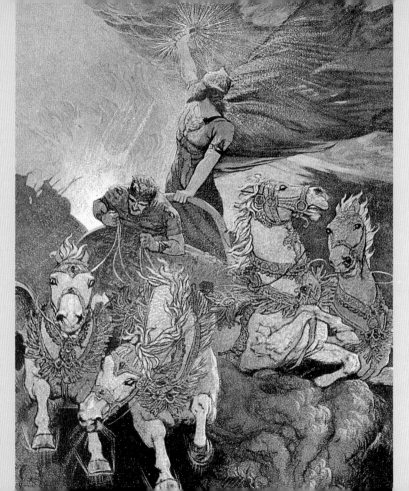

WALLCOUSINS

Merodach Sets Forth to Attack Namat
20th Century

This illustration showing Merodach's chariot drawn by four charging white horses is taken from a series of myths and legends entitled *Myths of Babylon* by Donald MacKensie.

Charles Ernest Wallcousins, d. 1976

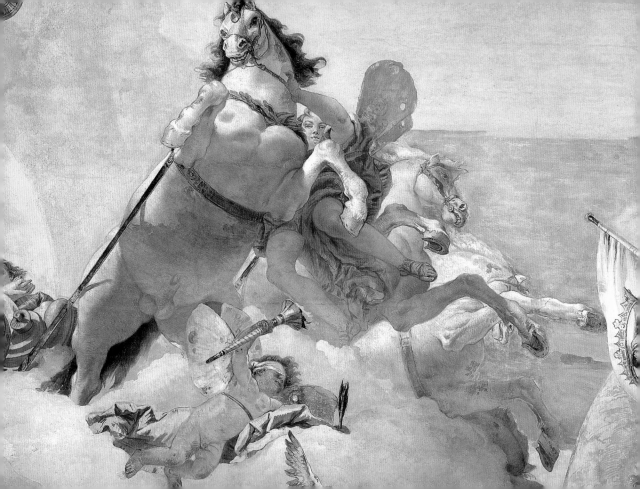

TIEPOLO
The Sun Chariot's Steed
c. 1758

Tiepolo displays all his virtuosity in this detail from his dramatic ceiling fresco. The chariot-bearing horses tower above us as they emerge from diaphanous clouds in a swirling confusion of *putti* and doves. The fresco is an allegory of the wedding of Lodovico Rezzonico and Faustina Savorgnan, in which Apollo delivers the bridegroom to the bride in his sun chariot.

Giovanni Battista Tiepolo, 1696–1770

FRENCH
Andromeda Rescued from the Monster by Perseus
c. 1410/20

Perseus rides the winged horse Pegasus as he rescues Andromeda. Although it is a Greek myth, this fifteenth-century version in a manuscript by Christine de Pisan (c. 1364–1430) is very much set in the medieval period, with both Perseus and Pegasus sporting the typical armor of a chivalric knight and his mount.

from left to right

THE CHARIOT
Cary Yale Visconti

THE CHARIOT
Visconti Sforza Tarot

THE CHARIOT
Medieval Scapini Tarot

THE CHARIOT
Tarot of Marseilles

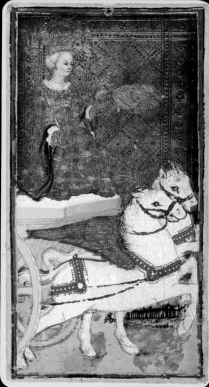

VII

LE CHARIOT

In these four versions of the chariot tarot card we see the symbolic pictorial use of a horse-drawn chariot. A king or queen carrying a scepter in his or her right hand drives an ornate chariot drawn by two horses. The horses pull in opposite directions and symbolically represent good and evil. The tarot originally began as a game of images in the northern courts of Renaissance Europe. The chariot is one of the major arcana cards in the tarot pack.

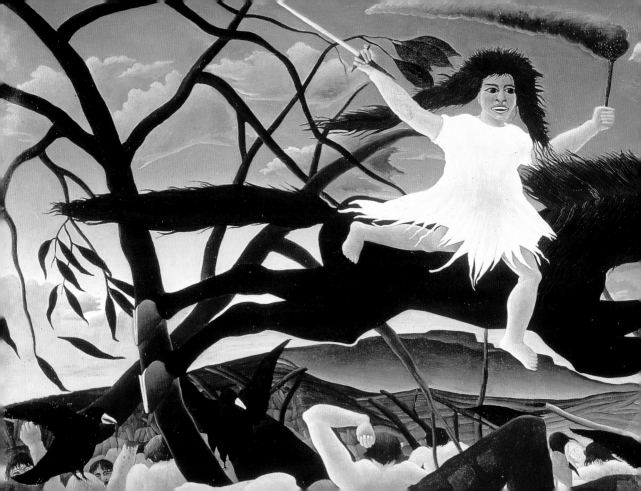

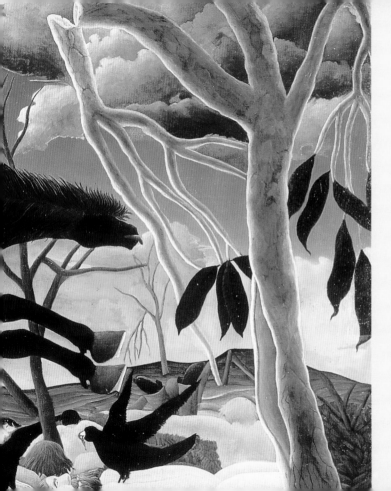

> 66
>
> Today art is moving in a direction of
> which our fathers would never even have
> dreamed. We stand before the new
> pictures as in a dream and we hear the
> apocalyptic horsemen in the air.
>
> 99

FRANZ MARC, 1880–1916`

ROUSSEAU
War
1884

This painting is also known as *The Cavalcade of Discord
(She) Sweeps Past Spreading Terror, Despair, Tears, and
Ruin*. Though ostensibly a comment on the horror
of war, it also comments in part on a less universal
theme. The man on the right, his eye picked out by
a raven, is said to be a portrait of the husband of
Rousseau's mistress!

Henri Rousseau, 1844–1910

WALLCOUSINS

Ride of the Valkyries

1920

This illustration shows the fearsome Valkyries advancing on horseback, something not easily achievable on stage. Richard Wagner's opera *Der Ring* consists of four works, of which *Die Walküre* (1856) forms the second part.

Charles Ernest Wallcousins, d. 1976

BYAM SHAW

Brunhilde Gives Herself to the Flames

1908

A dramatic moment from Wagner's *Die Walküre* as Brunhilde rides into the flames. Influenced by the Pre-Raphaelites, Byam Shaw painted literary and historical subjects that display a strong feeling for the narrative.

John Liston Byam Shaw, 1872–1919

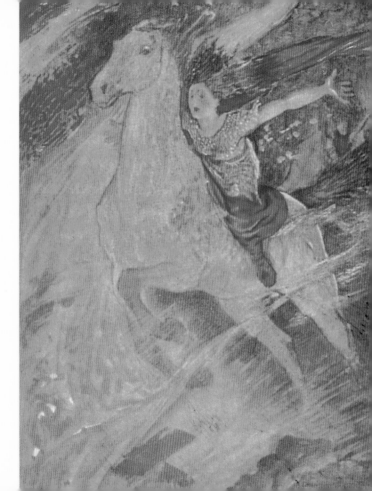

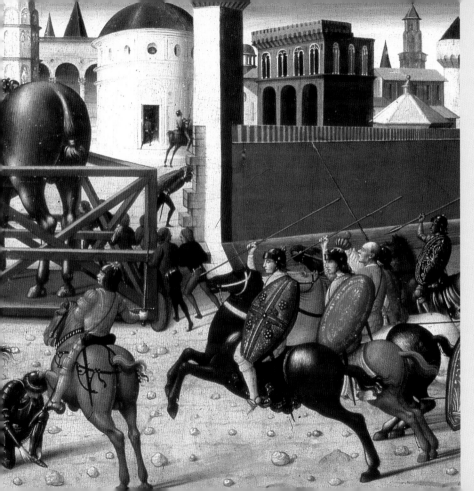

ANTONIO DI BIAGIO
The Siege of Troy II:
The Wooden Horse
Detail
c. 1490–5

This panel painting shows one of the most famous incidents of the legendary Trojan War (thirteenth century B.C.). Built by the master carpenter Epeius, the giant hollow horse was presented to the Trojans as an offering to Athena. Once the horse had been taken inside the city walls of Troy, the Greek soldiers hidden within emerged by night and opened the city gates to their fellow warriors, who then took the city.

Antonio di Biagio, fl. 1446–1516

RAPHAEL

Saint George and the Dragon
1501

The wonderful realism of the
horse and rider rendered by
Raphael's masterly draftsmanship,
contrasts with the hybrid
creature. This dragon is an
amalgam of beasts: clawed feet,
reptilian body and tail, webbed
wings, and a strangely small head.

Raphael (Raffaello Sanzio), 1483–1520

> **"**
> Saint George, that swinged
> the dragon, and e'er since
> Sits on his horse back at
> mine hostess' door.
> **"**

WILLIAM SHAKESPEARE, 1564–1616

FORD
Bellerophon
Fights the Chimera
19th Century

Not only Perseus but also
Bellerophon and Aurora rode
the winged Pegasus. Here,
Bellerophon slays the fearful
Chimera, the fire-breathing beast
with the head of a lion, the body
of a goat, and the tail of a dragon.

Henry Justice Ford, 1860–1941

HORSEPOWER

> ❝
> I was always well mounted. I am fond of a horse,
> and always piqued myself on having the fastest trotter
> in the Province. I have made no great progress in the
> world. I feel double, therefore, the pleasure of not
> being surpassed on the road.
> ❞
>
> THOMAS CHANDLER HALIBURTON, 1796–1865

**JOHN FREDERICK
HERRING, SENIOR**
*Arabs Chasing a Loose Arab
Horse in an Eastern Landscape*
19th Century

THE DEPLOYMENT OF THE POWER OF THE EQUESTRIAN PORTRAIT TO ELEVATE THE SITTER WAS NOT THE SOLE PRESERVE of military leaders. From Indian princes to European monarchs, many of the great and good have exploited the potent attributes of the horse when portraying

INDIAN
Prince on a Brown Horse
18th Century

their status. This extends to portraits of women and children where, by association, the mounted figure projects an image of confidence and ease and is seen to be fully in control of the horse. Our image of the doomed king Charles I (1600–49) is the statuesque figure familiar from Sir Anthony Van Dyck's portraits, most of which show Charles astride a horse. These wonderful images of divine kingship skillfully disguise the real nature of the stammering and weakly Stuart monarch.

The need for visual displays of status, among both the aristocracy and the emerging class of wealthy landowning industrialists in eighteenth-century Britain, produced a new genre of equestrian portrait. These were portraits of the

INDIAN
Indian Prince on Horseback
c. 1775

patron, his wife, family, estate, horse, and dog. George Stubbs's painting *The Milbanke and Melbourne Families* conforms to this type. The conspicuous inclusion of the horses and carriage contributes to the display of stolid wealth. Stubbs's wife, Mary, said of his work, "Every object in the picture was a portrait." Similarly, the type of painting that simply shows the thoroughbred horse, often with its groom, is a display of pedigree and breeding, of selection and refinement. All these images indirectly reflect and allude to the position and lineage of the patron.

The Arabian horses of the East have long been recognized as the finest, both in terms of performance and appearance. Already developed in Arabia by the seventh century, their characteristics are a small head, pronounced eyes, and wide nostrils; gray is the most common color. The first recorded Arabian horse to be imported into Britain was in 1121, followed by regular imports

SLONEM
Beyond the Rocks
1996–7

of Turkish and Barbary horses. Such horses were prized in the West for their long, graceful legs, which made them much speedier than their stocky northern equivalents.

Today, the most famous stud farm is in Najd, Saudi Arabia, although many fine farms exist throughout the United States. In

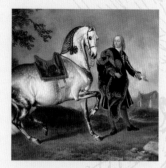

HAMILTON AND **BRAND**
The Dappled Horse
"Scarramuie" en Piaffe
18th Century

1788 the powerful and long-bodied thoroughbred stallion Messenger was imported into the United States from Britain, and the modern-day American standardbred—one of the best harness racers, which excels at pace and trot—can be traced back to Messenger. Naturally, though, the horse that says the most about its owner in a painting is one of obvious Arab descent.

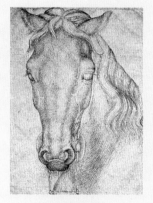

PISANELLO
Study of Neck and Head
of a Bridled Horse
c. 1430–40

In 1808 the first volume of *The Stud Book* was published. This lists in detail the pedigree of a thoroughbred horse. All modern-day racehorses and thoroughbreds cited in this book are descended from

just three Arabian stallions, the Byerley Turk, the Darley Arabian, and the Godolphin Arabian (also known as the Godolphin Barb), and from the forty-three so-called "Royal Mares," imported into Britain during the reigns of James I (1566–1625) and Charles I (1625–49). *The American Stud Book* was started shortly afterward, in 1897.

The equestrian world's fascination with the Arabian horse found a parallel in the Romantic Movement, with its portrayal of a faroff exotic Orient. Artists such as Eugène Delacroix (1798–1863), who was influenced by a visit to North Africa in 1832, produced numerous potent images of Arabs and their horses. These are dynamic paintings that present a heady mix of beauty, implied virility, and untamed strength. The rearing, excited animals that feature in these pictures are of the same lineage as the fine pedigree horses that George Stubbs (1724–1806) painted at rest in English pastures.

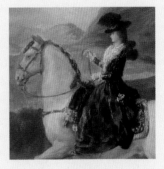

GOYA
*Portrait of Maria Teresa
de Vallabriga on Horseback*
1783

> 66
> Once more upon the waters! yet once more!
> And the waves bound beneath me as a steed
> that knows his rider.
> 99

GEORGE GORDON, LORD BYRON, 1788–1824

EGYPTIAN
Four Horses
14th Century B.C.

This perfectly matched team of four horses
would be a symbolic sign of wealth and status
as they pulled the chariot of a pharaoh. The
sculptor of the relief has shown great subtlety
in the way the rhythmic movement of the four
is suggested by the repeated poses.

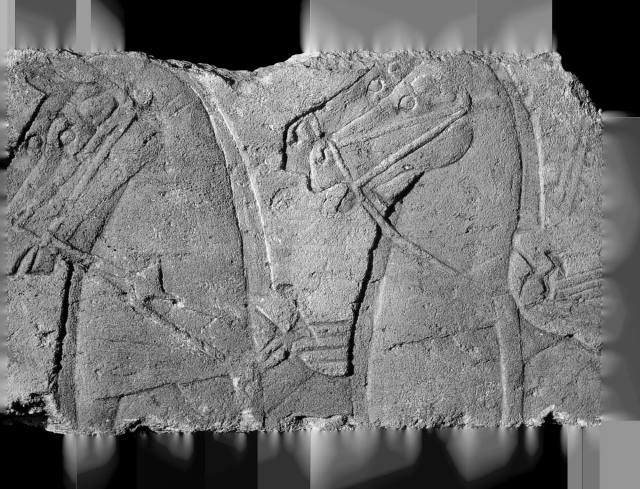

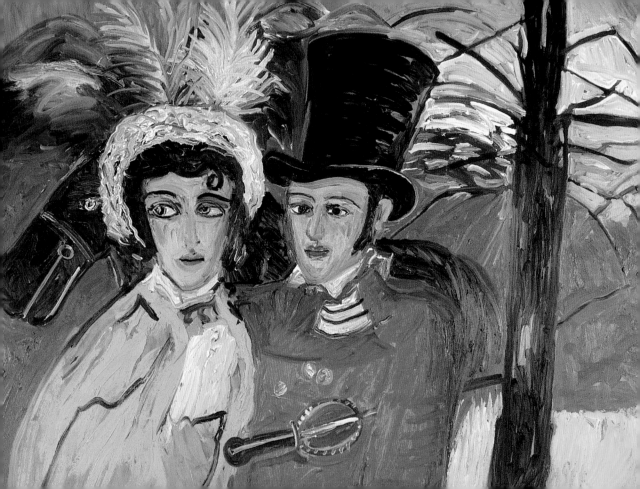

England is the
paradise of women,
the purgatory of
men, and the hell
of horses.

JOHN FLORIO, C. 1533–1625

SLONEM

Beyond the Rocks

1996–7

A contemporary reworking,
in mural form, of the classic
eighteenth- and nineteenth-
century portrait painting. It is
intent on displaying status and
social standing, complete with the
ubiquitous thoroughbred horse.

Hunt Slonem, b. 1952

ENGLISH

Untitled

19th Century

A witty cartoon derived from
Punch magazine—never have a
horse and its rider presented quite
so elegant a rear view as this!

DELACROIX
An Arab with His Horse
1855

Delacroix visited North Africa in 1832 and this painting shows the fusion of his fascination with the exotic and his interest in painting animals. This interest was due in part to the influence of fellow French artist Théodore Géricault (1791–1824).

Eugène Delacroix, 1798–1863

POLLARD
*Hunters on Their Way
to the Hunting Stables*
1829

These impeccable huntsmen and their freshly groomed hunters (complete with docked tails and monogrammed blankets) project an image of aristocratic power as they stop at this humble wayside inn for a "cup of cheer."

James Pollard, 1792–1867

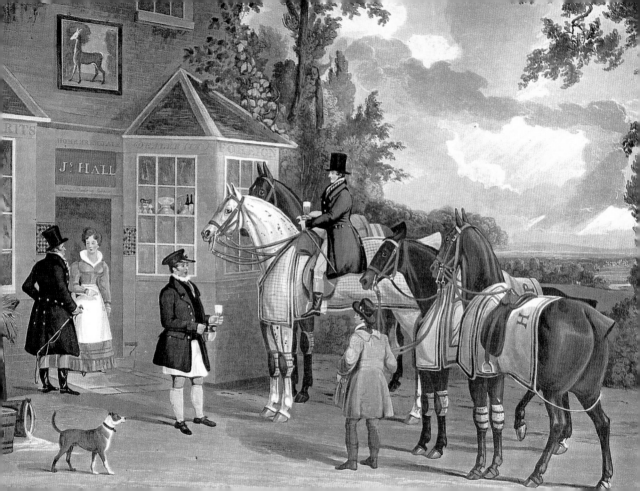

INDIAN

Prince on a Brown Horse
18th Century

Using the same visual devices as
the Western equestrian portrait,
these Indian paintings of princes
(here and opposite) present
images of nobility and rank.
Both horses have all the classic
attributes of the thoroughbred:
the small head, wide nostrils,
and short back.

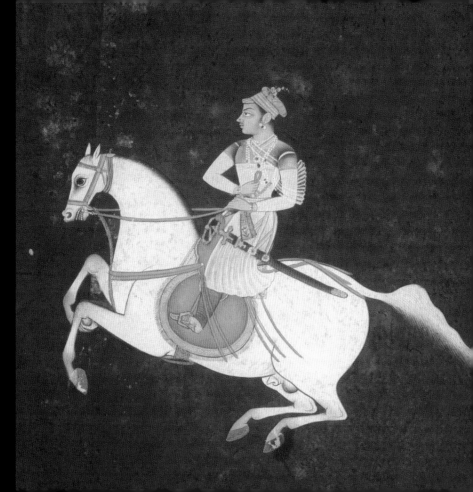

INDIAN

Indian Prince on Horseback

c. 1775

This painting originates from
Bundi in Rajasthan, northern India.
So light and elegant is this
thoroughbred horse that it
appears to fly through the air
with the utmost grace.

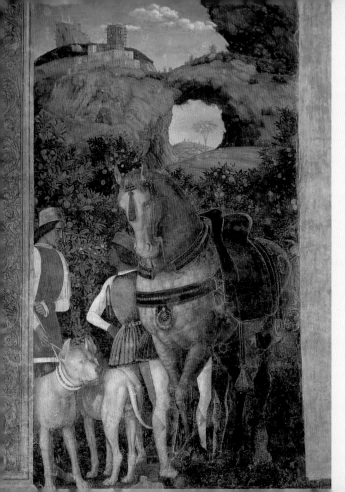

MANTEGNA

*Meeting between Lodovico Gonzaga
and His Son Cardinal Francesco*
Detail
1474

Mantegna painted a series of frescoes, the *Camera
degli Sposi*, as a memorial to the Gonzaga family
in Mantua. This detail shows the servants with a
horse and dogs of obviously distinguished lineage.
They would have been included in the scene as
an expression of the family's status and wealth.

Andrea Mantegna, c. 1431–1506

MARTINI

Portrait of Guidoriccio da Fogliano
Detail
1328

Martini painted this fresco portrait of the
mercenary soldier Guidoriccio da Fogliano for the
town hall at Siena. The patterning of Guidoriccio's
robes extends over the body of the horse, so that
both appear as one powerful, unified mass.

Simone Martini, c. 1284–1344

HAMILTON AND BRAND

The Dappled Horse "Scarramuie" en Piaffe
18th Century

A stark contrast is apparent in this painting, in which the immaculate Scarramuie and his groom sit uneasily beside the semiderelict dwelling in the background. Both the horse blanket held by the groom and the right rear flank of the horse bear the owner's insignia. *En piaffe* is a dressage term, from *piaffer,* meaning to stamp or paw the ground.

Johann Georg Hamilton, 1672–1737,
and J.C. Brand, 1722–95

ROMNEY

Portrait of John Walter Tempest
18th Century

Though he longed to paint large classical subjects in the grand style, it was as a portrait painter that Romney made his living. Here, he has posed the young Tempest in a relaxed manner standing by the side of his grazing horse. Though this strikes a note of informality, the status of the sitter is never in any doubt.

George Romney, 1734–1802

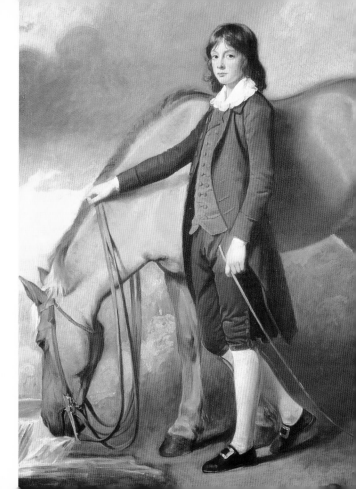

ENGLISH
Untitled
19th Century

This cartoon from *Punch* pokes gentle fun at
these genteel ladies, in their search for public
status and fashionable display. To make heads
turn as their horse-drawn sleigh rides by, they
have had the horse painted with dots to match
the traveling rug!

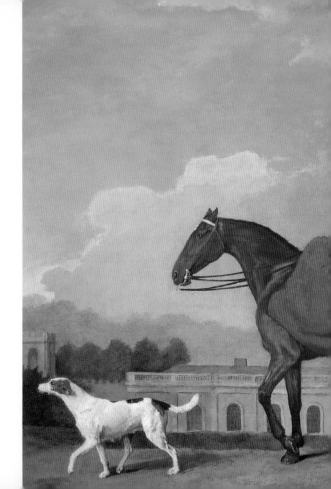

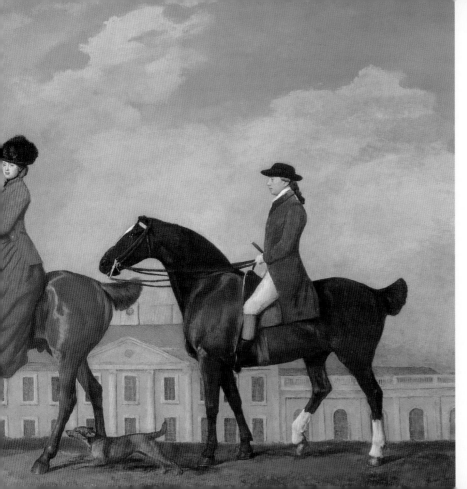

STUBBS

*John and Sophia Musters
Riding at Colwick Hall*
1777

A wonderful example of the classic eighteenth-century English genre picture of a man of status with his wife, house, estate, horses, and dogs. At a time when large fortunes were to be made from expanding industrialization, the nouveau riche of the period adopted the established modes of the aristocracy to display their social standing.

George Stubbs, 1724–1806

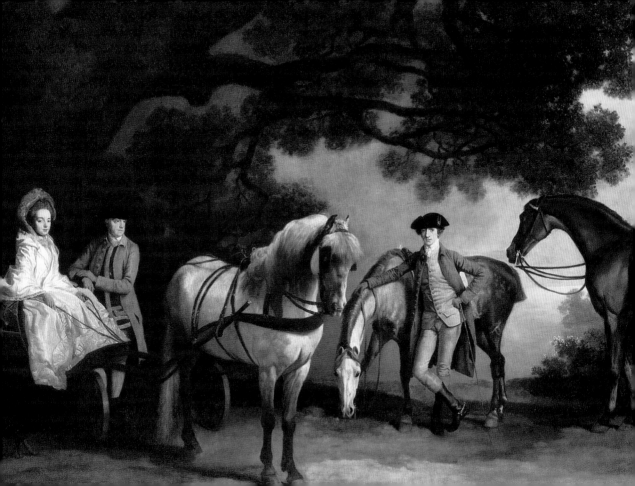

STUBBS

*The Milbanke and
Melbourne Families*
c. 1769

In this group family portrait
Elizabeth Milbanke rides in a
carriage called a timwhiskey,
as she is probably pregnant.
Note the contrast in the type of
horse used to pull the carriage
and those ridden by the men.

George Stubbs, 1724–1806

GENTILE DA FABRIANO

*The Adoration
of the Kings*
Detail
1423

Here, the artist depicts an elegant
scene of courtly display and finery
in which the horses mingle in an
eclectic crowd of men, dogs,
leopards, and monkeys.

Gentile da Fabriano, c. 1370–1427

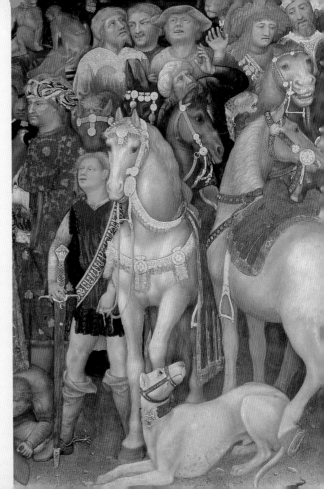

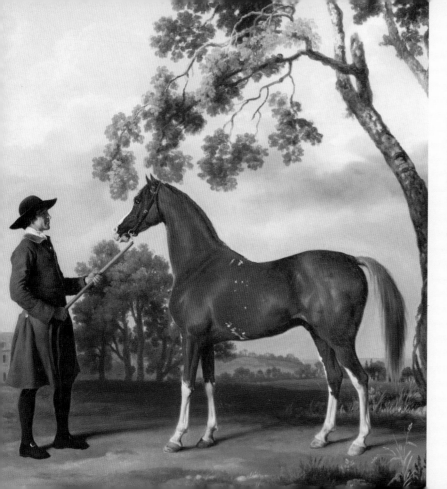

STUBBS

*Lord Grosvenor's
Arabian with a Groom*
c. 1765

Stubbs often included an attendant groom in his portraits of individual thoroughbreds and racehorses. Though little can be seen of the groom's features in this painting, the relationship of the man to the horse animates the scene, making him more than a mere bystander.

George Stubbs, 1724–1806

TOWNE

*A Palomino Frightened by an
Approaching Storm with a Spaniel*
1814

Thoroughbreds are renowned for their intelligence as well as their temperament, and Towne shows this one in a state of high excitement. Both horse and dog are startled by the breaking tree branch and the ominous-looking sky.

Charles Towne, 1763–1840

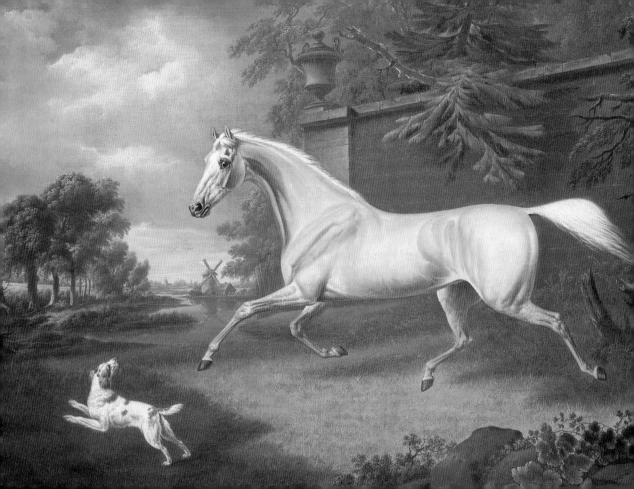

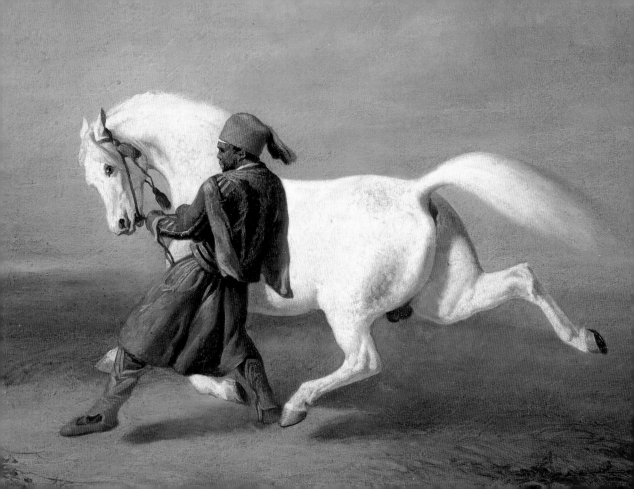

DREUX
The Pasha's Pride
19th Century

The pride and joy of a high-ranking Turkish official, this Arab stallion would have provided an effective display of the pasha's status, wealth, and power. The angle from which the horse has been painted also serves to advertise his potential breeding prowess.

Alfred de Dreux, 1810–60

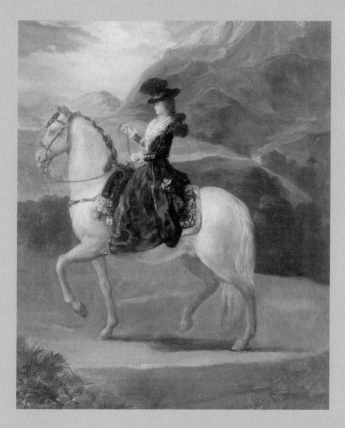

GOYA
Portrait of Maria Teresa de Vallabriga on Horseback
1783

Does this portrait show the horse as fashion victim? The coat of the crimped and preened equine contrasts perfectly with the blue of Maria Teresa's dress, making it the ultimate accessory!

Francisco de Goya, 1746–1828

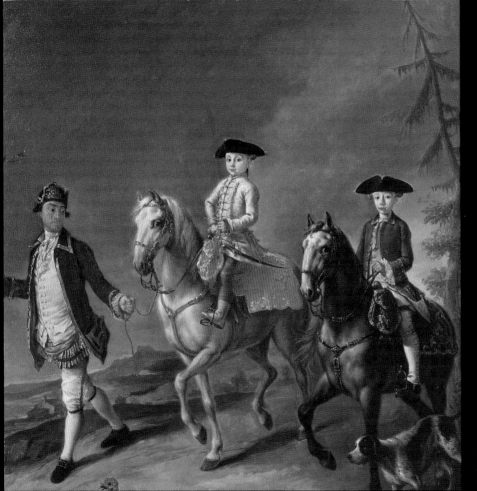

LONGHI
Horse Ride
1751

By the haughty expression on their faces it is apparent that these young boys obviously feel elevated to the position of princes as they trot along on their ponies. Longhi painted scenes of everyday life in his native Venice and these are most probably the sons of wealthy merchants.

Pietro Longhi, 1702–85

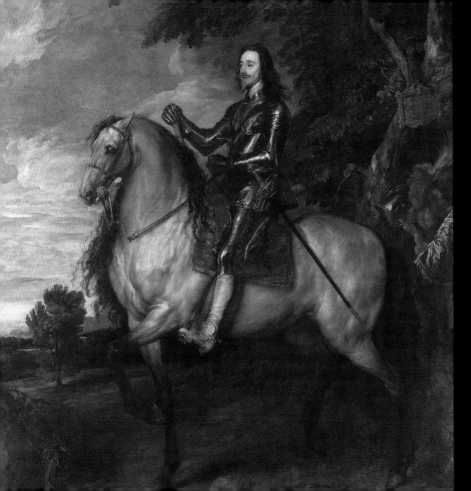

VAN DYCK

*Equestrian Portrait
of Charles I*
c. 1638

Van Dyck spent the last nine years of his life in England and produced twenty paintings of Charles I (1600–49), many of them equestrian portraits. These handsome propagandist images project the diminutive king as a statuesque figure, seated astride his horse, so that we must metaphorically and literally "look up to him." For his services Van Dyck was rewarded with a knighthood.

Sir Anthony Van Dyck, 1599–1641

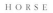

VELÁZQUEZ
Philip III on Horseback
1631–6

One of several equestrian portraits of Philip III of Spain (1578–1621), which—along with Velázquez's celebrated *Surrender of Breda*—formed a series of victory pictures. Here, the choice of colors, pose, and costume seems to express joyous celebration rather than kingly status.

Diego Rodriguez de Silva y Velázquez, 1599–1660

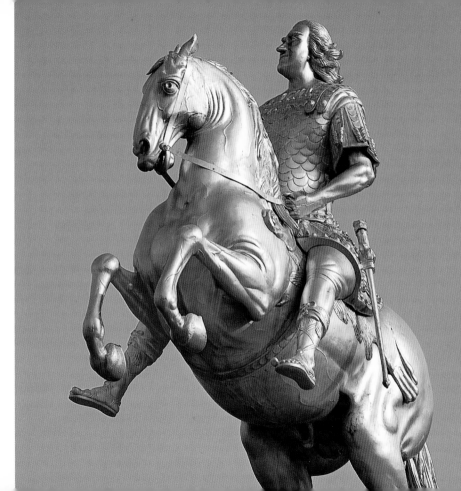

WIEDEMANN
Golden Rider
1736

Inspired by Bernini's statue of Louis XIV, Wiedemann produced this equestrian statue of Augustus II of Poland (1670–1733), elector of Saxony, from a *maquette*, or clay model, produced by Jean-Joseph Vinache (1696–1754) around 1730. It embodies all the regal power and authority associated with such statues, as Augustus towers above all spectators, silhouetted against the sky.

Ludwig Wiedemann, 18th Century

KNECHTEL

A Venetian Horse

1997

This late-twentieth-century pastel
study shows that the beauty and
power of the horse are a potent
and engaging subject for this
contemporary American artist.

Tom Knechtel, b. 1952

COOPER

*Two Bedouin with a Bay Arab
Stallion in the Desert*

1860

Here, Cooper has used the
convention of the eighteenth-
century English horse portrait and
has transported it to the Arabian
desert, with exotic palm trees
replacing a shade-giving oak.

Abraham Cooper, 1787–1868

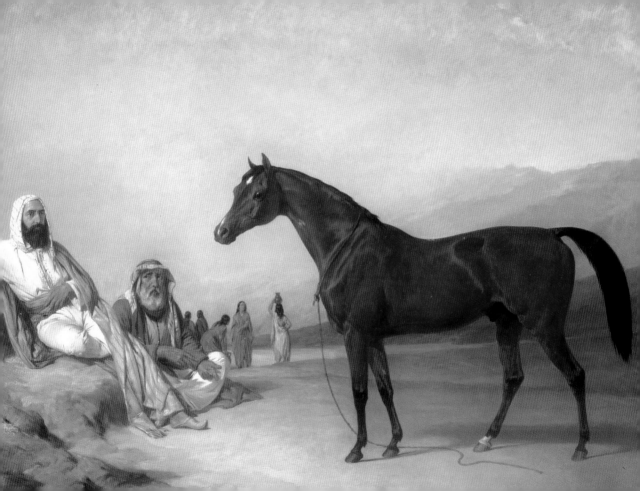

QUIGLEY
The Godolphin Arabian
18th Century

This rather naive painting is of the Godolphin Arabian stallion, which was imported to England in around 1730. Along with the Darley Arabian and the Byerley Turk, this horse was the progenitor of all modern-day thoroughbreds cited in *The Stud Book*.

Daniel Quigley, fl. 1750–78

LEECH
Mr. Bragg's Equestrian Portrait
1852

Considerable artifice has been employed by artists when painting animals. An amusing example is satirized in this delightful picture of Mr. Bragg posing for his equestrian portrait, taken from *Mr. Sponge's Sporting Tour*.

John Leech, 1817–64

COLEMAN
Two Horses
1990

In the two views of the horse presented in this painting Coleman explores varying ways to present horsepower. On the right, an art-historical reference to Théodore Géricault is made in the expressive handling of the medium. The left-hand view is a contemporary photorealistic image of a thoroughbred.

Brad Coleman, b. 1961

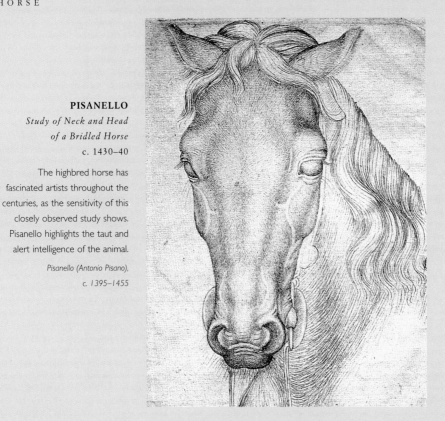

PISANELLO
*Study of Neck and Head
of a Bridled Horse*
c. 1430–40

The highbred horse has fascinated artists throughout the centuries, as the sensitivity of this closely observed study shows. Pisanello highlights the taut and alert intelligence of the animal.

*Pisanello (Antonio Pisano),
c. 1395–1455*

WARD
White Stallion
19th Century

Ward uses thick impasto paint applied in expressive lines across the stallion's coat, mane, and tail to create a sense of life pulsating through the animal's body. As the wind lifts the mane from the forehead, the profile of the horse is reminiscent of the mythical unicorn.

James Ward, 1769–1859

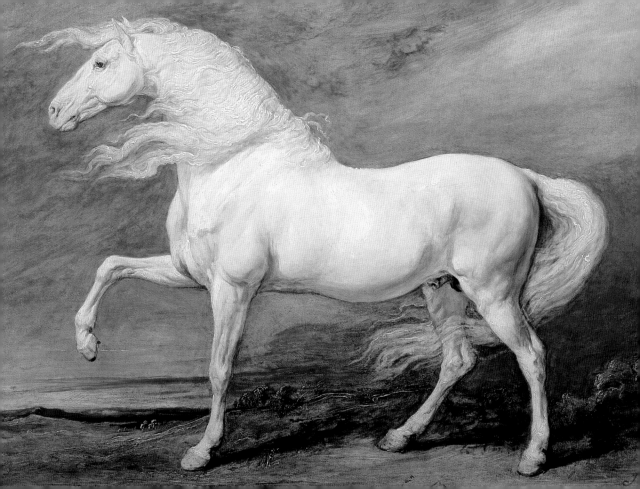

> 66
> The best carriage horses are those which can most steadily
> hold back against the coach as it trundles down the hill.
> 99

ANTHONY TROLLOPE, 1815–82

PENFIELD
Horse and Trap
1900

A finely turned-out horse and trap affords
this driver, his passenger, and dog an
opportunity for conspicuous display. All
eyes must turn as they enjoy a brisk trot
through town. This image was produced
by Penfield for a poster advertising the
New York City store Heller and Bachrach.

Edward Penfield, 1866–1925

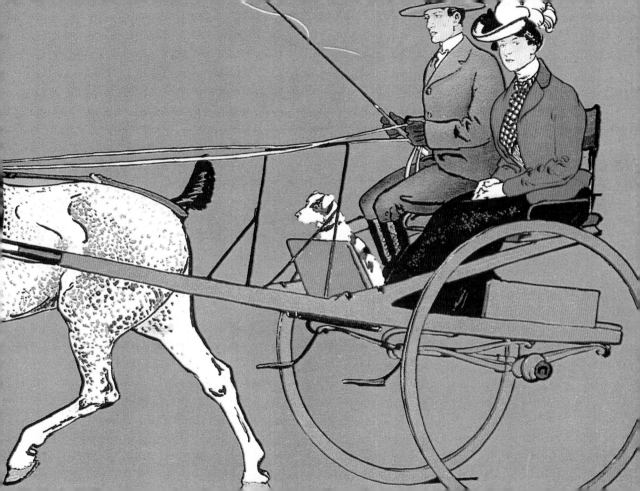

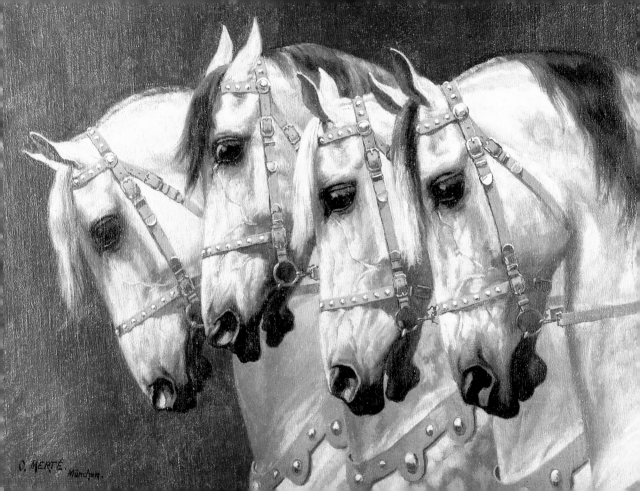

O. MERTÉ. München.

PERFORMING HORSES

"

A good rider may often be thrown from his horse,
And climb on once again to face forward his course,
Which is how I went forward myself on my way,
And come, Christ, and give me my true judgment day.

"

TRADITIONAL IRISH POEM, 18TH CENTURY

OSKAR MERTE
Heads of Four Horses
19th/20th Century

A CHINESE EARTHENWARE SCULPTURE, *DANCING HORSE*, DATED A.D. 657, SHOWS US THAT THE GRACE OF THE HORSE has been apparent for a very long time. Artists have often taken playful delight in

YOUNG
Red Horse
1992

illustrating the unexpected elegance and lightness of movement that can be achieved by such a large and weighty animal. There is an apparent incongruity in the performance of these delicate feats of grace by the mighty horse, which reaches its apogee in the art of dressage.

Dressage began in the early part of the sixteenth century and was originally for military use. The most skilled dressage horses are the Lipizzaners from Slovenia, a cross between an Andalusian and a Barb; they were named after a stud farm near Trieste in Italy in 1580. Today they can be seen performing at the Spanish Riding School in Vienna. Usually gray (or very rarely bay), the Lipizzaner is a small, powerful horse with slender legs and long, silky mane and tail.

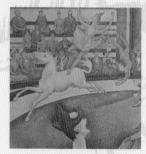

SEURAT
The Circus
1891

Haute école is the most elaborate and specialized form of dressage. The movements, or airs, have names that are as resonant of grace and beauty as any ballet terms: the levande, the croupade, the capriole. In the piaffe the horse seems magically to trot without moving forward, backward, or sideways—instead the impulse is upward. A more robust form of skill is demonstrated by the American quarter horse, which is often used in reining competitions. The horse performs maneuvers called "reining patterns," which involve spins, circles, and sliding stops, all performed at great speed.

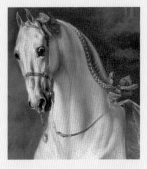

HAMILTON AND **BRAND**
The White Stallion
Leal en Levande
18th Century

Horses often occupy a prominent role in formal and ceremonial processions. *Procession to Celebrate Palio in Siena* by Vicenzo Rustici (1556–1632) shows a mounted parade prior to the *palio*. Several *corsa de palio*—festivals of medieval origin featuring bareback horse races—are held annually in Italian cities. The race at Siena is very famous, dates back to 1482, and involves completing three turns around the Piazza del Campo at breakneck speed.

The winner gains the *palio*, a black-and-gold silk standard. A more sedate use of the horse in modern-day processions can be seen in London on such occasions as the state opening of Parliament and the lord mayor's parade.

Famous Hollywood horse-and-rider double acts include the Lone Ranger and his mount Silver, and Roy Rogers and Trigger.

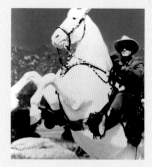

And where would all those classic Wild West movies be without the numerous unsung and unnamed horses that galloped across the screen? The real-life

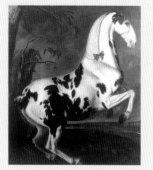

counterparts would have been seen at the first professional rodeo staged in 1882. At the Fourth of July celebrations in Nebraska, Buffalo Bill Cody (1846–1917) arranged contests in shooting, riding, and bronco busting (the bronco being a half-wild horse of the western plains and a buster a cowboy). These events later became known as Cody's Wild West Show.

Thankfully the practice of using live animals for public performance has largely fallen from favor. However, the use of horses (and other animals) in circus and cabaret shows was perfectly acceptable to nineteenth-century sensibilities and featured in the work of artists like Henri de Toulouse-Lautrec (1864–1901) and Georges Seurat (1859–91). In that period both circus and cabaret shows often featured equestrian performances. The modern concept of the "circus" follows a much older precedent, originally being the space where all Roman four-horse races were run. Rome had the largest, the Circus Maximus, which held a staggering 260,000 spectators. What we now recognize as the circus began in 1768, when an English trick rider, Philip Astley, discovered that due to centrifugal force it was fairly easy to stand on a horse's back while it galloped around a circular ring. Today the performing horse that one is most likely to see on stage is a poor parody of the real thing: the two-person pantomime neddy.

SORF
*Romance of
the Red Horse*
1998

They swayed about upon a rocking horse,

And thought it Pegasus.

JOHN KEATS, 1795–1821

ALMARAZ
Night Theater
1982

Almaraz uses the metaphor of the stage to portray the playful madness of Los Angeles, complete with blue prancing pantomime horses and nude riders, as well as palms, smog, and searching helicopters.

Carlos Almaraz, 1941–89

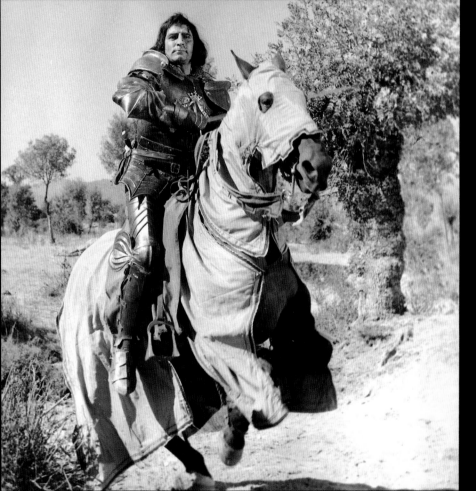

BRITISH

Richard III
1955

Pictured here in one of his most illustrious Shakespearean roles for the big screen is Sir Laurence Olivier (1907–89) as Richard III. This shows the moment when King Richard (1452–85) has narrowly escaped death at the battle of Bosworth in 1485 and has lost his crown. He seizes a second horse and is seen galloping off to fight the Earl of Richmond's advancing army.

66

Giddyap, horsie, to the fair.

What'll we buy when we get there?

A penny apple and a penny pear.

Giddyap, horsie, to the fair.

99

NURSERY RHYME

RIVERA

Carnival de la Mexicana
Detail
c. 1936

The carnival is probably the most popular form of celebratory procession and has lost none of its magic for modern-day participants. This is one of a series of carnival paintings by Rivera, some of which show people sporting horse masks.

Diego Rivera, 1886–1957

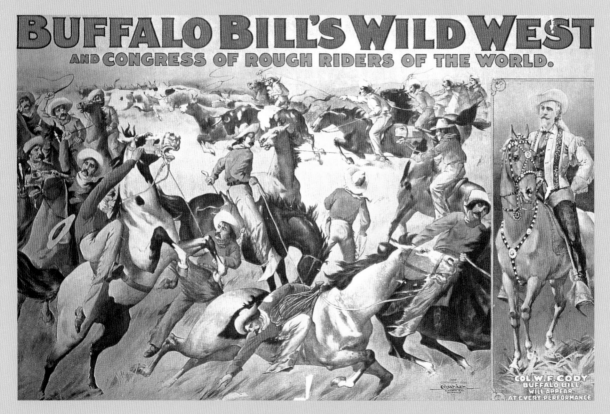

BUFFALO BILL'S WILD WEST
AND CONGRESS OF ROUGH RIDERS OF THE WORLD.

COL. W. F. CODY
BUFFALO BILL
WILL APPEAR
AT EVERY PERFORMANCE

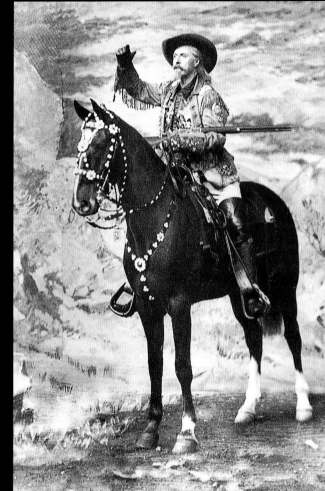

AMERICAN
Buffalo Bill's Wild West
1899

Colonel W.F. Cody (1846–1917) staged the first professional rodeo in 1882. These became known as his hugely popular Wild West Shows, featuring Buffalo Bill and his Congress of Rough Riders. This contemporary poster promises all the excitement and drama of the wild, open plains.

ENGLISH
Buffalo Bill on Horseback
1903

The legendary Buffalo Bill Cody appears here in front of a painted wilderness backdrop during a performance at London's Olympia Stadium. His cool demeanor belies the obvious excitement created once his bronco-busting and rough-rider shows were under way!

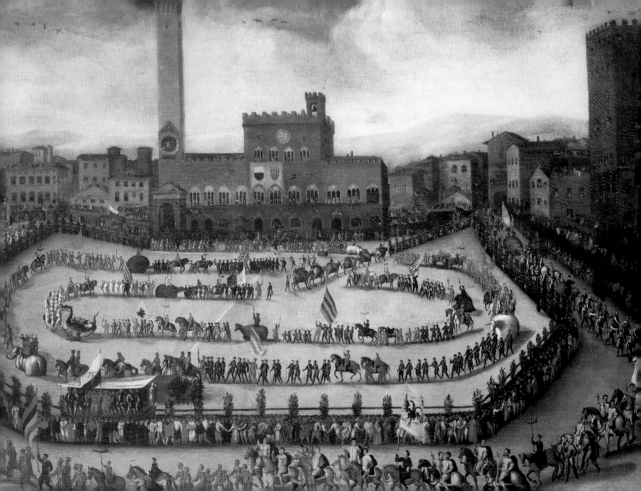

RUSTICI

Procession to Celebrate Palio in Siena

17th Century

This magnificently detailed painting shows the opening procession of the Siena *palio*, which as a civic celebration dates back to 1482. Prior to this, horse racing in the city was first recorded in 1232.

Vicenzo Rustici, 1556–1632

SEURAT

The Circus

1891

Though Seurat often aimed for a static quality in his work, here he chooses a composition full of movement and action. The circus simultaneously contains clowns, acrobats, and a daring trick rider.

Georges Seurat, 1859–91

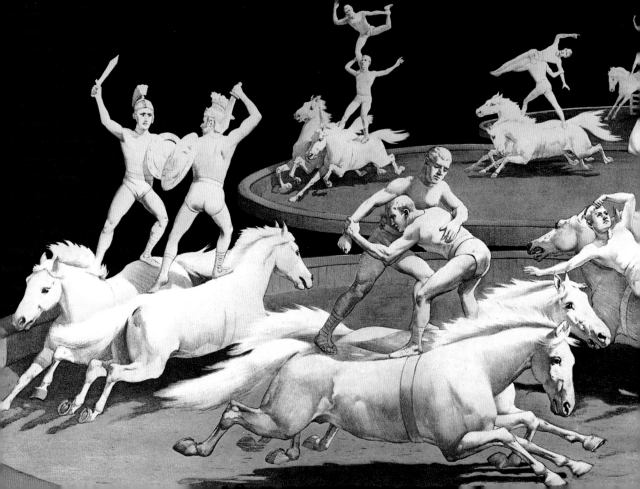

AMERICAN

Circus Poster

1890s

For several decades in the nineteenth century the circus was dominated by equestrian performances. These included trick riding (tricks performed on horseback), liberty horses (exhibitions of riderless horses), and scenic riding (pantomime performances on horseback). This poster advertises a somewhat artistic version of the last!

AMERICAN

Circus Poster

1909

This rather subtle and beautiful poster for Jupiter, the Balloon Horse, advertises an animal act that thankfully would never be performed today. How unexpectedly serene the horse looks as fireworks explode at its feet.

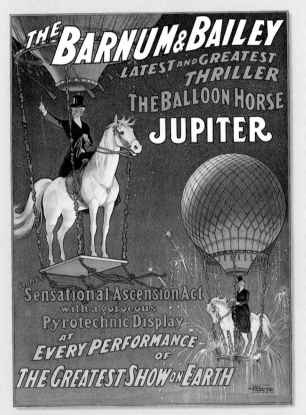

BURKE
Moving Toward Mastery
1997

The southern Californian artist Jonathan Burke employs animals and toys in his work as metaphors for exploring the human condition. The theme of the history of transportation is suggested amid this stagelike setting with its playful toy figures of knights on horseback.

Jonathan Burke, b. 1949

AMERICAN
The Lone Ranger
20th Century

The masked Lone Ranger and his trusted steed Silver were successful stars of the movie and television screens, and formed one of the most famous horse-and-rider double acts of Hollywood.

YOUNG
Red Horse
1992

This delightful horse is a real star! Its playful, coy expression cannot help but evoke a smile in the viewer. The colorful reds and blues of its coat and mane remind us of the carousel horse, so long associated with childhood fairground pleasures.

Sarah Young, b. 1961

CATLIN
Red Indian Horsemanship
19th Century

Displays of horsemanship have never been confined to the circus ring. Here, a group of Native North Americans perform gravity-defying acts that involve slipping down the side of the saddle, enabling the rider to gain a better aim with his bow. This would test the control of horse and rider.

George Catlin, 1796–1872

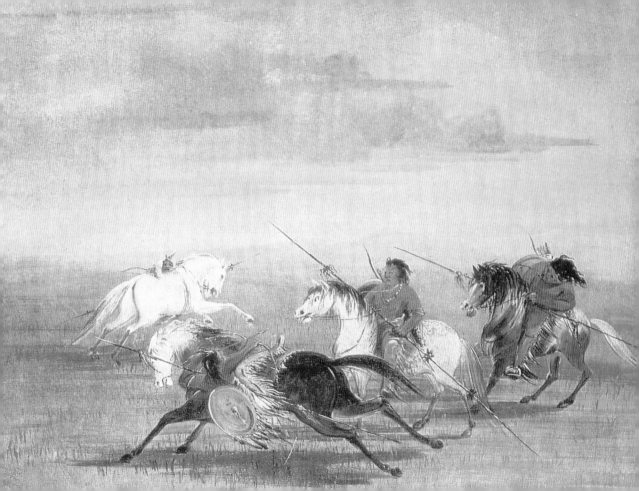

66

A little neglect may breed mischief . . .
for want of a nail, the shoe was lost; for want of a
shoe, the horse was lost; and for want of a horse
the rider was lost.

99

BENJAMIN FRANKLIN, 1706–90

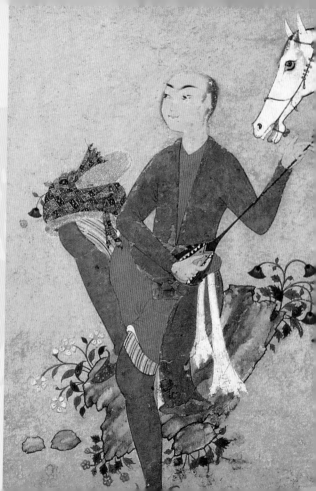

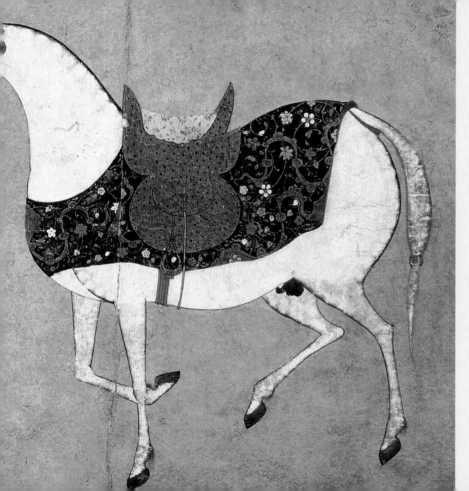

AL-HUSAINI AL-JAZDI
*Young Man with
Lute and Horse*
1594/5

A pretty Persian miniature
painting playfully depicts a young
musician accompanied by his
highbred-looking horse. The
horse sports a finely plaited mane
and a tightly bound tail.

Sharaf al-Husaini al-Jazdi, 16th Century

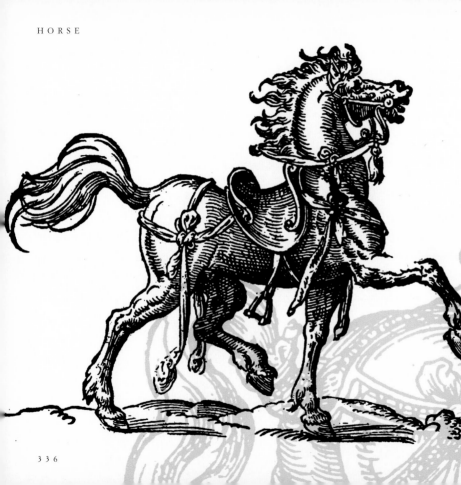

AMMAN
Art Booklet
1578

Bedecked by ribbons, bows, feathers, and ornate saddles, these three horses are certainly set to be star performers. Alas, they are a flight of fantasy! In reality only the most meticulously trained horses, such as those used by police forces, could withstand such distractions without taking fright.

Jost Amman, 1539–91

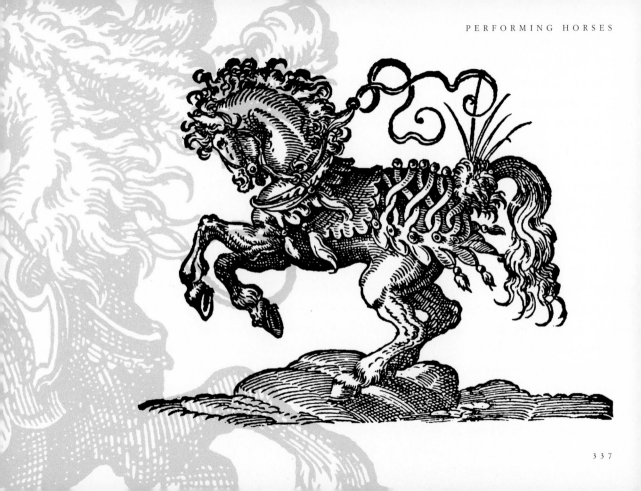

"
Give me another horse! Bind up my wounds!

Have mercy, Jesu!—Soft, I did but dream.

O coward conscience, how dost thou afflict me?
"

WILLIAM SHAKESPEARE, 1564–1616

HAMILTON AND **BRAND**
The White Stallion Leal en Levande
18th Century

The idealized Italianate landscape and the
neoclassical ruins surrounding this stallion seem a
fitting backdrop to his dressage display, as he
performs the movement known as the *levande*.

Johann Georg Hamilton, 1672–1737, and J.C. Brand, 1722–95

AMERICAN

Roy Rogers and Trigger
1942

Along with Gene Autry, Roy Rogers introduced the popular phenomenon of the singing cowboy. Here he is photographed in Madison Square Garden, New York, mounted on his horse Trigger, during rehearsals for the movie *The Rodeo*.

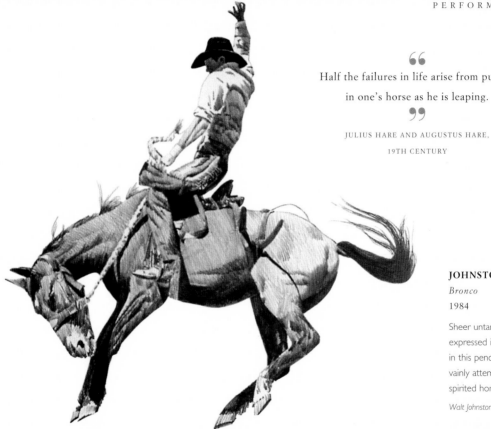

66

Half the failures in life arise from pulling
in one's horse as he is leaping.

99

JULIUS HARE AND AUGUSTUS HARE,
19TH CENTURY

JOHNSTON

Bronco

1984

Sheer untamed energy is
expressed in the animal's pose
in this pencil drawing, as the rider
vainly attempts to control the
spirited horse.

Walt Johnston, b. 1932

341

SORF

The Knightly Dream
1998

This boy's fantasy role is that of the medieval knight, with the wheelbound toy horse transformed into a noble steed. The fact that we cannot see the faces of the riders in either of these paintings lends them an atmosphere of secrecy and concealment.

Zdenek Sorf, b. 1965

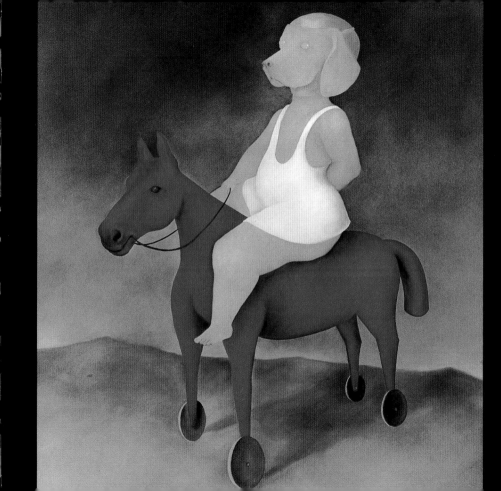

SORF
*Romance of
the Red Horse*
1998

The figure of the horse is
often an integral part of
Sorf's paintings based on
dreams and fantasies. Here,
the red toy horse plays an
ambiguous role in this
young girl's dreams, her face
obscured by a dog mask.

Zdenek Sorf, b. 1965

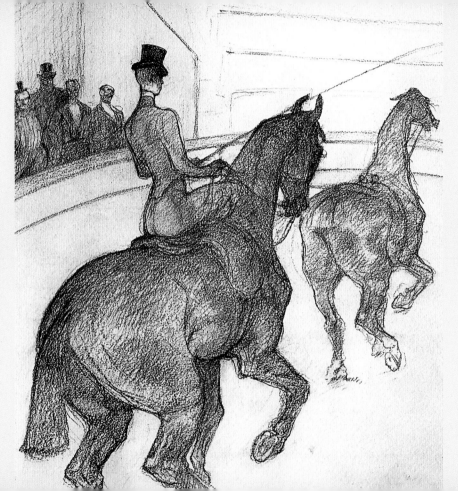

TOULOUSE-LAUTREC
The Tandem
1899

Toulouse-Lautrec returned to the subject of the circus many times. In the later part of the nineteenth century both circus and cabaret shows often featured equestrian performances. This charcoal drawing shows a female rider running two horses in tandem, one harnessed in front of the other.

Henri de Toulouse-Lautrec, 1864–1901

> 66
> Ride a cock-horse to Banbury Cross,
> To see a fine lady upon a white horse;
> With rings on her fingers and bells on her toes,
> She shall have music wherever she goes.
> 99

NURSERY RHYME

GRANVILLE

The Circus

19th Century

The dynamic angle from which this young female trick rider is viewed makes one further appreciate the drama and daring of this skillful feat. It also affords a view of the excited and thrilled audience.

Isidore Granville, 19th Century

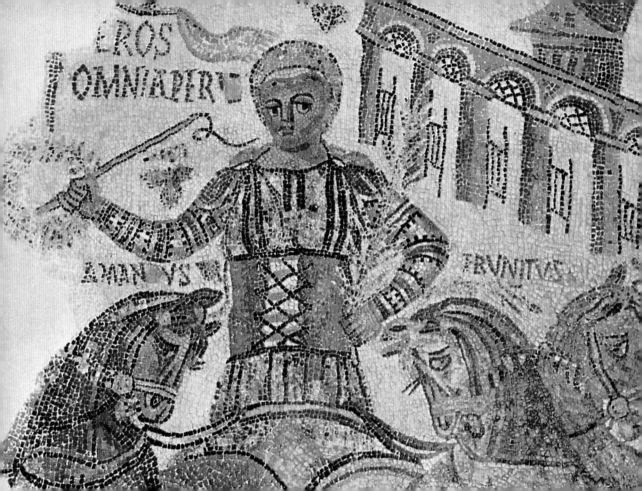

ROMAN

Roman Quadriga
Undated

The *quadriga* was a four-horse chariot used for races in the Roman circus. This charioteer is completing a lap of honor. He has just won a race for the emperor Caligula (A.D. 12–41), who was a fanatical spectator of these daring performances.

FURNISS

"The Political Sandow"
1893

"How much more will he bear?" asks the caption to this political cartoon, which draws a humorous analogy between the antics of the circus and Parliament. This is one of the cartoons for the parliamentary review that Irish caricaturist Furniss produced for *Punch* magazine.

Harry Furniss, 1854–1925

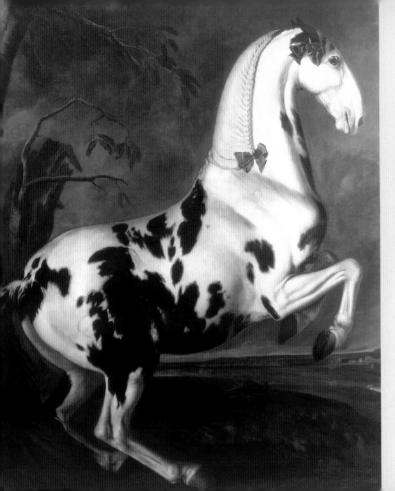

HAMILTON

*The Piebald Stallion
at the Eisgruber Stud*
18th Century

This piebald displays the treasured physical
characteristics of the Lipizzaner horse: he is small,
graceful, and has slender legs and a long, silky mane
and tail. His endearing face also suggests that he
possesses the breed's other qualities: intelligence
and a sweet nature.

Johann Georg Hamilton, 1672–1737

CHINESE

Dancing Horse
A.D. 657

This white earthenware sculpture of a dancing
horse was made in China during the Tang dynasty
(A.D. 618–906). The beautifully observed form of
the horse is animated by the prancing stance,
bowed head, and upturned tail. Similar sculptures
were produced in bronze and often displayed
miraculous feats of balance.

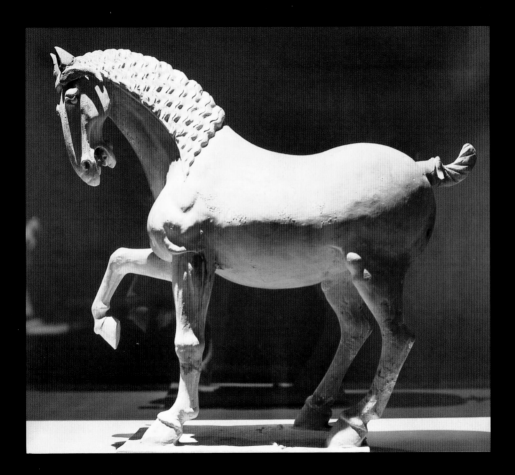

Well, God's a good man.
An two men ride of a horse,
one must ride behind.

WILLIAM SHAKESPEARE, 1564–1616

HAMILTON

The Black Horse Curioso
Performing a Capriole
18th Century

The *capriole* is a dressage air, or
movement, here performed with
gravity-defying skill by Curioso.
The unusual saddle would help
the rider to achieve the correct
academic seat, which involves
sitting erect and deep in the
middle of the saddle.

Johann Georg Hamilton, 1672–1737

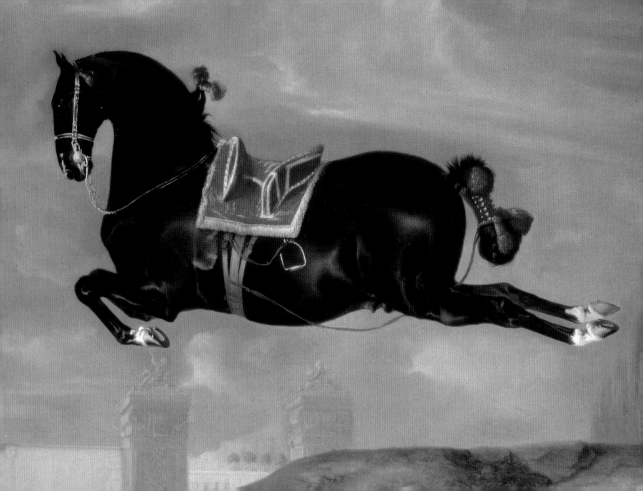

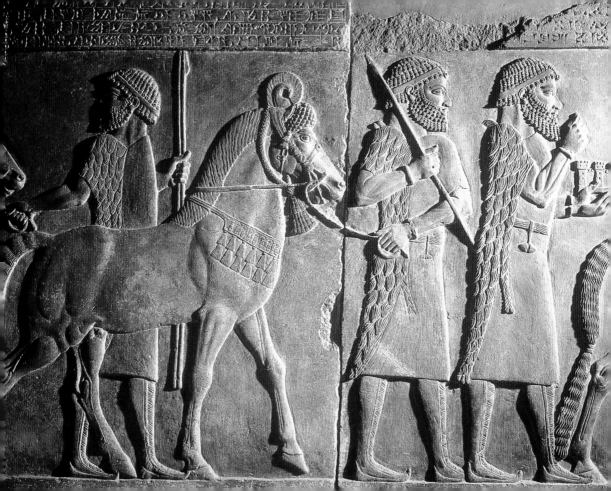

ASSYRIAN
*Tributary Medes
with Horses*
8th Century B.C.

This bas-relief from the palace of Sargon II in Chorsabad, Iraq, depicts a stately procession in which horses seem to play an essential role. Note the fine braiding of tail and mane, along with the decorative ceremonial bridle and breastpiece.

STERN
Animal Acts
1992

Stern chooses a circus setting and subverts the norm as she depicts a female form kneeling captive in a cage surrounded by an audience. An unfettered yellow horse stands beside the cage.

Pia Stern, b. 1952

3 5 3

LINTON

The Merchant of Venice
20th Century

The problems of staging mounted
Shakespearean scenes in the theater are easily
overcome in illustrated versions of the text.
Linton specialized in producing watercolors
featuring medieval and Stuart subjects.

Sir James Drogmole Linton, 1840–1916

INDEX OF ARTISTS

CURTIS, *Edward Sheriff*
1869–1955
American photographer born in Wisconsin, where his neighbors were native tribes. This influenced his later photographic studies of ethnic groups. President Roosevelt (1858–1919) was interested in Curtis's photographs of Native North Americans, declaring them works of art.
Pages 200–1

DAUMIER, *Honoré*
1808–79
French cartoonist who worked for *La Caricature* and *Charivari*, producing 4,000 lithographs of social and political satire.
Pages 4–5, 107

DAVID, *Jacques-Louis*
1748–1825
French neoclassical painter of academic history scenes and portraits. His work is synonymous with the French Revolution and he became a deputy, voting for the execution of Louis XVI (1754–93). David was imprisoned for a time after the fall of Maximilien de Robespierre (1758–94). Later he became an ardent supporter of Napoleon (1769–1821), who exploited his art for propagandist purposes.
Pages 178, 210

DEGAS, *Edgar*
1834–1917
French painter who studied under Jean-Auguste-Dominique Ingres (1780–1867). He later abandoned the academic style for a less conventional use of composition. Influenced by Édouard Manet (1832–83), James Whistler (1834–1903), and the new art of photography, he experimented endlessly with the use of media. He exhibited at the Impressionist exhibitions, choosing subjects from everyday life. Degas produced a large body of sculpted works in later life.
Pages 10–11, 40–1

DELACROIX, *Eugène*
1798–1863
French painter of the Romantic Movement and a pupil of Pierre-Narcisse Guérin (1774–1833). He was influenced by Théodore Géricault (1791–1824), and particularly by his interest in English art and his portrayal of animal subjects. Delacroix produced pictures based on contemporary and exotic literary subjects, such as battles and animals in combat, as well as large-scale decorative schemes.
Pages 244–5, 284

DREUX, *Alfred de*
1810–60
French painter of equestrian subjects, such as racehorses, hunting scenes, and mounted portraits, as well as large-scale history paintings. He studied under Léon Cogniet.
Pages 18–19, 298–9

DÜRER, *Albrecht*
1471–1528
German painter, print maker, and writer, renowned for his altarpieces and woodcut book illustrations. Initially apprenticed to his goldsmith father, he later became a pupil of Michael Wolgemut (1434–1519). Dürer traveled widely and was a true Renaissance man, studying mathematics, Latin, and humanist literature. His works are rich in complex iconography.
Pages 192–3, 252–3

EAKINS, *Thomas*
1844–1916
American painter, particularly of portraits. He studied anatomy in medical classes and this became the subject of some of his more notorious paintings, such as *Gross Clinic* (1875). Eakins was influenced by Édouard Manet's realism after a visit to Paris in 1866.
Pages 60, 92–3

EMMS, *John*
1843–1912
Prolific English animal painter, who is best known for his pictures of foxhounds and fox terriers. He exhibited more than 300 paintings at the Royal Academy during the course of his career, and used to pay his bar bills with paintings.
Pages 7, 142–3

FORD, *Henry Justice*
1860–1941
English illustrator and painter, usually known as H.J. Ford. He served in the Artists' Rifles during the First World War and was a friend of Edward Burne-Jones (1833–98), whose influence can be seen in the dreamlike quality of Ford's work.
Page 273

FURNISS, *Harry*
1854–1925
Irish illustrator who worked for *Punch*, *Zozimus,* and the *Illustrated London News*. From 1912 to 1914 he worked in the cinema, as a writer, producer, and actor in New York, returning to London at the outbreak of war.
Page 347

FUSELI, *Henry*
1741–1825

Swiss-born painter who studied art from 1763 in Berlin, then traveled to England. He returned there after some time in Italy and began producing works of great imaginative power. Fuseli was simultaneously professor of painting at the Royal Academy and keeper of paintings.
Pages 227, 242

GARRARD, *George*
1760–1826

English animal painter and sculptor, pupil of Sawrey Gilpin (1733–1807). His patrons included the Duke of Bedford and the Whitbread brewing family. From 1795 sculpture accounted for most of his output.
Pages 78–9

GAUGUIN, *Paul*
1848–1903

French painter who gave up his job as a stockbroker in 1871 to devote himself to painting. He exhibited with the Impressionists (whose work he collected) between 1881 and 1886. His rejection of Western civilization, coupled with his search for a simpler way of life, took him to Tahiti and the South Seas. He died there after years of illness and poverty.
Pages 118–19, 159

GENTILE DA FABRIANO
c. 1370–1427

Italian painter who produced one of the masterpieces of the International Gothic style, the *Adoration of the Magi*, an altarpiece that is now in the Uffizi in Florence.
Page 295

GÉRICAULT, *Théodore*
1791–1824

For two years Géricault was a pupil of fellow French artist Carle Vernet (1758–1836) but left remarking, "One of my horses would have devoured six of his." He was a painter of contemporary scenes of everyday life and of horses, and was influenced by Antoine-Jean Gros (1771–1835). Géricault often worked directly onto the canvas, rather than making preparatory squared-up drawings, and his work has a resulting immediacy.
Pages 38–9, 74, 110–11, 128, 146, 162–3, 204

GOYA, *Francisco de*
1746–1828

Spanish painter and print maker whose early success producing tapestry cartoons for the royal manufactory led to his appointment as the principal painter to the king in 1799. Goya often commented on contemporary political events in his work, notably in his series of etchings *The Atrocities of War* (1810–13) and the paintings *The Second of May* and *The Third of May 1808* (c. 1814).
Pages 33, 279, 299

GOZZOLI, *Benozzo*
c. 1421–97

Italian fresco painter, and assistant of Fra Angelico (c. 1400–55). Examples of his fresco cycles can be found in Florence and Pisa (partially destroyed during the Second World War).
Pages 84–5

GRANT, *Sir Francis*
1803–78

Scottish painter born in Edinburgh who became president of the Royal Academy in 1866. He painted sporting scenes and popular portrait groups, such as *Melton Hunt*, executed for the Duke of Wellington (1769–1852).
Pages 14, 26–7

GRANVILLE, *Isidore*
19th Century
Page 345

HAMILTON, *Johann Georg*
1672–1737

Flemish painter who specialized in depicting hunting scenes and horses. He studied under his father James Hamilton and later worked for Frederick I of Prussia (1688–1740) and for the Emperor Charles VI (1685–1740).
Pages 278, 290–1, 317, 318, 338–9, 348, 350–1

HERRING, *John Frederick, Senior*
1795–1865

British painter of sporting scenes. Born into a coaching family (his father made horse-carriage accessories), Herring started his artistic life painting inn signs, coach doors, and horse portraits. He subsequently studied under Abraham Cooper (1787–1868) and his work enjoyed great popularity and was widely reproduced as prints. All three of Herring's sons became animal painters.
Pages 274–5

HOKUSAI, *Katsushika*
1760–1849

Japanese painter and print maker. Hokusai was extremely prolific and it is thought that he made 30,000 drawings and illustrations for some 500 books. His woodblock prints influenced many late-nineteenth-century artists, such as Vincent Van Gogh (1853–90) and Paul Gauguin (1848–1903).
Pages 98–9

HOLDSWORTH, *Anthony*
b. 1945

British-born American artist who paints in the tradition of the *plein air* artists, directly from life. Interested in both city and country scenes, Holdsworth chooses his subjects from a wide range of locations.
Pages 152–3

HURD, *Peter*
1904–84

American illustrator. He was a pupil at the Art School of Pennsylvania and featured in the exposition of American art in London in 1945.
Page 18

JACKSON, *Lee*
b. 1909

American painter.
Pages 126–7

JACOPO DI PIETRO
16th Century
Page 258

JANOSOVA, *Anita*
b. 1951

American artist who has studied in the United States and in Italy. Interested in feminist themes, she portrays her female models as great mythic figures.
Page 136

JOHNSTON, *Walt*
b. 1932

American artist highly acclaimed for his perspective drawings of people and animals. He lives in New Mexico and his paintings of flowers are widely exhibited and collected.
Page 341

KARPELLUS, *Adolf*
20th Century

German poster artist.
Page 220

KEMP-WELSH, *Lucy-Elizabeth*
1869–1958

English painter best known for her pictures of horses. She studied at Hubert Von Herkomer's art school.
Page 173

KEUSCHDEN, *F.E.*
19th Century
Pages 58, 76–7

KNECHTEL, *Tom*
b. 1952

American artist whose fine draftsmanship has won him exhibitions in Los Angeles and New York.
Page 304

KOLLER, *Rudolf*
1828–1905

Swiss painter who studied in Zurich under Johann Jakob Ulrich (1798–1877) and in Düsseldorf under Carl Ferdinand Sohn (1805–67). After spending time in Paris and Munich he returned to Zurich and painted mainly romantic pastoral scenes.
Pages 64–5

KUPKA, *Frantisek*
1871–1957

Czech artist who trained in Prague and Vienna before going to Paris in or around 1895. An influential figure in the early development of abstract art, Kupka was involved with the Fauves, Gustave Klimt (1862–1918), and Jacques Villon (1875–1963). He wrote a book on artistic creation and practiced as a spiritual medium.
Pages 172–3

KUSTODIEV, *Boris*
1878–1927

Russian painter and stage designer, influenced by the 1887 exhibition of the group of Russian realist painters known as the Wanderers. He studied at the Academy of Arts in St. Petersburg and painted scenes of Russian provincial festivities.
Pages 68–9

LANDSEER, *Sir Edwin*
1802–73

English animal painter. Landseer's sentimental anthropomorphic scenes made him Queen Victoria's favorite artist. He is responsible for the massive lion sculptures at the foot of Nelson's Column in Trafalgar Square, London. He died insane after four years of illness.
Pages 72–3

MERTE, *Oskar*
b. 1872
Pages 314–15

MILLER, *Paton*
b. 1953
American artist born in Seattle, he studied at the Honolulu Academy of Art and Southampton College, New York.
Pages 46–7, 132, 158–9

MOORE, *Henry*
1898–1986
English sculptor who believed in carving directly into wood and stone, producing massive abstract works based on forms observed in nature and on the human body; he also produced works in bronze. He fulfilled many public commissions.
Page 138

MOREAU, *Gustave*
1826–98
French Symbolist painter whose pupils included Henri Matisse (1869–1954) and Georges Rouault (1871–1958). Moreau was one of the principal painters associated with the Symbolist Movement, along with the artists Pierre Puvis de Chavannes (1824–98) and Odilon Redon (1840–1916).
Page 255

MUYBRIDGE, *Eadweard*
1830–1904
British-born photographer who emigrated to the United States and became a pioneer of motion photography. His studies *The Horse in Motion* (1878) and *Animal Locomotion* (1887) were widely studied by animal artists.
Pages 36–7

NEMESIO, *Ernesto*
b. 1978
American artist who lives and works in Los Angeles. He studied at the Art Center College of Design, California, and in Europe.
Pages 116–17

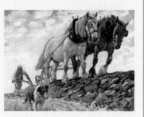

NOBLE, *Edwin*
b. 1876
British animal painter and illustrator who studied at the Slade School, the Royal Academy, and Lambeth.
Pages 94–5, 97

OD, *Kira*
b. 1960
American artist who started as a medical illustrator and then turned to sculpture. Od often creates powerful mythic figures by combining human and animal forms.
Page 245

PALANKER, *Robin*
b. 1950
American artist from Buffalo, New York. She is well represented in West Coast galleries. Her work also appeared in Douglas Messerli's *Silence All Around Marked*.
Pages 174–5

PEALE, *Rembrandt*
1778–1860
One of an American family of painters, Rembrandt studied under Benjamin West (1728–1820) in England. He painted portraits and still lifes and was one of the first American artists to practice lithography.
Page 207

PEI-HUNG, *Hsu*
1895–1953
Chinese artist who studied in Paris, then became professor at the Art School of Nanking. In 1949 he became rector of the Central Academy of Fine Arts.
Page 140

PENFIELD, *Edward*
1866–1925
American painter and graphic artist.
Pages 80–1, 312–13

PETROV-VODKIN,
Kuzma Sergeyevich
1878–1939
Russian artist who trained as an icon painter and went on to study painting in St. Petersburg and Moscow. He was associated with the Blue Rose Group.
Pages 225, 228–9

PISANELLO
(Antonio Pisano)
c. 1395–1455
Italian painter and leading exponent of the international gothic style. He produced portrait medals, including a set for Alfonso of Aragon, King of Naples (1396–1458). Many wonderful drawings by him survive.
Pages 278, 310

POLLARD, *James*
1792–1867
English painter and etcher, son of Robert (c. 1755–1838), an engraver, painter, and publisher. After working for his father, Pollard established himself as a sporting artist, specializing in coaching scenes.
Pages 22–3, 284–5

ROWLANDSON, *Thomas*

1756–1827

English caricaturist and illustrator, whose sensitivity of line and color sometimes appears at odds with the satirical ribaldry of his subjects.

Page 23

RUBENS, *Sir Peter Paul*

1577–1640

Prolific Flemish painter who attained many influential positions and was engaged in diplomatic missions. He became court painter to the Spanish governors of The Netherlands and was knighted by Charles I (1600–49). He ran a large studio to facilitate his vast output (the young Anthony Van Dyck, 1599-1641, worked as his chief assistant), which he controlled with great care. Most pictures were finished by him, but the extent of his involvement in a work was dictated by the price being paid.

Pages 176–7, 194–5

RUSTICI, *Vicenzo*

1556–1632

One of a family of artists who were active in Siena from the fifteenth to the seventeenth centuries. Vicenzo was the son of the painter Lorenzo Rustici and the pupil of Antonio Casolani.

Pages 326–7

SANCHEZ, *Stephanie*

b. 1948

American painter of moody still lifes, animals, and birds. She is represented at the Oakland Museum, California, and the Madison Art Center, Wisconsin.

Pages 240–1

SARTORIO, *Giulio Aristide*

1860–1932

Italian painter, print maker, writer, and teacher, known for his pictures of landscapes and animals, particularly horses.

Pages 120–2

SCHOONOVAR, *Frank*

1877–1972

American painter.

Page 260

SEURAT, *Georges*

1859–91

French neo-Impressionist painter. He studied and was influenced by current aesthetic theories and scientific writings on the phenomena of vision and the theory of color. He devised his own method of painting by using color contrasts and the compositional device of the Golden Section. He exhibited at the last Impressionist exhibition of 1886.

Pages 316, 327

SHERRIFFS, *Robert Stewart*

1906–60

English illustrator who initially specialized in heraldry and later became film caricaturist on the magazine *Punch*.

Pages 14, 32

SLONEM, *Hunt*

b. 1952

American artist who produces large, exotic and florid canvases of animals and birds. He exhibits widely and is represented by the Marlborough Galleries.

Pages 225, 259, 277, 282–3

SMYTHE, *Edward Robert*

1810–99

An English painter from Ipswich who lived and worked in East Anglia. He produced landscape and coastal scenes populated by people and animals.

Pages 66–7

SORF, *Zdenek*

b. 1965

Czech painter born in Prague, who first studied nuclear physics and mechanical engineering before turning to art. Sorf was awarded the Franz Kafka Medal and has exhibited in Germany and Kuwait, as well as his own country.

Pages 164, 319, 342–3

SOROLLA Y BASTIDA, *Joaquin*

1863–1923

Spanish painter born in Valencia. Sorolla was a leading Spanish Impressionist, most notable for the effects of sunlight that he achieved in his work.

Pages 145, 150–1

STERN, *Pia*

b. 1952

American-born painter, now living and working in Hawaii. The intense colors of her animal paintings are much admired for the spiritual quality of their beauty.

Page 353

STUBBS, *George*

1724–1806

English painter best known for his stunning pictures of horses. After time spent in isolation in Lincolnshire, dissecting horses, he moved to London and published his *Anatomy of the Horse* in 1766. However, his empirical observation, though masterful, never detracts from the pictorial imagination that animates all his best works.

Pages 50–1, 140–1, 156–7, 166–7, 292–3, 294–5, 296

THEAKER, *Harry*
1873–1954
British painter, potter, and illustrator, who was head of the Regent Street School of Art in London in the 1930s. Theaker illustrated many children's books and fairy tales and was a member of the Art Workers' Guild.
Pages 180, 188

TIEPOLO, *Giovanni Battista*
1696–1770
Italian painter from Venice. Tiepolo produced many wonderful fresco decorations in palaces and churches in Italy, Germany, and Spain, employing an impressive use of dazzling perspectives. He is thought of as the best exponent of the rococo style.
Pages 262–3

TINTORETTO
(Jacopo Robusti)
1518–94
Italian painter born in Venice, reputedly a pupil of Titian (c. 1488/9–1576). Along with Paolo Veronese (c. 1528–88), Tintoretto worked on the interior of the Doge's Palace in Venice after fires in 1574 and 1577. His most notable work is that in the Scuola di San Rocco, Venice, which was completed in 1588.
Page 236

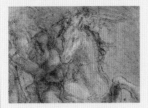

TITIAN *(Tiziano Vecellio)*
c. 1488/9–1576
The finest Venetian painter, who became painter to the republic in 1516 and court painter in 1533. He was a pupil of Gentile Bellini (c. 1429/30–1507) and of Giovanni Bellini (c. 1430–1516), but his greatest influence was Giorgione (c. 1476/8–1510). Among his most famous works are the *Pesaro Altar* (1519–26), *Venus of Urbino* (c. 1538), and *Assumption* (1516–18) in Venice.
Pages 206–7

TOULOUSE-LAUTREC, *Henri de*
1864–1901
French painter and print maker, influenced by the everyday subject matter of Edgar Degas (1834–1917) and by Japanese prints. He is best remembered for his posters of the famous cabaret and circus figures of Montmartre, as well as for his nonjudgmental studies made in brothels.
Pages 8, 15, 39, 80, 88, 344

TOWNE, *Charles*
1763–1840
English painter, son of the portrait painter Richard Town (Charles added the "e" later in life). Towne originally worked as a heraldry and coach painter and is known for his landscapes and animal pictures.
Pages 296–7

UCCELLO, *Paolo*
(Paolo di Dono)
c. 1396/7–1475
Early Italian Renaissance painter. He was interested in perspective, particularly in foreshortening, although he never took its application to its logical conclusion; instead he often included more than one viewpoint in his works. Much of Uccello's work has an attractive decorative quality.
Pages 216–17, 226, 236–7

VAN DYCK, *Sir Anthony*
1599–1641
Netherlandish painter who was assistant to Peter Paul Rubens (1577–1640) as a young man. Van Dyck painted religious subjects, but is best known for the originality and power of his portraits. He worked at the English court of Charles I (1600–49) from 1632 until his death. Van Dyck was highly influential on later portrait painters.
Page 301

VAN GOGH, *Vincent*
1853–90
Dutch painter who spent time in England, Belgium, and France, where his brother Theo ran a Parisian gallery full of Impressionist works. He studied for the clergy and worked as a missionary; he also spent time with Paul Gauguin (1848–1903) in the south of France, but became mentally ill there in 1888—a recurring condition until his suicide in 1890. His early dark works gave way to the vivid colors and expressive handling of paint that characterize his best-known paintings.
Pages 60, 82–3

VAN OSTADE, *Isack*
1621–49
Dutch painter of genre subjects from Harlem. He was a pupil of his brother Adriaen (1610–85), who was a prolific painter of peasant scenes.
Page 79

VARI, *Sophia*
b. 1940
Born in Greece, Vari studied at the École des Beaux Arts in Paris, where she now lives. She produces two-dimensional works and sculptures and is represented in collections in Europe and the United States.
Pages 6, 122

VELÁZQUEZ,
Diego Rodriguez de Silva y
1599–1660
Spanish artist who became court painter in Madrid in 1623. Due to the demands of the market, he mostly produced portraits, including many fine equestrian portraits of Philip IV (1605–65). His work is characterized by great realism tempered by an imaginative interpretation of character.
Page 302

VERNET, *Carle*
1758–1836
Member of a French family of painters and the son of Claude-Joseph (1714–89), a leading landscape painter. Carle painted large battle scenes for Napoleon (1769–1821), as well as racing and hunting pictures for Louis XVIII (1755–1824).
Pages 179, 204–5

VERNET, *Horace*
1789–1863
The son of Carle Vernet, Horace also specialized in scenes of the Napoleonic era, as well as painting oriental and animal pictures. He was director of the French Academy in Rome from 1828 to 1835.
Pages 132–3

VINCENT DE BEAUVAIS
c. 1190–1264
French Dominican and encyclopedist, who gathered together the entire knowledge of the Middle Ages in the *Speculum Majus.*
Page 184

WALLCOUSINS, *Charles Ernest*
d. 1976
English watercolor painter, mainly of landscapes.
Pages 261, 268–9

WARD, *James*
1769–1859
English animal painter and engraver who became painter and engraver of mezzotints to the Prince of Wales. As a follower of the apocalyptic clergyman Edward Irving (1792–1834), Ward was said to pray for divine inspiration in the studio.
Pages 128–9, 310–11

WARNER, *Christopher*
b. 1953
American artist now painting and teaching in Los Angeles. Animals populate his canvases, whether he is portraying dense urban landscapes or the wide-open spaces of the prairies.
Pages 13, 48, 61, 85, 136–7

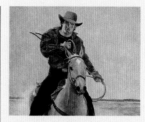

WELCH, *William John*
b. 1929
American portrait painter who exhibits widely in New York, California, and the southern states.
Pages 154–5

WIEDEMANN, *Ludwig*
18th Century
German artist.
Page 303

WILKIE, *Sir David*
1785–1841
Scottish painter of genre scenes, who became painter to the king in 1830 and was knighted in 1836. Ill health took him to the continent, where his exposure to Italian and Spanish art impacted on his style. After a trip to the Holy Land he died on the return voyage..
Pages 144, 160

WOODLOCK, *David*
1842–1929
Irish painter who worked in England. He painted mainly figures, landscapes, and gardens.
Pages 56–7

WRIGHT, *Curtis*
b. 1963
American painter and print maker from southern California, one of whose interests is the particular quality of light found on the Pacific Coast.
Pages 41, 103, 113

YOUNG, *Sarah*
b. 1961
English print maker and illustrator who studied at Reigate School of Art and Brighton School of Art. Young's illustration work is widely published in books and magazines and by card and design companies. She also produces innovative three-dimensional artwork.
Pages 226, 246–7, 256, 316, 332

ZOKOSKY, *Peter*
b. 1957
American artist from Long Beach, California. His whimsical canvases are widely exhibited throughout the West Coast.
Pages 52–3, 104, 124–5

PICTURE CREDITS

ARCHIV FÜR KUNST UND GESCHICHTE, LONDON

pp.2, 39 Staatliche Kupferstick Kabinett, Dresden; 64/5 Aarauer Kunsthaus, Aarau; 80 Musée Toulouse-Lautrec, Albi; 89, 266/7 Musée d'Orsay, Paris; 106 Pech-Merle, France; 107 Stiftung und Sammlung Weinburg, Zurich; 112, 118 Pushkin Museum, Moscow; 119 National Gallery, Berlin; 138 Art Gallery of Ontario, Toronto; 139 Forschungsbibliothek, Gotha; 148/9 Solomon Guggenheim Museum, New York; 165, 250 Bayerische Staatsgemäldesammlung, Munich; 168 Tretyakov Museum, Moscow; 171 Staatkupferstich, Dresden; 182 Städtische Sammlungen, Belgrade; 202, 206 Munich Staatliche Graphische Sammlung, Munich; 231 Musée des Beaux Arts, Bordeaux; 232/3 Scuola di San Giorgio degli Schiavoni, Venice; 255 Musée Gustave Moreau, Paris; 262 Ca Rezzonico, Venice; 272 Uffizi Gallery, Florence; 289 Palazzo Publico, Siena; 335 Hermitage Museum, St Petersburg; 349 Kiangsi Historical Museum, China.
S. Domingie/AKG: p.295 Uffizi Gallery, Florence.
Dieter E. Hoppe: p.303.
Erich Lessing/AKG: pp.10, 327 Musée d'Orsay, Paris; 123 Essen Folk Museum, Essen; 128, 352 Louvre, Paris; 134 Peking National Museum, Beijing; 166/7, 170, 280, 288 Palazzo Ducale Camera degli Sposi, Mantua.
Jean Louis Nou/AKG: p.55 Meherangarh Fort Museum, Jodhpur.

THE BRIDGEMAN ART LIBRARY, LONDON

pp.7, 142 John Noott Galleries, London; 19, 30/1 Prado, Madrid; 40, 44/5 Muzeum Narodowe, Krakow; 49 Sotheby's, London; 50 Jockey Club, Newmarket; 56, 73, 129 Phillips, London; 66, 78, 311 Ackerman and Johnson Ltd., London; 67 Oldham Art Gallery, Oldham; 76/7 Gavin Graham Gallery, London; 79 National Gallery, London; 84 Palazzo Medici-Riccardi, Florence; 111 Louvre, Paris; 156/7, 160 Victoria and Albert Museum, London; 163, 234, 258, 270/1 Fitzwilliam Museum, Cambridge; 169, 314 Bonhams, London; 188/9 Kunstindustri Museet, Oslo; 190/1 Musée de la Tapisserie, Bayeux; 197/8 Leeds Museums, Leeds; 216/17, 254 Uffizi Gallery, Florence; 235 Southampton Art Gallery; 238 Lambeth Palace, London; 242 Goethe Museum, Frankfurt; 263, 290, 292, 339, 351 Kunsthistorisches Museum, Vienna; 291 Museu de Arte, São Paulo; 305, 306 National Horse Racing Museum, Newmarket; 348 Liechtentstein Royal Collection, Liechtenstein.
Christie's/Bridgeman: pp.26, 74, 100, 110, 162, 274, 297, 298.
Giraudon/Bridgeman: p.230 Scuola di San Giorgio degli Schiavoni, Venice.
Index/Bridgeman: p.151 Museo Sorella, Madrid.

CAMERON COLLECTION

pp.22, 25, 285.

CORBIS, LONDON

pp.16, 68/9 State Russian Museum, St Petersburg, 185, 211.
Archivo Iconographics S.A./Corbis: p.20 National Museum of Art, Merida; 21 Musée Condé, Chantilly; 29 Biblioteca Nazionale, Marcia; 33, 302 Prado, Madrid; 38, 204 Louvre, Paris; 68/9 State Russian Museum, St Petersburg; 159 Musée d'Orsay, Paris; 172 National Museum, Prague; 184 Musée Condé, Chantilly; 210, 228, Tretyakov Museum, Moscow; 284 Hermitage Museum, St Petersburg; 300 Museo del Settecento, Venice; 326, Arte and Immagini.SR.L./Corbis: p.299.
Bettmann/Corbis: pp.214, 340.
Burstein Collection/Corbis: pp.88, 176; Nelson Atkins Museum, Missouri, 286.
Jan Butchofsky Houser/Corbis: p.135.
Geoffrey Clements/Corbis: pp.86/7 The Frick Collection, New York.
Pierre Colombel/Corbis: p.243.
The Corcoran Gallery of Art, Washington, D.C./Corbis: p.207.
Dean Conger/Corbis: p.62.
Gianni degli Orti/Corbis: pp.75, 345 Musée Carnevale, Paris.
Sergio Doramtes/Corbis: p.209.
Edimedia/Corbis: pp.82/3 Musée d'Orsay, Paris.
Angelo Homak/Corbis: p.287.
Hulton-Deutsch Collection/Corbis: p.221.